The User's Guide to Photographic Film

The User's Guide to Photographic Film

by Dan O'Neill

AMPHOTO
an imprint of Watson-Guptill Publications
New York

To my wife Maria who typed the final manuscript, my son Danny, all the people who stood in front of the camera, and the many people out of its view who helped to make the pictures possible, I dedicate this book.

Copyright © 1984 by Dan O'Neill

First published 1984 in New York by AMPHOTO,
an imprint of Watson-Guptill Publications,
a division of Billboard Publications, Inc.,
1515 Broadway, New York, NY 10036

Library of Congress Cataloging in Publication Data

O'Neill, Dan.
 The user's guide to photographic film.

 Includes index.
 1. Photography—Films—Handbooks, manuals, etc.
I. Title.
TR283.54 1984 771'.5324 84–18541
ISBN 0-8174-3513-1
ISBN 0-8174-3512-3 (pbk.)

Manufactured in the United States of America

1 2 3 4 5 6 7 8 9/90 89 88 87 86 85 84

I wish to thank the following companies and people for their invaluable help in the production of this book: Agfa-Gevaert; Eastman Kodak Co.; Fuji Film USA; Ilford Ltd.; Konica Corp.; Polaroid Corp.; 3M, Fotomat; Nikon Inc.; Broncolor; Rajah Camera; Rolliflex; Minolta Corp.; Spiratone Inc.; Unicolor; Kiron Corp.; Tokina Optical Corp.; Vivitar Corp.; Gitzo; Alpa; Sima; Tiffen Manufacturing Corp.; Rolev; B & W; Franklin Dist.; Negafile; Mamiya; Gossen; Linhof; Ricoh; Falcon; Gepi; Sekonic; Durst; Patterson; Philips; Omega; photographers Peter Ide and Chuck Goodman; Stephanie Bonagura for hairstyling and makeup; and models Edna Rosa, Enid Rosa, Wanda Rawlins, Lisandra Martinez and Denise Rios.

Contents

Seeing the Light: How Film Works

Light is energy and matter. As light travels through space, it acts as part of the electro-magnetic spectrum in the form of energy waves. Visible light is a very small part of the electromagnetic spectrum, which includes sound waves; radio waves; microwaves; radar; x-rays; infrared, ultraviolet (UV), and gamma rays, and cosmic radiation.

When a photon, the smallest unit of light energy, strikes an object it acts like a particle (mass), causing a reaction. For instance, when a photon strikes a silver halide crystal in a film's emulsion, it causes electrons and silver ions to migrate, moving within the crystal to collect around a sensitivity speck. This reaction forms a latent image, which can then be magnified and converted chemically into a permanent image.

We also use the particle reaction of light every time we use a filter over our camera lens. Photographic filters work by using dyes that selectively pass certain wavelengths and block others: the more intense the color of the filter, the stronger is its blocking action.

We see the particle reaction of light every day. At high noon the sun is at its closest to us for that day and the light rays pass through the least amount of atmosphere so that the sun appears white. Late in the afternoon when the sun is near the horizon, its light has to pass through more of the earth's atmosphere. This blocks more of the blue light, making the sun appear yellow, orange, or red as more and more blue light is absorbed.

Another aspect of light is its color temperature, which is expressed in degrees Kelvin. The Kelvin scale is an absolute scale measured in degrees centigrade +273. Color tem-perature is an expression of the visual aspect of color. Color temperature is the amount of heat it takes for a perfect black body to produce a given color. When the color temperature is low, it produces only long wavelengths of light, which we see as red. As the color temperature rises, shorter wavelengths are produced along with the longer wavelengths, resulting in a wider color range. When the color temperature reaches 5500K, which is considered photographic daylight, we see it as white light because all wavelengths are being produced.

Color temperature is important because film cannot adjust itself to various color tem-peratures as the eye can. I remember the first time I saw a London bus pull up at night under a sodium lamp. The bus appeared to be brown. My mind said, "Wait a minute, that bus is red," and as I was looking at the bus, it turned red. The mind can adjust its vision with color controls until it sees what it knows it is supposed to see. Film can only see the color temperature it is designed to see and will produce improper coloration. However, the color temperature reading of a film can be balanced to see colors properly under alternate light sources by using color-conversion or light-balancing filters.

Black-and-white and color films essentially see and record light the same way. In fact, color images are initially recorded as black-and-white images.

When a photon strikes a silver halide crystal it causes the aforementioned particle reaction. As more photons strike the same crystal, more electrons and silver ions collect,

causing a buildup of silver ions that will translate into a dense speck when developed. The number of developed crystals and the denseness of the crystals in a given area determine the density or intensity of the final image.

In a black-and-white film, the developed black silver is the end product and creates its range of tones according to the density of the black silver. Originally, black-and-white films had only one emulsion layer, but some of the modern black-and-white films in the medium-and high-speed range have a double emulsion layer: one layer has large, sensitive grains for recording low light levels and shadow areas, while the second layer has finer grains that record higher light levels and produce a much finer grain structure than is possible with a single-emulsion film.

Color film has three emulsion layers, or layer groups, each sensitive to a different primary color. The top layer of all color films is sensitive to blue light. Behind this layer is a yellow filter layer to stop blue and UV light from reaching the other layers. The third layer is sensitive to green light, and the bottom layer is sensitive to red light.

Many of today's color films have two and three layers sensitive to the same light waves. The top layer, the one nearest the incoming light, has larger grains that are sensitive to low levels of light. Higher light levels expose all of the high-speed top layer and the less sensitive finer grains in the lower layer. Thus the bright areas of a picture will be finer grained than the shadow areas.

Many things happen during the processing of a color film. Different controls and different layer structures are used in different emulsions and these are discussed in the detailed film descriptions that follow.

All color films develop their silver halide crystals. Color negative films develop their dye clouds in the same stage as the silver halide crystals develop. The color dyes that make up the final image form around the developing halides, creating dye clouds. Color transparencies first develop a silver negative image. The undeveloped silver in the film, which equals a positive image, is then developed in a color developer and dyes are simultaneously formed creating a positive color image. Once the color dye formation is complete, the silver is bleached out of the emulsion and removed by fixer solution. What is left is a color negative which has to be printed to produce a final image, or a color transparency which can be viewed as a final image, used to make prints or used directly for the printing process.

Each of the three primary color layers develop their direct opposite subtractive color in their emulsion layers: the blue sensitive layers have yellow dye couplers, green has magenta dye couplers, and red has cyan dye couplers. Dye couplers are complex chemical packages that control the development of dye clouds. When you photograph a red image on a color transparency film, it records a red negative image. When the image is reversed, no cyan dye forms where the red negative image has been formed, but magenta and yellow dyes do form. When you view the transparency, light passing through the magenta and yellow layers combine to reform the red image.

Instant prints use dye migration and/or dye transfer processes to form their image. Again, photographing the red image on a Polaroid 600, instant-print film, the red sensitive layer is exposed as a negative image. As the cyan dye tries to migrate to the surface, the red negative image stops it; only the magenta and yellow dyes migrate to the surface recreating the red image.

Know Your Film Through Thorough Testing

All too often you will hear a photographer say, "I tried a roll of such-and-such film and did not like it." Shooting a single roll might tell you a bit about a particular film, or it might give you the wrong information.

But even if your results are good with one roll of film, that one roll of film cannot give you anywhere near enough information for you to know that film. A mistake many make is to set up a test series under controlled conditions and carefully process the film. The results are fine and they go about exposing the next few rolls in an entirely different manner and process the film in a casual way. The results are fair to poor and they blame it on the film.

Testing must be thorough, which requires the use of a half dozen or so rolls of film. Exposure sequences should be made under controlled conditions to find out the exposure latitude of the film you use in your photography. These sequences will also tell how to underexpose or overexpose this film under special situations, or how to create dramatic effects. An exposure sequence is made by first finding the metered exposure for the film you are using, then making a series of exposures starting four stops under the indicated exposure and progressing in half stops until you arrive at a four-stop overexposure.

One exposure sequence is not enough, for an exposure sequence should be made under the various lighting conditions in which you shoot pictures: direct sunlight, open shade, overcast sky, available light, direct flash, bounce flash, studio lighting, etc. You will find a great difference in the film's range under the various lighting conditions, both in the amount of under- or overexposure it handles and in the contrast ratio a particular scene will have.

The next step, after seeing and digesting the exposure sequence results, is to shoot a few rolls of your favorite subjects under various lighting conditions, working as you normally do. Do not take special care or set up as if you were testing, just shoot as you normally would. Compare these results to the exposure sequences to discover if your method of photographing and your anticipation of how the pictures should look hold up to the controlled test series. If there are discrepancies, look for the *why* of it. It might be the film, or it might be any number of things from an inaccurate meter, to camera shake, to improper camera holding, to a dirty lens.

One photographer told me that he had tested a new version of a film and that it was no sharper than the old film. I looked at his results, and they proved what he said. But, when I looked at his camera, the lens had a veil over it created by humidity. The veil of humidity on the lens is enough to destroy the sharpness and resolution of the best films.

I have also seen a number of cases where lack of sharpness was blamed on the film and/or the camera when in actual fact the problem was due to camera shake. The use of a tripod, monopod, or other camera support can improve the sharpness and resolution of

your pictures by eliminating camera shake, especially when using telephoto or zoom lenses, or slow shutter speeds.

When testing film, always use equipment that you are familiar with and know is in working order. Never test a new film with a new camera, lens, flash, etc., because you would be working with two unknown factors instead of one.

I use the Macbeth Color Checker Color Rendition Chart to make tests of film. The Macbeth is carefully made with special dyes to give you a range of colors encountered in ordinary photographic situations plus a six-step gray scale.

All 35mm film tests were done with a Nikon F3 and a Nikon 105mm ƒ/1.8 lens. The roll films were tested with a Rolleiflex SLX and a Rollei 180mm ƒ/4 lens. Sheet films were tested in a Rajah 4 × 5 Cub with a Nikon 270mm ƒ/6.3 short-mount telephoto lens. All cameras were firmly mounted on a Gitzo Cremaillere tripod. Lighting was by Broncolor Impact 41 and Impact 21; the Impac 41 main light had an Impaflex soft box and the Impact 21 was used as a light bounce fill. Color temperature of the Broncolor units was 5400K checked with a Minolta Color Meter III where model Denise Rios was sitting: the slight warming from 5500K was due to the slight warming effect of the white diffuser material on the Impaflex.

As you can see, strict controls were used for the tests so that the variations you see in the test shots with each film are due to the film characteristics. To eliminate the variables of printing, all color negative tests were developed and printed by Fotomat. All other color prints were made on Agfacolor MC 310 paper processed in Kodak Ektaprint Chemicals using a Durst processor. Color transparency film tests were processed by Agfachrome Labs or by Kodak Labs. Black-and-white negatives were processed in their various recommended developers and printed on Ilfospeed paper. You can see that rigid controls must be used in all aspects of testing a film from the equipment to the processing. Minor processing errors are especially bad because you may think it is the fault of the film and it would be easy for a lab to convince you of this. Insist on your rights to get properly exposed and color balanced prints.

When comparing your test results, look for variances between the control shots and the general shots. If, for instance, your exposures of the general shots are different from what you targeted as the best exposure from your control shots, adjust your meter setting to produce correct exposures. If your exposures are erratic, you may need new batteries and the battery contacts cleaned; if that does not work, your meter will need to be repaired.

The best way to make comparisons between an old film and a new film is through a set of prints magnified 17 × or greater. The actual prints only have to be 8 × 10, but the magnification should be high so you can see and evaluate the edge sharpness, definition, grain structure, color purity, etc. Only under high magnification can you really begin to see the workings of an emulsion. The better you understand the films you use, the better you will be able to use them to produce the end result of photography: fine images.

The Physical Characteristics of Film

The physical properties that make up the character of a film are grain, sharpness, resolving power or definition, contrast, and, in color film, color balance, color purity, and color saturation.

Grain is the single most important feature of any film, as it is the basis for the formation of the photographic image. It is also the single most, or least, noticeable feature of a film. Since the beginning of photography, there has been a constant search by many for the ultimate grainless film. I have spent all too many hours listening to photographers complain about grain and grainy films. Many of these photographers make large prints, which they then inspect at close quarters and complain about the grain. The first rule of thumb is to view and judge a print at a proper viewing distance where the eye can take in the whole picture at a glance; the best viewing distance for an 8 × 10 print is at arm's length, or about three feet.

But the real problem with these people is that they cannot see the forest for the trees. Grain is not something bad, evil, or a thing to abhor. Grain adds texture to a picture; lack of graininess can therefore mean lack of texture. Large blank areas can often be enhanced by the texture of grain. Soft, dreamy scenes can be turned into scenes with feeling by the use of textured grain. Mist and fog scenes often die without grain to give them texture. Grain can also enhance certain portraits, nudes, and fashion pictures. Of course graininess can also destroy many pictures where it becomes unsightly or destroys detail.

Learn to use grain as one of your photographic tools. You should have both fine-grain and grainy films in your repertoire and know when and how to use them. To get even more texture, some photographers take grainy films and push process them to increase their graininess.

Closely related to the graininess of a film is its ability to produce sharp images and to resolve fine detail. The general rule of thumb is that definition of fine detail deteriorates as the grain size of the film increases, but sharpness often increases with grain size. However, fine grain does not guarantee high resolving power, nor does larger grain guarantee sharpness because there are other factors that effect the definition and sharpness a film produces, such as emulsion thickness, number of emulsion layers, film contrast, and developing process. External factors, such as lighting contrast, lens contrast, lens resolving power, and lens aperture used, also effect the final sharpness and definition a film produces.

A thick emulsion causes light to scatter through the emulsion, exposing grains that would otherwise remain unexposed; this causes a lowering of both resolving power and sharpness. The multi-structured emulsions of today's color films are also potential areas for a further lowering of sharpness and definition because of light scattering between layers. But new techniques in color chemistry that keep light scatter to a minimum and limit developer action from spreading to adjacent unexposed grains has helped to im-

prove the resolving power and sharpness of the new films. New high-density color couplers have allowed film manufacturers to make thinner emulsions, which improve a film's sharpness and definition.

Grain shape also determines a film's resolving power and sharpness. T-grains, which are flat tablet shaped grains, can dramatically increase film speed with a minimal increase in graininess. However, if you use too much T-grain in an emulsion, it becomes very grainy. T-grains must be mixed with compact forms of grain, which produce good sharpness and resolving power because of their structure.

Sharpness and resolving power have been improved in all types of films. Color negative films are the least sharp of all because they use colored couplers in the emulsion, which develops the orange mask that all color negatives have. The extra dyes combine with the dyes of the image, which lowers the sharpness and resolution of color negative films. Color transparency films use only colorless couplers and develop dye clouds only of the image, which produces a higher degree of resolution and sharpness. Black-and-white films use only silver halides and produce good sharpness and resolution.

Contrast is an expression of the degree of separation between the tones of an image. When we speak of the contrast of a film, we are usually describing its overall contrast, or the difference between its brightest and darkest tones. A low-contrast film has a wide range between its brightest and darkest tones, a medium-contrast film has a moderate range, and a high-contrast film has a narrow range.

The contrast of a film is also affected by outside factors, such as lens contrast, lighting contrast, and the developer used. Contrast will also be increased if development is extended to push a film to a higher exposure index.

Black-and-white films measure their contrast from the pure white of the paper base they are printed on, through the intermediate gray tones to the deepest black where no detail appears. Black-and-white contrast depends only on variations in brightness. Contrast in color films depends on brightness, color intensity, and hue. Color intensity is determined by the purity and saturation of colors, which produce contrast or no contrast. For example, a hot, bright pink next to a deep, dull red produces contrast because their color intensities are different, even though their hues are similar; a hot, bright pink next to a bright red provide little contrast because of their similarities of intensity. Hue is simply the similarity or difference between colors: there is more contrast between red and yellow than there is between red and orange.

The color balance of a film is its relationship of warmth or coolness in relationship to an imaginary concept of neutrality. Warmth means that a film's coloration leans towards the red side of the color spectrum while coolness leans towards the blue side. Color balance is subjective, so whether you choose to use a warm, cool, or neutral film depends upon your taste.

Color purity and color saturation have become very high in most modern films, adding to the pleasing character of most color images. Color saturation means that a color has depth. Purity means that colors have very little contamination in them, so that the color you saw when you made the exposure is the color you should see in the photograph.

The Characteristics of Film Exposure

Film is sensitized to respond to light and color at a particular color temperature. As mentioned before, films cannot shift their vision under different light sources; they have to be targeted for a specific light source in order to reproduce scenes and colors as naturally as possible. A film balanced for daylight exposures is balanced for average daylight at 5500K. Tungsten and long exposure films are balanced for tungsten illumination at 3200K.

If a color daylight film, which is sensitized for daylight exposure, is exposed under tungsten illumination, the results will be off color; the same thing holds true for tungsten films exposed under daylight conditions. Another aspect of sensitivity is the fact that most films sensitized for daylight are also designed for short exposure times, while tungsten films are generally designed for slow and long exposure times. Modern black-and-white films are sensitized so that they produce fairly similar results under all types of lighting at the same exposure indexes.

Sensitivity is also used to refer to a film's response to light. That is, whether it has a slow, medium, or fast speed. A slow-speed film has less light sensitivity than a high-speed film. Many of today's films have multiple emulsion layers with different light sensitivities to give these films a broad response under a variety of lighting conditions and lighting contrasts.

Each film also has a spectral response, which is sometimes referred to as sensitivity. The spectral response refers to a film's response to the spectrum of visible light and the actinic invisible rays around it. Most general purpose films have a spectral response that is already high at 400 NMs, which means that they are also sensitive to ultraviolet radiation. Their response stays high down through 600 NMs and then drops off sharply at about 650 NMs to no spectral response.

Special purpose films often have special spectral responses. For example, most high-contrast films have a spectral response only in the blue region of 400 to 500 NMs. Other films have extended red sensitivity for special applications. For instance, Kodak High Speed Recording film is used under very low light levels of tungsten light, so its red sensitivity is extended to record details under these rich red light sources.

Infrared films have spectral responses that extend into the invisible region of the infrared. Because these films are also sensitive to other light, a filter must be used to block out all but red and infrared light, or even all visible light. For instance, you can use a deep red filter to photograph with Kodak High Speed Infrared film and be able to see the images you are photographing. However you can always record purely in the infrared region by using a visually opaque infrared filter. Infrared color film is actually a false color film designed to form its color images in the green, red, and infrared regions. Since the emulsion is sensitive to blue light, filters must be used to keep blue light from spoiling the film's marvelous colorations.

The spectral response of standard films are changed to give them their special characteristics. For example, a tungsten film will have two to three times stronger spectral response in the 400 to 500 NM region than does a daylight film: this makes up for the blue deficiency of the tungsten light source. Some of the newer high-speed color films have corrected blue response for low light levels, and normal blue responses at higher levels, which allows these daylight films to produce acceptable results under illumination that it was not intended for.

Almost every film has a specific film speed at which it performs best. There are a few films that have more than one exposure index (EI). Agfapan Vario-XL and Ilford XP-1 are black-and-white films that use color negative technology to produce variable speed films. Kodak Technical Pan Film has a variety of EIs depending upon the contrast you want and the developer it is processed in.

Any film can be exposed without a meter under daylight conditions by using the rule of sunny f/16. With your subject in direct sunlight, you set your lens aperture to f/16 and convert the first number of the ISO rating of that film to the nearest shutter speed: an ISO 400/27° film would be f/16 at ⅟₅₀₀ sec. and an ISO 64/19° would be f/16 at ⅟₆₀ sec. From this point you can figure out almost any daylight exposure scene, as shown in the following chart.

Exposure Adjustments from "Sunny f/16"

bright or hazy sun on bright sand, snow, or still waters	close down one stop or use next higher shutter speed
hazy sun producing no distinct shadows	open up one stop or use next slowest shutter speed
backlighted subjects closeup, light overcast skies	open up two stops or use shutter speed two steps slower
heavy overcast sky	open up three stops or use shutter speed three steps slower
dark clouds, rain	open up four-five stops or use shutter speed four-five steps slower

At their given ISO ratings, most films have a fairly good exposure latitude. This is the brightness range that a film can reproduce in a given scene. A typical general purpose color negative or black-and-white negative film has an exposure range of about seven f-stops while general purpose color transparency films have an exposure range of about five f-stops.

Do not mistake the exposure latitude for a given scene as a total film exposure latitude where you underexpose or overexpose the whole scene by a bunch of f-stops. The best pictures come from the correct exposure for any given film of any given scene. In these terms, most films only have an exposure latitude of one-third to one f-stop. For special effects, you may underexpose or overexpose a film by two, three, or more stops, but you will not get a normal brightness range of that particular scene.

The sensitivity and spectral response of films are targeted for certain exposure times. The reciprocity law of photochemistry states that a certain intensity of light on a certain photo sensitive emulsion exposed for a specified length of time will produce a correct exposure. So long as light intensity \times the exposure time remains constant, the response of the emulsion will remain constant. Thus an exposure made on a given film that produces a correct exposure at f/16 at $\frac{1}{30}$ sec. should also produce an identical exposure at f/1.4 at 4 secs.

The reciprocity law is an ideal and the actual situation is that all films suffer from reciprocity failure somewhere along the range of exposure times. Reciprocity failure happens under very high speeds, such as with automatic electronic flashes that can produce exposure times of $\frac{1}{10,000}$ sec. and shorter.

Reciprocity failure occurs in most tungsten films in the relatively slow shutter speed area around $\frac{1}{30}$ sec. However 3M 640 T is a high-speed tungsten film and has reciprocity characteristics similar to a daylight film. Many of the new daylight films have reciprocity characteristics up to a high end of $\frac{1}{1000}$ to $\frac{1}{10,000}$ sec. and a low end of $\frac{1}{8}$ to 1 sec. Above and below these exposure times, the films will need some adjustment in aperture or exposure time; color films may also need some filter correction. The instruction sheets that come with many films give you reciprocity information on that film.

There are far too many exposure control methods to discuss here. Suffice it to say that you should thoroughly test the films you use to learn what you can and cannot do with them.

COLOR TRANSPARENCY FILMS

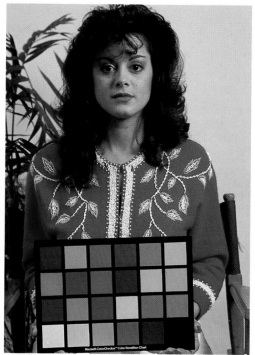

Agfachrome CT 18

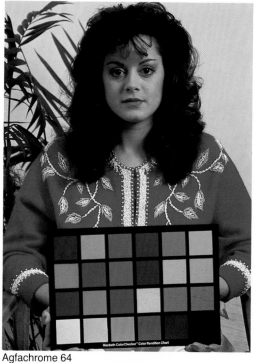

Agfachrome 64

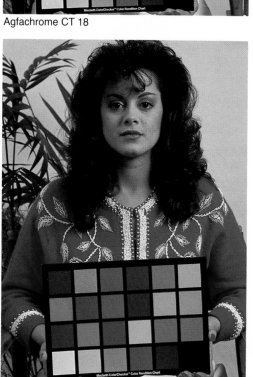

Agfachrome 100

Agfachrome 200

Fujichrome 50 Professional

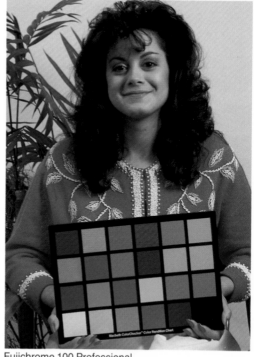

Fujichrome 100 Professional

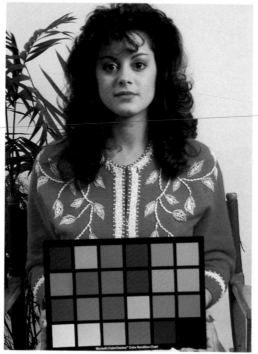

Fujichrome 400

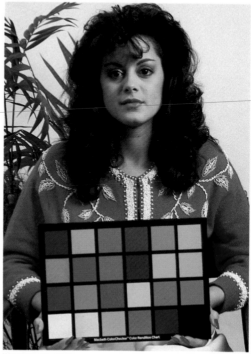

Ilfochrome 100

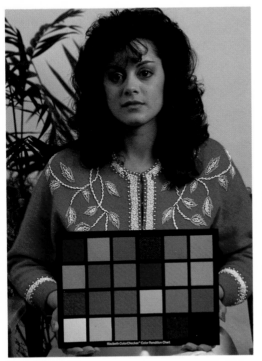

Kodachrome 25

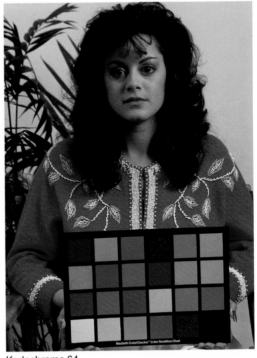

Kodachrome 64

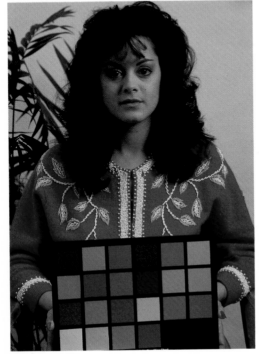

Ektachrome 64

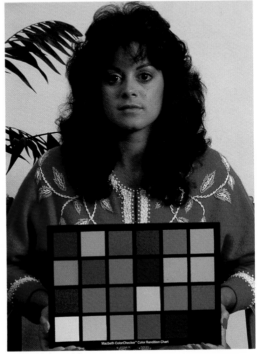

Ektachrome 100

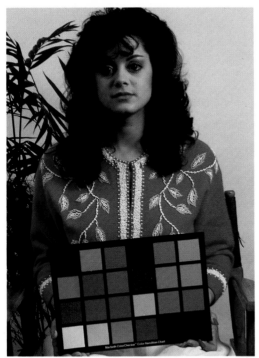

Ektachrome 400

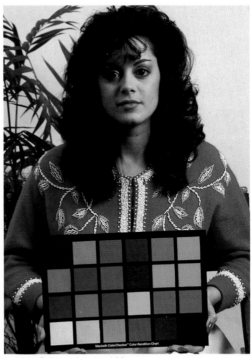

Konica/Sakurachrome 100

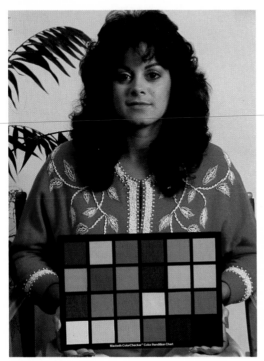

3M Color Slide 100

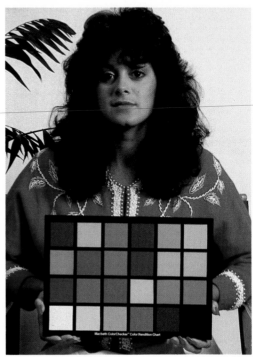

3M Color Slide 400

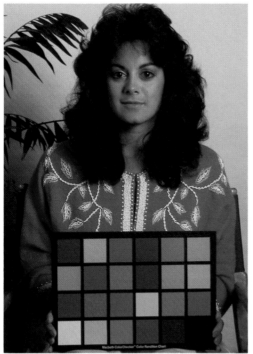

Ektachrome 160T

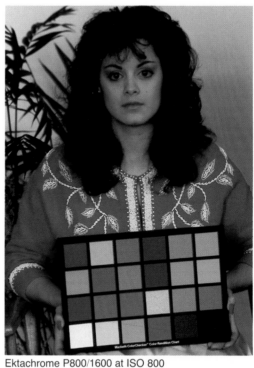

Ektachrome P800/1600 at ISO 800

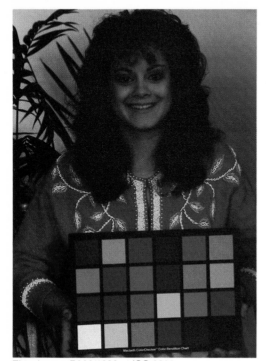

Ektachrome P800/1600 at ISO 3200

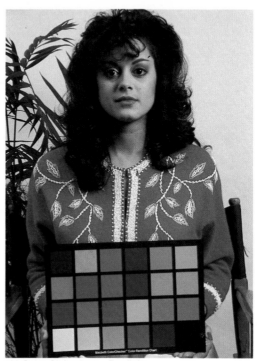

3M Color Slide 1000—Daylight

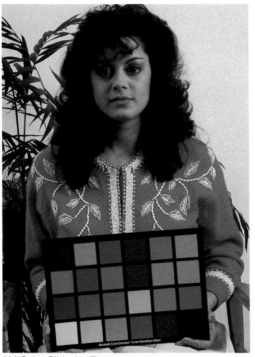

3M Color Slide 640T

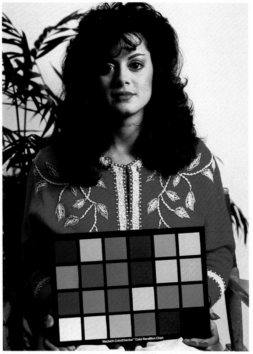

Ektachrome Infrared Film with Tiffen Y52 Filter

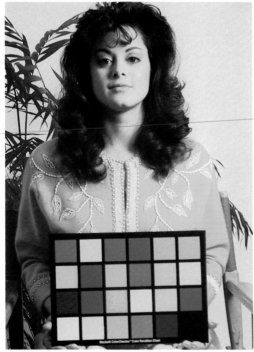

Ektachrome Photomicrography Film
with Tiffen CC20 G Filter

Kodachrome 25/Dan O'Neill

Ektachrome 100/Dan O'Neill

3M Color Slide 1000—Daylight/George Long, courtesy 3M

Ektachrome Photomicrography Film/Dan O'Neill

Agfachrome 50T/Dan O'Neill

Ektachrome Infrared Film/Dan O'Neill

Introduction to COLOR TRANSPARENCY FILMS

Color transparency film is film that produces a final, positive image that can be directly viewed, viewed via projection, or printed on a color reversal enlarging paper. Color transparency film is often referred to as slide film mostly because 35mm transparencies are mounted in glass, cardboard, or plastic mounts for easy handling and safe use in a slide projector. It is also known as color reversal film because it starts out with a negative image that is reversed to a positive image during processing.

The majority of professional photographers use transparency film when they shoot color. There are many reasons why transparencies are used by pros over color negatives. Most pros shoot images for reproduction in books, magazines, newspapers, brochures, television, etc., and transparencies are final images that are used directly for printing; color negatives need to be printed before they can be used. Transparencies produce sharper images than color negative film because they use only colorless couplers and clear base film, while color negatives have color couplers to produce the orange mask for easy printing because it leaves no colorless area in the negative, making filtration easy. Transparencies are used directly in the printing process while color negatives need a secondary step before their images can be printed, which produces a lower brightness range and generally less quality.

With color transparencies you see exactly what you have while color negative films depend upon the interpretations of color printers. There is a greater variety of color transparency films than any other type of film precisely because they are end products and each film displays its own characteristics.

Color transparency film can be push- or pull-processed to higher or lower exposure indexes because it is first developed to a black-and-white negative image before it is processed to a positive image and color couples. Thus they not only have variety, but also versatility.

Finally, color transparency films have a higher degree of permanence than color negative films: colorless couplers have more permanence than the color couplers used in color negative film.

Agfachrome CT 18
and 50S Professional

MANUFACTURER: *Agfa-Gevaert AG*
TYPE: *very fine-grain, slow-speed color reversal films (transparency)*
SIZES: *CT18: 35mm cartridges and 120 rolls; 50S: 35mm cartridges, 120 rolls and sheets*
FILM SPEED: *ISO 50/18°*
COLOR BALANCE: *daylight 5500K*
NOTES: *processing included in price of Agfachrome CT18. The 50S professional film can be processed by Agfa labs or by the user in Afgachrome Process 41 (available in Europe only)*
APPLICATIONS: *reproduction of fine detail; images for very high magnification or projection; especially good on gray days*

Agfachrome CT18 and Agfachrome 50S Professional are very fine-grain reversal films with good exposure latitude. The grain pattern is regular and the grain itself is very sharp. Contrast is very strong, producing snappy, sharp prints with good separation of tones.

Agfachrome CT18 and Agfachrome 50S Professional have excellent color saturation. They are warm films, even warmer than the Agfachrome 64 films. Agfachrome CT18 and 50S are particularly noted for their brilliant reds, oranges, and yellows, and strong reproduction of brighter greens. Whites are warm, particularly with slight underexposure, and blacks are neutral. Skin tones are particularly flattering, for CT18 and 50S render flesh tones as a healthy, tanned complexion.

The difference between the two films is that the professional version is manufactured under stricter controls than is the amateur version. The professional version will exhibit very little, if any, exposure or color variation from batch to batch as its manufacturing tolerance is ± ½ of a color unit. The amateur version has tolerances of ± ½-stop and ± 5 color units.

Agfa recommends cold storage for Agfachrome 50S Professional as the properties of film are best preserved in a refrigerator or freezer. 50S Professional, like all professional films, is manufactured on target while amateur films have a built-in aging process because they are usually stored without refrigeration. However, 50S may be kept unrefrigerated for a reasonable period of time because the emulsion contains stabilizers, which help preserve the film's characteristics. This, of course, excludes hot and/or humid weather, which rapidly age a film.

PROCESSING CT18 processing is included in the purchase price of the film, as Agfa feels best able to maintain quality control of its films. CT18 and 50S are processed in Agfachrome Process 41, a difficult process re-

quiring re-exposure of the film between the stop bath and the color developer. Processing is not included with 50S Professional, but this film may be processed at any Agfa lab or by the user in Agfachrome Process 41 kits.

If CT18 or 50S is exposed a stop above or below its rated ISO, Agfa will give that roll special processing if a note is attached to the film can stating the actual exposure index used and that the roll needs special processing.

APPLICATIONS The very fine grain, high resolution, and strong contrast of Agfachrome CT18 and 50S Professional make these excellent films for photographing finely detailed subjects. When the lighting or the subject are of low contrast, the good contrast of CT18 and 50S add the separation needed to distinguish similar shades. Good contrast is also important when detailed images need to be projected or printed at high magnifications, because contrast provides the snap needed for good-looking large images.

As a slow-speed general-purpose film, Agfachrome CT18 is thought of as a good weather film, and is particularly good for landscapes and portraits. Its warmth and good contrast make this film suitable for giving low light subjects extra punch. For example, portraits in open shade tend to have a bluish tinge, which the warmth of CT18 will counteract. Gray days tend to be heavy in blue and ultraviolet light, often producing drab, low-contrast pictures. The warmth and high color saturation of Agfachrome CT18 strengthens what color there is and its strong contrast improves upon the low contrast situation.

Under low light situations, CT18 and 50S will probably require slow shutter speeds, which is not a problem because these films have good reciprocity characteristics. Exposure times from ⅛ to 4 sec. need no time correction but possibly a CC05 Red color compensation filter. At such slow shutter speeds, be sure to use a tripod or other camera support.

Agfachrome 50S Professional has the same applications as Agfachrome CT18.

Agfachrome CT 21

MANUFACTURER: *Agfa-Gevaert AG*
TYPE: *fine-grain, medium-speed color reversal film (transparency)*
SIZES: *35mm*
FILM SPEED: *ISO 100/21°*
COLOR BALANCE: *daylight 5500K*
NOTES: *processing included in the price of the film; though difficult, the user may process in Agfa Process 41*
APPLICATIONS: *general-purpose medium-speed slide film; counteracts cold light of flash units; portraiture; nature and travel; snow and water scenes; in shade or overcast conditions*

Agfachrome CT21 is in many ways similar to Agfachrome CT18. Both are general purpose films, but CT18 is a slow speed, very fine-grain film, whereas CT21 is a medium-speed film one stop faster at ISO 100/21° with fine-grain structure. Both are very warm films with excellent color saturation. Both produce flattering, healthy warm skin tones, excellent greens, and brilliant reds, oranges, and yellows. Agfachrome CT21 is intended to be a companion film to CT18, to be used when photographing in low-light conditions.

Agfachrome CT21 will give you a 50-percent greater shooting distance than CT18, or an extra stop for greater depth of field at the same shooting distance. CT21 also is a very good film to use with electronic flash. Most electronic flash units used on-camera are high in blue light, which may result in cold whites and blue-tinged flash tones. The warmth of CT21 helps counteract cold tone due to flash, and tends to produce clean whites and natural-looking skin tones.

PROCESSING Agfachrome CT21 is sold only with processing included by Agfa labs. It may be purchased with or without mounting in plastic slide mounts, as can be other Agfachrome films, for some photographers need uncut film. However, if you have purchased a roll without mounting and later decide to have it mounted, a mounting voucher may be purchased at any Agfa dealer. The reasons for included processing are that Agfa feels best able to maintain high standards of processing, and the process is difficult because it demands exacting re-exposure to light during processing to reverse the image from negative to positive.

APPLICATIONS Agfachrome CT21 is an excellent film for portraits, scenics, candids, and travel photography. It is especially useful for photographs taken around snow and water because its warmth counteracts the coolness of such scenes. Its medium speed and extra warmth also makes CT21 a good film to use in open shade or under cloudy skies.

Agfachrome 64
and 64 Professional

MANUFACTURER: *Agfa-Gevaert AG*
TYPE: *very fine-grain, medium-speed color reversal films (transparency)*
SIZES: *35mm*
FILM SPEED: *ISO 64/19°*
COLOR BALANCE: *daylight 5500K*
NOTES: *processing included in purchase price of Agfachrome 64. The Professional film can be processed by Agfa labs; Process 41 is available in Europe for user processing*
APPLICATIONS: *closeups; nature; finely detailed subjects; general purpose in good weather/lighting; good in shady situations and with flash*

Agfachrome 64 and Agfachrome 64 Professional are very fine-grain reversal films with good exposure latitude. The grain pattern is regular, and the grain itself is very sharp. Contrast is very strong, producing snappy, sharp prints with good image separation. The Agfachrome 64s are warm films and are noted for their color saturation. Warm tones such as red, orange, and yellow reproduce brilliantly on the Agfachrome 64s. Greens and blues are clean, whites pure, and blacks neutral. Flesh tones are warm and flattering.

Very fine grain, good resolution, and strong contrast make Agfachrome 64 and 64 Professional good films for closeups of flowers and other finely detailed subjects. They are good general purpose films to be used under good lighting conditions, especially where detail is important; more important than just overall shape and color. Agfachrome 64 and 64 Professional are also good choices whenever high magnification prints are going to be made, or finely detailed large projections are needed, as sharpness is enhanced by good contrast to produce large magnifications with good detail.

The essential difference between the amateur and professional versions is one of manufacturing tolerances. Agfachrome 64 has a manufacturing tolerance of ±3 percent, while the tolerance for 64 Professional is a tight ±1 percent. Tighter tolerance means that the professional emulsion will have a consistent and accurate exposure index from batch to batch. The tighter tolerance also means that the professional film will exhibit little or no color shift from batch to batch. Agfachrome 64 Professional provides the professional, commercial, and industrial user with predictable results from batch to batch.

Agfa recommends cool storage for 64 Professional film, but it is not an absolute necessity, for the emulsion contains stabilizers, which help preserve the film's characteristics under conditions of normal tem-

GENERAL PURPOSE

perature and humidity. However, any film that is going to be kept for a long period of time is best preserved in a refrigerator or freezer to minimize aging.

PROCESSING The purchase price of Agfachrome 64 includes processing by Agfa, mounting in durable plastic mounts, and first class return mail. The reason Agfa includes processing is twofold: quality control and difficulty of processing procedures. Agfa feels best able to maintain high quality processing control. The type of reversal process used with Agfachrome 64 is difficult, as part of the process requires that the film be re-exposed to light between the stop bath and the color developer. In the United States, there are no user processes available, but in Europe, Process 41 is available for Agfachrome 64 Professional and other Agfachrome films.

If you make a mistake and expose Agfachrome 64 a stop or so above or below its standard rating of $^{64}/_{19}°$, Agfa will give that roll special processing attention if you send a note attached to the film can stating the actual ISO used and that the roll needs special processing.

APPLICATIONS Agfachrome 64 is a general purpose slide film usually used under good lighting conditions. It is widely used for vacation and travel photography, as well as personal and family imagery. Agfachrome 64 is a slow-speed film associated with good weather and good light levels. However, its warmth also makes it a good choice in bad weather as its warmth helps to counteract the bluish cast produced by overcast skies. It is also a good film to use in open shade and with electronic flash, as both have a high blue and ultraviolet content.

Photography outdoors and in forests will benefit from the warmth, very fine grain, and strong contrast of Agfachrome 64. The warmth will give you good strong browns and greens with no bluish cast. The very fine grain of these films will give excellent detail and their strong contrast gives good separation in low-contrast situations. At low light levels a camera support or tripod is necessary for long exposures. For exposures from 1/8 to 4 sec., try a CC05 Blue, or no filter at all under bad weather situations.

The foregoing comments apply equally to Agfachrome 64 Professional.

Agfachrome 100
and 100 Professional

MANUFACTURER: *Agfa-Gevaert AG*
TYPE: *fine-grain color reversal films (transparency)*
SIZES: *35mm*
FILM SPEED: *ISO 100/21°*
COLOR BALANCE: *daylight 5500K*
PROCESSING: *included in price of Agfachrome 100. The Professional film can be processed by Agfa labs or in Process 41*
APPLICATIONS: *General purpose transparency; travel, vacation, family photography; helps counteract cold tone of electronic flash and open shade*

Agfachrome 100 and 100 Professional are medium-speed reversal films with good exposure latitude. The grain structure is fine, the grain pattern is regular, and the grain itself is very sharp. Agfachrome 100 and 100 Professional are "warm" films; i.e., reds, yellows, and oranges are rendered particularly strong. Greens and blues are clean, whites are pure, and blacks are neutral. Flesh tones are slightly warm and flattering.

Because of their fine razor-sharp grain, Agfachrome 100 and 100 Professional are excellent film choices when testing cameras and/or lenses; if there is anything wrong with the optical path, the images will appear unsharp and/or overly grainy. With good cameras and lenses, both Agfachrome 100s produce very sharp, crisp, well-saturated images with little or no apparent grain.

The essential difference between the amateur and professional versions is one of manufacturing tolerances. Agfachrome 100 has a manufacturing tolerance of ±3-percent while the tolerance for 100 Professional is a tight ±1-percent. Tighter tolerance means

that the Professional emulsion will have a consistent and accurate exposure index from batch to batch. It also means that the professional film will exhibit little or no color shift from batch to batch. Thus the professional, industrial, and commercial user who needs predictable exposure and color renditions from batch to batch can expect it with Agfachrome 100 Professional.

Agfa recommends cool storage for 100 Professional film, but this is not absolutely necessary as the emulsion contains stabilizers, which help preserve the film's characteristics. However, any film that is going to be kept for a long period of time is best preserved in a refrigerator or freezer to keep film aging to a minimum.

PROCESSING The purchase price of Agfachrome 100 includes processing by Agfa, mounting in durable plastic mounts, and return by first-class mail. The reasons for having processing done by Agfa are twofold: quality control and difficulty of processing procedures. Agfa feels best able to maintain

GENERAL PURPOSE

high quality processing control of its films. The other reason is the difficulty of the type of reversal process used with Agfachrome 100—part of the process requires that the film be reexposed to light between the stop bath and the color developer. In the United States there are no user processes available, but in Europe Process 41 is available for Agfachrome 100 Professional and other Agfachrome films.

If a roll of Agfachrome 100 at ISO 50/18° or ISO 200/24°, Agfa will give that roll special processing if you send a note attached to the film can stating the ISO roll was actually exposed at and that the roll needs special processing.

APPLICATIONS Agfachrome 100 is a general-purpose transparency film. It is widely used for travel and vacation photography, and family photography. It has good exposure latitude, which makes it a good film for use in the high contrast condition of direct sunlight, as it produces reasonable shadow detail. Agfachrome 100 also works well under low contrast conditions such as open shade and cloudy days, and its medium speed will usually allow hand-holding the camera under low-light conditions. Agfachrome 100 is particularly well-suited for taking portraits and people pictures on cloudy days, in open shade, and by electronic flash. Under these conditions, skin and white objects take on a blue cast due to the high blue content of the light. The warmth of Agfachrome 100 helps to neutralize this blue cast and produces pleasing flesh tones and clean whites. Flowers, forests, and landscapes are other subjects appropriate for the sharpness and warmth of Agfachrome 100. The foregoing comments apply equally to Agfachrome 100 Professional.

Agfachrome 200
and 200 Professional

MANUFACTURER: *Agfa Gevaert AG*
TYPE: *fine-grain, medium-speed color reversal films (transparency)*
SIZES: *35mm*
FILM SPEED: *ISO 200/24°*
COLOR BALANCE: *daylight 5500K*
PROCESSING: *processing included in price of Agfachrome 200. Agfachrome 200 Professional can be processed by any lab or by user in E-6 or AP 44 chemistry*
APPLICATIONS: *general purpose; lowlight; macrophotography; sports and action; with flash; nature; portraits*

Agfachrome 200 and Agfachrome 200 Professional are fine-grain, medium speed color reversal films intended for general use wherever high shutter speeds and/or great depth of field are needed. At ISO 200/24°, they are Agfa's fastest color slide films. These are general purpose films as are the slower Agfachromes, but the 200s have extended speed range for shooting under low light, permit the use of high shutter speeds for sports and other action photography, and give greater depth of field in macro and general photography. In flash photography the 200s give twice the shooting range of an ISO 50/18° and 25 percent more range than an ISO 100/21° film; with flash at identical distances, the 200s provide greater depth of field than slower films.

Agfachrome 200 and 200 Professional have fine grain, good resolving power, good sharpness, and moderate contrast. The grain of the 200s is actually a bit finer than it is in Agfachrome 100, but the image sharpness is less in the 200s. Overall, the 200s are a good replacement for Agfachrome 100 when that extra bit of film speed is needed to get the picture.

The difference between the amateur and professional emulsions lies in narrowness of manufacturing tolerances. Agfachrome 200 has a manufacturing tolerance of $\pm \frac{1}{2}$ stop, or a variance in exposure index (EI) of 150/22° to 300/25°; it can also have a color shift variance of ± 5 color units. Agfachrome 200 Professional has a a much tighter tolerance, with an EI variance of $\pm \frac{1}{10}$ stop and a $\pm \frac{1}{2}$ color unit variance in color shift, which, for all practical purposes, can be ignored.

Agfa Gevaert recommends cool storage for its 200 Professional film, but this is not needed except for longterm storage, as the emulsion contains stabilizers which help to preserve the film's characteristics under normal conditions of temperature and humidity. However, any film that is going to be kept for a long period of time is best preserved in a

GENERAL PURPOSE

refrigerator or freezer to minimize film aging. When temperature and humidity are high, all film should be refrigerated.

PROCESSING Agfachrome 200 and 200 Professional are E-6 compatible films. Unlike other Agfachrome films, they may be processed by almost any lab around the world using standard E-6 chemistry to process color reversal films. Agfa also manufactures a kit for small batch processing of the 200 and other E-6 type films: Agfachrome Process AP44. Agfachrome 200 is sold with processing by an Agfa lab included because Agfa-Gevaert feels that processing by the manufacturer gets the most out of its films. Agfachrome 200 Professional is also supplied without processing, as many professional, commercial, and industrial users have labs or use a local photoprocessor. Separate processing envelopes are available for those users who want to send Agfachrome 200 Professional to the manufacturer for processing.

The Agfachrome 200s can be push- or pull-processed one or two stops in E-6 or AP44 processes. Agfa labs will push- or pull-process your film if you attach a note to the cannister telling them what EI was actually used.

APPLICATIONS The warmth and saturation of Agfachrome 200 and 200 Professional are similar to those of Agfachrome 100. Speed, warmth, and saturation make the 200s good films for candid pictures, available light portraiture, and photography under adverse lighting conditions such as overcast skies and deep shade. Greens are difficult to photograph under overcast skies because they are low-intensity colors with a tendency to register as bluish green, but the warmth and strong color intensity of the 200s keep greens bright even in adverse lighting conditions. The Agfachrome 200s also are flattering to skin tones in good as well as poor light.

Agfachrome CT 50,
CT 64, RS 50, and RS 64

MANUFACTURER: *Agfa-Gevaert AG*
TYPE: *ultrafine-grain color reversal films*
SIZES: *35mm cartridges and 120 rolls*
FILM SPEED: *CT/RS 50: ISO 50/18°; CT/RS 64: ISO 64/19°*
COLOR BALANCE: *daylight 5500K*
NOTES: *E-6 Process. CT designates processing included and RS designates processing not included*
APPLICATIONS: *general purpose; portraits; candids; scenic photography; flower photography*

Agfachrome CT and RS films come in both amateur and professional versions: the amateur version comes in the familiar orange box while the professional films come in a silver box marked professional.

Agfachrome CT/RS 50 and CT/RS 64 are a new generation of color reversal films that are the product of a group of technological advances developed by Agfa Gevaert. The heart of the new technologies is the development of a new silver halide technology that allows Agfa to grow structured twin crystals. Twin crystals are those that consist of two parts similar to each other like twins.

The twin silver halide crystals are flat and coated with many sensitizing dyes which produce great light sensitivity and high film speed while keeping graininess low. Actually, the graininess would increase if the flat crystals were the only crystals used. But mixed in with the flat crystals are compact, pebble-shaped crystals which keep the flat crystals from becoming the sole grain factor. The compact crystals are designed to produce a very high-edge sharpness because

their size and shape allow for a sharp cut between various elements in the image. For example, the compact grains produce sharply defined eyelashes whereas if there were only flat crystals in the emulsion, the eyelashes would have fuzzy edges.

The final contribution to a highly sensitive emulsion with low graininess and high resolution is a process that eliminates the very small and the very large halide crystals which increase graininess and lower resolution and sharpness.

There are other factors that control sharpness beyond the grain structure. Light scatter degrades the sharpness because it exposes silver halides which should not be exposed. A thick emulsion will have more light scatter than a thin one because there is more room for the light to scatter. Agfa has been able to make a very thin, blue-sensitive double top layer by using a new yellow coupler with a color intensifying action that increases color saturation even though fewer grains are used to record the image.

Agfa also uses special new screening dyes

in all the emulsion layers. The screening dyes selectively absorb light bouncing off the silver halide crystals, but not the light passing directly to the crystals. The selective absorption of light scatter keeps the unexposed crystals next to the exposing crystals from being exposed. The great reduction in light scatter is another improvement that helps to maintain the high degree of sharpness in the Agfachrome CT and RS films.

All the new Agfachrome CT and RS films, including CT/RS 100 and CT/RS 200, have pairs of blue, green, and red sensitive emulsion layers. The top part of each color layer pair has only large, highly sensitive twin crystals, while the bottom part has smaller, less sensitive ones. When you make an exposure, both the top and bottom layers will record the normal areas, while only the top layers record the low intensity shadow areas. If the different size grains were mixed together to form one layer, shadow detail and color would be lessened, some sharpness would be lost, and graininess would increase.

Agfachrome CT and RS 50 and 64 are ultra fine grain films with high resolution and excellent sharpness. They can record very fine, delicate detail. CT/RS 50 and CT/RS 64 are balanced for exposure by daylight and daylight quality light and have a warm color balance. Although the color balance is warm, color renditions are quite faithful to the original colors. The warmth is particularly noticeable in flesh tones and in whites. The warmth is also particularly noticeable in the strong reds, oranges, and yellows produced by CT/RS 50 and CT/RS L4. Both films also have a high degree of color saturation and color purity. All CT/RS films produce very rich, dense blacks that give images a look of richness and strength.

PROCESSING The CT indicates that the processing is included in the price of the film and the RS indicates that processing is not included. All amateur films are supplied with processing included while the professional films come in both CT and RS versions. Agfa's theory is that many professionals will process their own film or have it processed at a local lab, while other professionals and many serious amateurs will use the Professional CT version and have it processed by Agfa. Both the amateur and professional versions of these films employ E-6 processings.

APPLICATIONS Agfachrome CT/RS 50 and CT/RS 64 are excellent general purpose films on both the amateur and the professional levels. The amateur will use them for portraits, group shots, scenics, and flowers, whether around the home or on holiday. The professional will use them for portraiture where fine detail is needed, in commercial work where brilliant, vibrant color is needed, in industrial work where faithful color reproduction is needed, and in landscape, architectural and flower photography where delicate detail and subtle color shadings need to be captured.

Agfachrome CT/RS 50 and CT/RS 64 are intended for exposure times from $\frac{1}{1000}$ to 4 sec. They thus make good films to use under poor light conditions where the subject is stationary and a sturdy tripod can be used. The warm color balance is particularly useful under low light level situations such as open shade or overcast skies, where the warmth will counterbalance any bluish cast.

Agfachrome CT 100,
CT 200, RS 100, and RS 200

MANUFACTURER: *Agfa-Gevaert AG*
TYPE: *very fine grain, sharp color reversal films*
SIZES: *35mm cartridges, 120 rolls, and sheets*
FILM SPEED: *CT/RS 100: ISO 100/21°; CT/RS 200: ISO 200/24°*
COLOR BALANCE: *daylight 5500K*
NOTES: *E-6 process films. CT designates processing included and RS designates processing not included*
APPLICATIONS: *general purpose; hand-held photography in medium to low light situations*

Agfachrome CT/RS 100 and CT/RS 200 are the higher speed versions of Agfachrome CT/RS 50 and CT/RS 64. The difference between the amateur and professional versions of the CT and RS films is one of manufacturing tolerances. The professional versions have accurate film speeds and consistent color balance from batch to batch. The amateur versions can have variations in both film speed and color balance, but are still well within the requirements of the amateur photographer. The professional photographer requires more consistency and predictability from batch to batch so that he does not have to waste time calibrating and matching a new emulsion batch to a previous emulsion batch. The professional pays a bit more for this convenience, but to him it is worth it.

The Agfachrome CT/RS films use DIR-compounds (Developer Inhibitor Release) that limit the growth of silver halide crystals during development so that they do not grow any larger than they have to. Without DIR-compounds, the crystals would grow uncontrolled, become overly large, increasing graininess and lowering sharpness and reso-

lution. Agfa has developed these DIR compounds so that they can be used in all emulsion layers, including the high-speed top layers.

There are new yellow dyes in the blue sensitive layers which produce increased color saturation allowing for thin blue sensitive layers. Special red sensitizers are also used to produce faithful reproduction of colors, including many formerly hard to reproduce subtle tones found in fabrics and flowers such as delphiniums. While the excellent color fidelity is due in good part to the new dyes and new dye couplers used in the Agfachrome CT and RS films, there are other factors that allow the dyes to do their strong and subtle work.

First, there is a UV filter that blocks ultraviolet light from reaching the emulsion. All color films use a yellow filter below the blue sensitive layer to block blue and UV rays from reaching the green and red sensitive layers, but Agfa may be the first to use a UV filter to protect the blue sensitive layer from the color-destroying effects of UV radiation.

Second, there is a red filter used between

GENERAL PURPOSE

the green and red sensitive layers. This filter prevents green light from reaching the red layer. This filter not only produces purer reds, yellows, and oranges, it also keeps green colors from becoming contaminated by green light exposing some of the red sensitive crystals.

Finally, Agfa employs white couplers between each of the different color sensitive layers. The white couplers are active chemicals that prevent dye formation activity from migrating from one color sensitive layer to another. This ensures clean, pure, and faithful color reproduction.

All the Agfachrome CT/RS films have surprisingly good exposure latitude. The broad exposure latitude is the result of many factors, but the main ones are the fast and slow layer pairs in the red, green, and blue sensitive areas, and the new, stronger, and purer dyes that produce color even when the film is underexposed or overexposed.

PROCESSING The RS prefix designates that the film comes without processing included in the price. Since these are E-6 process films, they are easily processed in any E-6 type process, such as Agfa Process AP 44, Unicolor Rapid E-6, Paterson E-6 or Kodak Hobby Pac Color Reversal Process. They are also easily processed by any lab that offers E-6 processing, and many professionals and serious amateurs prefer to have their film processed by a local lab.

APPLICATIONS Agfachrome CT/RS 100 and CT/RS 200 are amateur and professional general purpose films for use when high shutter speeds or great depth of field are more important than absolute sharpness, resolution, and fine grain. To be sure, CT/RS 100 and CT/RS 200 are very sharp, fine grained films with very good resolution, and little difference will be noticed between these medium speed films and the slow speed CT/RS 50 and CT/RS 64.

CT/RS 100 and CT/RS 200 are particularly useful for hand held photography under cloudy skies, in the rain and in open shade. Under these circumstances, these films have features beyond their film speed that help to produce fine pictures. There are other films, including Agfa films, that have a warm color balance that help to neutralize the extra blue in such situations. But the CT/RS films are the only color reversal films that have a UV filter to block the high ultraviolet content of these lighting situations. The built in UV filter is especially handy when using special lenses such as fisheye or ultra wide-angle lenses, or compact 35mm cameras where UV filters are impractical or cannot be used. The built in UV filtration is particularly effective when photographing hazy scenes and when photographing in the mountains where there is often a great deal of ultraviolet radiation present.

CT/RS 1000 was introduced along with XR/XRS 1000 just as we were going to press. CT/RS 1000 gives Agfa a full range of color reversal films from slow speed to very high speed. CT/RS 1000 produces grain about that expected from last year's ISO 400/27° film. Sharpness and color saturation are high and resolution is good. As a very high speed color reversal film that uses standard E-6 processing, CT/RS 1000 will be a widely used general purpose color transparency film for very low light levels. It will also be used with slow lenses such as telephoto and 200m lenses, especially for sports, wildlife, and other situations where the action must be captured on film. CT/RS 1000 images look so good that this film should replace ISO 400/27° as an all around, very high speed film.

Agfachrome CT/RS 100, CT/RS 200 and CT/RS 1000 are films to be used exclusively, or in tandem with the slower speed CT/RS 50 and CT/RS 64 to cover a wide variety of photographic situations and needs.

Fujichrome 50 RF
and 50 RFP Professional D

MANUFACTURER: *Fuji Photo Film Company*
TYPE: *extremely fine-grain, slow-speed, color reversal film (transparency)*
SIZES: *RF–35mm; Professional D–35mm, 120 rolls, 4 × 5 and 8 × 10 sheets*
FILM SPEED: *ISO 50/18°*
COLOR BALANCE: *daylight 5500K*
PROCESSING: *sold without processing. E-6 processing available via Fuji processing mailers, through a dealer, local lab or by the user*
APPLICATIONS: *general purpose; detailed subjects; for strong or subtle colors; glass and metallic objects; images for projection or great enlargement; nature*

Fujichrome 50 RF and Fujichrome 50 RFP Professional D are a new breed of coupler-in-emulsion color reversal films. They are processed in E-6, a process once thought to be inferior in quality to such processes as Kodak K-14, in which Kodachrome films are developed. However, with the introduction of Fujichrome 50RF and 50RFP (along with 100 RD and 100 RDP) this prejudice ended. These films contain all new emulsion technology and techniques that have enabled new levels of film performance.

The grain structure itself is new in Fujichrome 50 RF and 50 RFP; though the grain particles are of varied sizes, they grow uniformly during development. Fuji calls this UDG (Uniformly Developing Grains). UDG not only produces extremely fine grain, but also grain more uniformly distributed than ever before possible. This translates into films with very high resolving power, capable of capturing fine details and subtle definitions in color. A second part of the new technology is a new Latex-type Coupler (L-Coupler) in the emulsion, which incorporate high density color coupler particles. Because these particles take up far less space than do couplers in other films, Fujichrome 50 RF and 50 RFP have thinner emulsions, which minimizes light scatter for outstanding image sharpness.

Fujichrome 50 RF and 50 RFP also employ the sharp spectral sensitivity and Auto Masking Emulsion (AME) techniques used also in Fujichrome 100 RD and 100 RDP. Fujichrome 50 RF and RFP have two blue-sensitive, two green-sensitive, and three red-sensitive layers to insure a high degree of color saturation in high as well as low light levels. Along with producing a good exposure latitude, the multiple colored layers also help achieve good color saturation in both highlight and shadow areas of each image. Of special interest is that deep colors, such as dark green foliage, photograph very well, even in underexposed shadow areas, on these films.

Fujichrome 50 RF and 50 RFP have excep-

tional reciprocity characteristics. For exposure durations from $\frac{1}{4000}$ to one sec. there is no need for exposure or color balance correction. Thus when using high-speed cameras, such as the Nikon FE-2 at $\frac{1}{2000}$ or $\frac{1}{4000}$ sec., or when using electronic flashes with short light durations, no compensation is necessary. Fujichrome 50 RF and 50 RFP may also be used in low available light levels at slow shutter speeds without color compensation, and slow shutter speeds may also be used for great depth of field without incurring reciprocity failure.

Fujichrome 50 RF and 50 RFP have a neutral color balance that remains neutral under cool lighting conditions, such as is produced in open shade or by many on-camera electronic flashes. Under warm lighting conditions, Fujichrome 50 RF and 50 RFP become warm neutral rather than taking on a warm cast; in other words, skin tones take on a healthy glow, but whites remain white.

Fujichrome 50 RF and 50 RFP are excellent films for images used at very high magnifications. The extremely fine grain and uniform grain make these emulsions very suitable for enlargement and projection. Grain distribution is important for fine grain, if the grain is irregular and clumps, images will look mottled at very high magnifications.

Fujichrome 50 RFP is designed to be used for reproduction rather than projection purposes. Specifically, the film base is designed to be compatible with the scanner resolution process widely used in photo engraving. RFP is also manufactured to very stringent exposure and color balance requirements, while the amateur emulsion is manufactured to looser tolerances. Fujichrome 50 RF is made so that it will age into correct color balance by the time it reaches the photographer, while 50 RFP is manufactured for optimum immediate performance, and should be refrigerated if stored for any length of time. The amateur film is only available in 35mm, but the professional film is available in 35mm, 120 rolls, and 4 × 5 and 8 × 10-inch sheets.

PROCESSING Fujichrome 50 RF and RFP are sold without processing, though Fuji mailers are available. These films may also be processed through a photo dealer, at a color lab, or by the user in any E-6 type process such as Fuji CR-56, Agfa Process AP44, or Unicolor Rapid E-6.

APPLICATIONS Fujichrome 50 RF is an amateur, slow-speed, general-purpose film and 50 RFP is a professional version of the same. Each is a perfect film to use when photographing the rich detail and subtle color variations of such subjects as flowers and porcelain. Because of the Uniformly Developing Grains in particular, 50 RF and 50 RFP are excellent films for portraying the subtle shadings of glass, and metallic objects such as finely wrought silver. These are excellent films to use whenever high color saturation is desired, yet they are also excellent for capturing delicate colors, precisely because of very high color saturation. Fujichrome 50 RFP, in particular, is ideal to use when creating images for posters or murals.

Fujichrome 100 RD
and 100 RDP Professional D

MANUFACTURER: *Fuji Photo Film Company*
TYPE: *ultrafine-grain medium-speed, color reversal film (transparency)*
SIZES: *RD–35mm; Professional D–35mm, 120 rolls; 4″ × 5″ and 8″ ×10″ sheets*
FILM SPEED: *ISO 110/21°*
COLOR BALANCE: *daylight 5500K*
PROCESSING: *sold without processing, E-6 processing available via Fuji processing mailers, through your dealer, by the user*
APPLICATIONS: *medium speed general purpose photography; in overcast conditions; for sky and water; nature, still life and closeups; RDP is used in astrophotography, commercial and industrial photography, science and medicine*

Fujichrome 100 RD and Fujichrome 100 RDP Professional D are a new breed of color reversal films of the coupler-in-the-emulsion type. They are processed in E-6 chemistry, a relatively simple color reversal process found in most color labs worldwide and one that is easy to handle in a home darkroom. In the past, E-6 films were considered inferior to coupler-in-the-developer films, such as the Kodachromes. However, Fuji has developed new emulsion technologies and manufacturing techniques that have brought the quality of the Fujichromes up to the standards of the best films available.

One of the new techniques employed in 100 RD and 100 RDP is sharper spectral sensitivity. Most films have rounded sensitivity curves for each of the three color-sensitive emulsion layers. 100 RD and 100 RDP have sharp peaks in paired blue-, green-, and red-sensitive layers are produced by new spectral sensitizers incorporated into the silver halide emulsions. The sharp spectral sensitivity produces outstanding color definition and clarity. A second breakthrough emulsion technique, which further enables sharp spectral sensitivity, is called Auto Masking Emulsion (AME), which effectively masks one emulsion layer from the others, resulting in very little color mixing during development and clear, bright colors. Combined, AME and sharp spectral sensitivity in the multiple color-sensitive layers produce sharp, pure, well-saturated images on 100 RD and 100 RDP.

Fujichrome 100 RD and 100 RDP also employ the UDG and L-Coupler technologies used in Fujichrome 50 RF and 50 RFP. 100 RD and 100 RDP are multi-layered emulsions with two blue-, two green-, and three red-sensitive layers, insuring good color saturation at high and low light levels in highlights as well as in shadow areas.

The real strengths of 100 RD and 100 RDP

for the photographer lies in its wide exposure latitude and good contrast, which allow shadow areas to remain open, showing detail and color. Even in greatly underexposed slides, definition and color saturation remain very good so the image can be duplicated, producing a fine, second generation transparency. This is an excellent performance feature, as most films lose all definition and color when extremely underexposed. You can thus photograph a scene under very high contrast conditions and restore shadow detail later by masking the original and making a duplicate transparency.

Another reason for excellent definition, even in greatly underexposed areas, is the exceptional sharpness of 100 RD and 100 RDP. This sharpness is the product of evenly distributed, ultrafine grain and L-Couplers, which allow a thinner emulsion and minimize light scatter. These emulsions' sharpness, which helps separate image details and colors, remains good in underexposed areas.

Fujichrome 100 RD is an amateur film, but its quality is equal to that of its professional mate, 100 RDP. The basic differences between them arise in manufacturing; RD is manufactured to looser tolerances than RDP and made to age so that it achieves its optimum performance capability when it reaches the hands of the photographer. RDP is manufactured to tight tolerances and is nearer optimum performance level when it is made. Thus RDP is refrigerated until its sale, and the purchaser should store it in a refrigerator. RD only comes in 35mm, while RDP comes in 35mm, 120 rolls, and 4 × 5 and 8 × 10-inch sheets. RD is designed for projection while RDP is specifically designed to be compatible with the scanner resolution process widely used in color separation for printing.

100 RD and 100 RDP have excellent reciprocity characteristics, needing neither color nor exposure correction from $\frac{1}{4000}$ to one sec. Thus the Fujichrome 100s are useful with the new high speed cameras such as the Nikon FA, which has a top shutter speed of $\frac{1}{4000}$ sec., as the photographer does not have to calculate reciprocity correction. They are also useful for achieving great depth of field and photography in low light levels because slow shutter speeds may be used without reciprocity failure.

PROCESSING Fujichrome 100 RD and 100 RDP are sold without processing. Processing mailers from Fuji are available separately. They may also be processed through your dealer, at any color lab, or by the user in any E-6 type process such as Fuji CR-56, Agfa Process AP44, or Unicolor Rapid E-6.

APPLICATIONS The Fujichrome 100s have a neutral color balance, even under cool lighting conditions such as overcast skies and open shade. As medium-speed, general-purpose films, they are particularly well-suited for portraiture in natural outdoor lighting or in the studio with electronic flash. They are excellent films for landscapes, still life, and closeups. They are also excellent films for cool situations such as snow and water scenes. RDP has applications in astronomy, commercial and industrial photography, science, and medicine.

Fujichrome 400 RH

MANUFACTURER: *Fuji Photo Film Company*
TYPE: *fine-grain, high-speed, color reversal film (transparency)*
SIZES: *35mm*
FILM SPEED: *ISO 400/27°*
COLOR BALANCE: *daylight 5500K*
PROCESSING: *sold without processing. E-6 processing available via Fuji processing mailers, through your local lab or by the user*
APPLICATIONS: *general purpose high speed slide film; sports, pet photography, action; low light photography; travel; portraiture; photojournalism; astrophotography*

Fujichrome 400 RH is one of a new breed of high-speed color reversal films with fine grain, good image sharpness, good exposure latitude and excellent color saturation. Fujichrome 400 RH actually was the first of Fuji's new generation of color films, appearing a few years before the rest of the Fujichrome and Fujicolor films now in use. The fine grain and good image sharpness are due to a uniform, concentrated grain structure. This emulsion's excellent color saturation and good exposure latitude are due to multiple color-sensitive emulsion layers: there are two blue-sensitive, three green-sensitive, and three red-sensitive layers. The multiple layers accomplish several purposes. What photons pass between the grains of one color layer of the emulsion are registered by grains in the second or third layers, thus producing high color saturation. These multiple layers also have differing effective speeds so that at least one color layer picks up shadow detail while all layers are exposed to brighter illumination for other parts of the scene.

The two blue-sensitive layers are particularly interesting because it is the second blue layer that is key to a spectral sensitivity distribution that gives Fujichrome 400 surprisingly good results when exposed under tungsten light. Most daylight color reversal films take on a sickly yellow-to-orange cast under tungsten illumination, whereas Fujichrome 400 does not acquire a color cast, but merely becomes very warm, remaining pleasant to the eye.

The color balance of Fujichrome 400 is cool neutral. Sometimes Fujichrome 400 will pick up a light blue cast in white areas under very cool lighting conditions, but this may be avoided by using a skylight filter. Even under very cool lighting conditions the blue tinge is not overwhelming, so a skylight filter is not an absolute necessity. However, a skylight filter is a rather good idea to have on

GENERAL PURPOSE

lenses at all times, for it protects a lens from dust, dirt, moisture, and scratches while suppressing blue in such light sources as open shade and many on-camera electronic flashes.

Under poor lighting conditions, such as overcast skies and in the rain, Fujichrome 400 remains neutral and has a high degree of color saturation. Bright colors remain bright under low light levels, but what is surprising is that deep colors also come out rather strong. With its good exposure latitude and good color saturation, Fujichrome 400, successfully maintains bright areas when the exposure is aimed at shaded areas, and vice versa.

Fujichrome 400 has very good reciprocity characteristics, needing no filter or exposure correction between $1/1000$ and one sec., which is exceptional for a high speed film. Fujichrome 400 may be used under extremely low daylight conditions or even in tungsten illumination without incurring reciprocity failure. With a light balancing filter such as a Tiffen 80A for correct color balance under tungsten illumination, this emulsion offers exposure speed to spare. The good reciprocity characteristics are also handy when photographing a low light situation where great

depth of field is needed, as this film's high ISO allows the photographer to use a slow shutter speed and a small aperture.

PROCESSING Fujichrome 400 RH is sold without processing. Fujichrome mailers are separately available. It may also be processed through your dealer or at your local lab. The user can process it in Fujichrome Process CR-56 or any E-6 chemistry, such as Unicolor Rapid E-6 or any Kodak E-6 processing kit.

APPLICATIONS Fujichrome 400 is a general-purpose, high-speed film for amateurs and professionals. It is used wherever great depth of field is needed under a variety of conditions. It is also used for stopping action in such fields as sports and animal photography. It is also particularly handy for night sports under daylight quality lighting. It is an excellent film for scenics, travel, and available light portraiture. Professionally, it is used in a wide range of fields, from astrophotography to photojournalism. Fujichrome 400 is an excellent film for street photography in cities where light levels are often low in the canyons between tall buildings. It is also a good film to carry for those times when light levels drop as clouds roll in or when the sun sets.

Ilfochrome 100

MANUFACTURER: *Ilford Ltd.*
TYPE: *very fine-grain, medium-speed color reversal film (transparency)*
SIZES: *35mm*
FILM SPEED: *ISO 100/21°*
COLOR BALANCE: *daylight 5500K*
PROCESSING: *sold without processing, but Ilfochrome services available for mounted or unmounted slides; E-6 process; user may process in Unicolor Rapid E-6, Kodak E-6 or other similar kits*
APPLICATIONS: *outdoor photography, landscapes, nautre; brightly colored subjects; general purpose slide film for travel, candid, and family photography*

Ilfochrome 100 is one of three new films that mark Ilford's return to the color film market. Ilfochrome 100 is a very fine-grain, medium-speed color reversal film with excellent color saturation thanks to a double layer in the emulsion for each of the three primary colors, which become double layers of cyan, magenta, and yellow when developed. The significance of these double layers is that a photon that misses a silver halide particle in the first layer gets picked up by a silver halide particle in the second layer, thereby insuring good saturation, even under adverse lighting conditions such as heavily overcast skies.

Ilfochrome 100 has a neutral color balance. It maintains its neutral color balance even in open shade and under gray, cloudy, outdoor conditions. There are some lighting situations where whites will acquire a slight bluish tinge, but usually whites rendered on Ilfochrome 100 will remain clean.

PROCESSING Ilfochrome 100 is sold without processing, but may be processed through any dealer at Ilfochrome Service Centers, at any lab using E-6 type processing, or by the user in E-6 type chemistry such as Unicolor Rapid E-6 or Kodak E-6 kits.

APPLICATIONS Ilfochrome 100 is a general purpose film with brilliant color reproduction. Excellent color rendition is due to the emulsion's properties of high saturation, minimal "cooling" of the emulsion under adverse conditions, and to its broad exposure latitude. It is not hard for any film to produce brilliant colors under bright, direct lighting, but to maintain bright colors under dull, cool light of low intensity is an achievement, and Ilfochrome 100 does this well. Bright reds, yellows, oranges, and greens reproduce very well on Ilfochrome 100 under low, indirect lighting. In scenics, blue skies are well-saturated and bright.

GENERAL PURPOSE

Kodachrome 25 KM
and 25 Professional PKM

MANUFACTURER: *Eastman Kodak Company*
TYPE: *extremely fine-grain, slow-speed, color reversal film (transparency)*
SIZES: *35mm; Pro Packs of 50 rolls*
FILM SPEED: *ISO 25/15°*
COLOR BALANCE: *daylight 5500K*
PROCESSING: *sold with and without processing. Kodak mailers or Kodak processing available at your dealer. Process K-14*
APPLICATIONS: *Images for extreme enlargement; especially good for warm-toned subjects, flesh tones and portraits; beauty, fashion and advertising; landscapes, flowers; travel photography; food; group photography*

Kodachrome 25 KM and Kodachrome 25 Professional PKM are the direct descendants of the original Kodachrome (ISO 6/9°), which was introduced in 1935. They are processed by the coupler-in-developer process K-14, which is complicated, exacting, and very difficult to use in the field or in a small darkroom. However, newer processes, such as the E-6 coupler-in-emulsion-type, were not able to match the fine grain, high color saturation, definition, and image permanence of the K-14 process until very recently, when Fuji introduced a group of new Fujichrome films that use an impressive new coupler-in-emulsion technology.

Professionals have been using Kodachrome films since the 1930s and some time ago urged Kodak to make professional versions of Kodachrome 25 and 64 that would have the same color balance from batch to batch and exact exposure information listed with each batch. Kodak responded by introducing Kodachrome 25 Professional and in 1984 will market Kodachrome 64 Professional. Like all professional films, Kodachrome 25 Professional should be refrigerated or frozen. Many professionals also refrigerate the amateur version of Kodachrome 25: Most pros buy film by the case, test the emulsion, and then refrigerate it to preserve its known speed and color balance.

Kodachrome 25 KM and PKM are slow-speed, extremely fine-grain films with a smooth, even grain distribution. This alone makes these emulsions capable of very high magnifications. In fact, a Kodachrome 35mm transparency is regularly used to make a Kodak display mural in Grand Central Station in New York City which measures 18 × 60 feet. Actually only a part of the 35mm slide is used for the mural, magnified in excess of 500×. It is not just the grain, high resolving power, nor even the edge sharpness that makes the Kodachrome 25s so enlargeable, it is also the high degree of color saturation and excellent color purity

that hold the image together at such extreme magnifications. Colors in the dye layers are so well aligned that they do not separate into component parts when greatly enlarged.

If the Kodachrome 25s have any weak point at all, it is in their relatively high contrast as compared to that of other slow- and medium-speed color reversal films. In general, shadow details block up faster with the Kodachrome 25 films than with comparable films. However, the higher contrast of KM and PKM also has its advantages when shooting under low contrast lighting or photographing low-contrast subjects such as flowers; the extra contrast puts "zing" into subjects that would appear bland on lower contrast films.

The Kodachrome 25s become even more useful when paired with high quality, very high speed lenses such as the Nikkor 35mm $f/1.4$, 85mm $f/1.4$, 105mm $f/1.8$, and 200mm $f/2$ at wide open apertures. Such lenses extend the range of these slow speed films for hand-held shooting under less than ideal lighting conditions. With the use of very high-speed lenses, KM and PKM become as useful as medium speed films with average speed lenses under cloudy skies and in the rain.

KM and PKM have very good reciprocity characteristics, making them useful for slow speed photography on a tripod or other camera support. They have an exposure range of $1/10,000$ to $1/10$ sec. and require a $1/2$ stop exposure increase at one second with no filter correction.

PROCESSING Kodachrome 25 KM and 25 PKM are processed in K-14 chemistry by Kodak. The Kodachrome 25s and 64s can be push-processed one to three stops or even pull-processed. The process is difficult and few labs will do this. If you do accidentally over-or under-expose Kodachrome film, contact a local professional lab or New York Film Works, 928 Broadway, New York, New York 10010 for a price list and schedule.

APPLICATIONS Kodachrome's KM and PKM are warm, neutral films that are particularly strong in rendering warmer colors such as reds, yellows, and browns. These films are also very good with greens, making KM and PKM good films for flowers, scenics, landscapes, and foliage. They also produce slightly warm, healthy-looking skin tones and portraits in natural light or when using electronic flash in the studio.

On the professional side, Kodachrome 25 KM and PKM are used in beauty, fashion, and advertising photography as well as in such areas as industrial, food, and landscape photography. As general purpose amateur/ professional films, they are widely used for travel and holiday photography, and are especially well-suited to group photography thanks to extremely fine grain and high resolving power.

Kodachrome 64 KR
and 64 Professional PKR

MANUFACTURER: *Eastman Kodak Company*
TYPE: *extremely fine-grain, slow-speed, color reversal films (transparency)*
SIZES: *35mm; Pro Packs of 50 rolls*
FILM SPEED: *ISO 64/10°*
COLOR BALANCE: *daylight 5500K*
PROCESSING: *sold with and without processing. Kodak mailers or processing service available at your dealer. Process K-14*
APPLICATIONS: *General purpose; close-up, nature, landscape, travel photography; portraits and family photography*

Kodachrome 64 KR and Kodachrome 64 Professional PKR are slow speed films that are actually the "high speed" versions of Kodachrome 25 KM and Kodachrome 25 PKM. Actually, these emulsions are only 1⅓ stops faster than Kodachrome 25, but that can make a big difference, especially for hand-held photography, when light levels are low. Kodachrome 64 KR and Kodachrome 64 PKR allow use of smaller apertures than the slower Kodachrome 25s do at the same light levels, resulting in greater depth of field.

Both Kodachrome 64 films are very similar to the Kodachrome 25 KM and PKM films, and are thus thought of as companion films that can be intermixed in slide shows or in print exhibitions with little noticeable difference. The Kodachrome 64s exhibit a bit more contrast than the Kodachrome 25s, which make the former better choices for photography under flat lighting conditions. The warm, neutral color balance of both Kodachrome 64s is a bit reddish when compared to that of the Kodachrome 25s. Greens are rendered very accurately and the warmer colors such as reds and yellows are slightly brighter on the Kodachrome 64s than they are on the Kodachrome 25s. The grain of the Kodachrome 64s is evenly distributed and slightly larger than that of the Kodachrome 25s, but still fine enough to be considered in the extremely fine-grain class.

Kodachrome 64 Professional PKR is manufactured to tighter tolerances than the amateur version. Like all professional Kodak films, each run of PKR is tested by Kodak, and the effective film speed of that particular run is listed in red on the film information sheet. PKR, like PKM, is sold in individual rolls or Pro Packs containing 50 rolls of the same film run.

The Kodachrome 64s have almost the same reciprocity characteristics as the Kodachrome 25s with exposure ranges from 1/10,000 to 1/10 sec.; however, at one second, the Kodachrome 64s need a CC 10 Red color compensating filter and one stop increase in exposure. With some electronic flashes and very short light durations a blue cast may occur with the Kodachromes; in such cases,

use a warming filter over the lens, such as a Tiffen 81B, or use a warming filter on the flash unit.

PROCESSING Both Kodachrome 64s require Kodak Process K-14. Though Kodak does not advertise it, the Kodachromes may be push-processed if needed. See the chapter on Kodachrome 25 for further details.

APPLICATIONS Kodachrome 64 KR and Kodachrome 64 Professional PKR are excellent general purpose transparency films. They are particularly useful for closeup, nature and travel photography. As these films tend toward warmth in their color rendition, they are good choices for portrait and family photography.

The Kodachrome 64s have one of the most important qualities needed for underwater photography—good contrast. When light enters water it becomes very diffuse, which lowers the contrast of all subject matter under water. This includes all types of aquariums, especially the large public ones found in many large cities. The light diffusion problem is least noticeable in the small home aquariums, where there is not enough water or particles suspended in the water to cause great light scatter.

Kodachrome 25 and 64 are both contrasty films, but Kodachrome 64 is a better choice for underwater photography because it has a higher film speed, giving you a stop and a third more exposure to work with. Water not only scatters and diffuses light, it also lowers the intensity of the light when it passes from air into water.

The color of water is in the blue to green spectrum. The longer wavelengths that give us red, yellow, and orange colors are weak just below the surface of water and do not penetrate much more than 12 feet below the surface. The warm to reddish cast of the Kodachrome 64s help to intensify the weaker warm colors whether you use flash or not.

Ektachrome 64 ER
and 64 Professional EPR

MANUFACTURER: *Eastman Kodak*
TYPE: *very fine-grain, slow-speed color reversal films (transparency)*
SIZES: *35mm cartridges, 120 rolls, and sheets*
FILM SPEED: *ISO 64/19°*
COLOR BALANCE: *daylight 5500K*
NOTES: *sold without processing, process via Kodak mailers, through your dealer or any lab with E-6 processing or by the user*
APPLICATIONS: *64 ER is general purpose film for nature, travel and outdoor photography, and good for use in high contrast lighting; 64 EPR is used in the studio and in the field for most commercial photography uses*

Ektachrome 64 ER and Ektachrome 64 Professional EPR, along with the ISO 200 and tungsten Ektachromes, brought in a new era of color reversal film and processing. These Ektachromes have hardened emulsions to withstand the higher processing temperatures of process E-6. Previous E-4 films had softer emulsions and required a pre-hardener bath before processing in order to withstand 100°F (38°C) processing temperatures. Process E-6 uses a chemical reversal process whereas the E-4 process required that films be reexposed to light to reverse the image. All E-6 films are processed for the same length of time in Process E-6, including E-6 duplicating films. In the earlier processes, times varied for different film emulsions, meaning that emulsions could not be intermixed for processing. The E-6 process is shorter, uses less water and is consistent for all E-6 films. It also lends itself to rapid three-step processing methods such as the Unicolor Rapid E-6 process, which combines the reversal and conditioning steps with the color developer step; the fixer and bleach steps are also combined. Kodak resisted the rapid process idea for years, but has recently joined in with its own rapid process Hobby-Pac Color Slide Film Kit for E-6 films.

The Ektachrome 64s are very fine-grain, slow-speed color reversal films with only moderate edge sharpness compared to other films of this speed class. The moderate edge sharpness is due in part to the emulsion's relatively low contrast and to color bleeding beyond the edges of an image where dye clouds in the emulsion layers are not well aligned. This only becomes apparent at very high magnifications, however. Ektachrome 400, a film developed a few years later than the Ektachrome 64s, has better edge sharpness as a result of improved emulsion technology.

The Ektachrome 64s have very good color saturation and render surprisingly good reds and yellows for a cool, neutral film. Skin tones are on the cool side, but remain rather pleasing, though not as pleasing as the warm,

healthy skin tones of the Kodachrome 25s. Ektachrome 64 ER and 64 EPR have especially good blue reproduction.

Ektachrome 64 ER and 64 EPR are intended for exposure in direct clear or hazy sunlight and under studio-type electronic flash. In open shade and heavy overcast conditions, it is best to use a skylight filter to suppress the blue cast that ER and EPR tend toward under such cool lighting conditions. Many on-camera electronic flash units have a high color temperature, so it is advisable to replace the skylight filter over your lens with a warming filter such as the Tiffen 81B, or use a warming filter on the flash unit.

The Ektachrome 64s have good reciprocity characteristics with an exposure range of $\frac{1}{1000}$ to $\frac{1}{10}$ sec. At 1 sec., ER and EPR need a color compensation of CC15B and a one stop exposure increase.

PROCESSING ER and EPR are sold without processing, but processing mailers are available for 35mm and 120 roll sizes. These emulsions require the E-6 process, which may be done by the user. The new rapid three-step processing chemistries make home E-6 processing feasible in any darkroom.

APPLICATIONS The Ektachrome 64s have moderate contrast and produce rather good shadow detail. They are therefore very good film choices for photographing subjects in strong light. Subjects including high contrast, such as pastels mixed with bright colors, or bright colors combined with deep colors, are also handled well by ER and EPR.

Ektachrome 64 ER is a general purpose amateur film used for scenics, portraits, and travel photography. EPR is widely used by professionals in the studio and in the field for many applications, from advertising to industrial to commercial photography. In roll and sheet formats, EPR is the most fine-grained and has the highest resolving power of any color reversal film produced by Eastman Kodak Company, as the Kodachromes are only available in 35mm. Thus EPR is widely used for medium and large format photography when daylight color reversal films are needed.

Ektachrome 100 EN
and 100 Professional EPN

MANUFACTURER: *Eastman Kodak*
TYPE: *very fine-grain, medium-speed color reversal film*
SIZES: *35mm cartridges, 120 rolls, and sheets*
FILM SPEED: *ISO 100/21°*
COLOR BALANCE: *daylight 5500K*
NOTES: *process in E-6, Hobby Pak, Unicolor Rapid E-6 or equivalent; Kodak Processing mailers available at your local dealer*
APPLICATIONS: *general purpose; closeup, nature, landscape, travel photography; portraits and family photography*

Ektachrome 100 is a very fine grain color reversal film with a warm neutral color balance that produces images with coloration closer to the color balance of Kodachrome than to the color balance of other Ektachrome emulsions. Ektachrome 100 is the newest of the standard E-6 Ektachrome family and it employs some of the newest Kodak color technology. The warmer, more pleasing color balance is one of the results of this new technology.

This warm color balance is particularly evident in pictures taken in open shade, under overcast skies, and by electronic flash, all of which have a high blue content plus heavy ultraviolet radiation, which affect colors by producing a cooling effect. The warm color balance of Ektachrome 100 helps to keep the colors in your pictures from taking on a blue and pasty pallor. Even though it is a warmer film, Ektachrome 100 produces stronger and brighter blues than Ektachrome 64, which is noted for its blues.

This apparent contradiction is a result of the new Developer Inhibitor Release (DIR) couplers, which limit the growth of exposed silver halides and restrict developer reaction from spreading to unexposed silver halide crystals in the same emulsion layer as well as in adjacent layers. This chemical action keeps color pollution to a minimum creating a high degree of color purity. Thus stronger and brighter blues appear in Ektachrome 100 than are possible in Ektachrome 64. A close look at shadow areas of a white shirt show up as a neutral gray on Ektachrome 100, while the same shadow areas on Ektachrome 64 are a distinct blue gray. Shadow areas are also a clean neutral on Ektachrome 100 while whites are a clean, slightly warm neutral.

Color saturation and color purity are both high because of the new chemical processes contained in the emulsion of Ektachrome 100. It also has a finer grain structure than Ektachrome 64 because of the limiting growth action on the developing silver halide crystals: the crystals are allowed to grow enough to produce a fine image, but limited from growing too much to destroy that fine image. The limited crystal growth

and nondevelopment of unexposed crystals also create sharper edges in the image. Edge sharpness is further enhanced by the color purity, which emphasizes a sharp delineation between colors.

All this adds up to rich, clean color transparencies that look very good projected on a screen and produce fine prints even at high magnifications.

PROCESSING Ektachrome 100 EN and 100 Professional EPN are processed in E-6 chemistry. This may be done in the home darkroom, or in any photoprocessing lab.

APPLICATIONS Ektachrome 100 is a particularly good medium speed general purpose film because it produces excellent results under both warm and cool daylight situations. It also handles the coolness of many on-camera electronic flashes very well, producing very natural colors. It is worth the trouble to take a roll of Ektachrome 100 and your favorite model for pictures and make a series of exposures in direct sunlight, in open shade, and by electronic flash. You will find that it is a super Ektachrome. Not only does Ektachrome 100 produce more pleasant skin tones than the cooler 64 and 200 Ektachromes, but it also reproduces more faithfully the delicate colors of flowers such as morning glories and the strong colors of azo dyed fabrics.

Ektachrome 200 ED
and 200 Professional EPD

MANUFACTURER: *Eastman Kodak*
TYPE: *fine-grain color, medium-speed reversal films (transparency)*
SIZES: *35mm cartridges, 120 rolls, and sheets*
FILM SPEED: *ISO 200/24°*
COLOR BALANCE: *daylight 5500K*
NOTES: *sold without processing; processing via Kodak mailers, or through your dealer; E-6 Processing by any lab or the user may use any E-6 chemistry made for home darkroom use*
APPLICATIONS: *action; in studio or with flash; sports; telephoto or zoom photography; portraits in warm light; to "cool" light*

Ektachrome 200 ED and Ektachrome 200 Professional EPD are medium-speed, fine-grain color reversal films processed in E-6 chemistry and are 1⅔ stops faster than the Ektachrome 64s. The Ektachrome 200s are a bit cooler with the whites having a distinctly cool look that could be called blue-white. The color saturation is average, with bright blues, deep greens, and slightly muted warm colors.

The grain structure of the Ektachrome 200s is somewhat obvious for medium speed films, as is sharpness when compared to other medium speed color reversal films. However, where great magnifications are not needed, ED and EPD are very useful. The advantage of these films, on the other hand, is that they have good film speed, allowing faster shutter speeds and/or greater depth of field than the slower Ektachrome 64s.

Under cool lighting conditions such as open shade or overcast skies, a skylight filter should be used. If your results are still too cool, use a warming filter over your lens such

as a Wratten 81, or 81A, or 81B. Use Tiffen glass filters for outdoor work, and Tiffen glass or Kodak gelatin filters for indoor use.

PROCESSING Ektachrome 200 ED and 200 Professional EPD are processed in E-6 chemistry. This may be done in the home darkroom, or in any photoprocessing lab.

APPLICATIONS The Ektachrome 200s are well-suited for photography in direct, clear or hazy sunlight and for use with studio-type electronic flash. They are a good choice for photographing action such as auto racing and outdoor sports, and for telephoto or zoom photography where high shutter speeds are needed. Moderate contrast makes these films well-adapted to shooting subjects under high sun on clear days where the shadows tend to remain open. Portraits are rather good when taken in the warm light of the early morning or late afternoon because the cool color balance of the Ektachrome 200s counteracts the extreme warmth of these situations.

Ektachrome 400 EL

MANUFACTURER: *Eastman Kodak*
TYPE: *fine-grain, high-speed color reversal film (transparency)*
SIZES: *35mm cartridges and 120 rolls*
FILM SPEED: *ISO 400/27°*
COLOR BALANCE: *daylight 5500K*
NOTES: *sold without processing; processed at any color lab with E-6 type processing; may be processed in the home darkroom*
APPLICATIONS: *action and sports; photojournalism; telephoto, zoom or slow lenses*

Ektachrome 400 EL is the original high-speed, fine-grain color reversal film. Unlike the rest of the Ektachromes, which are noted for their coolness, 400 EL is a warm neutral film. Whites look neutral on 400 EL when viewed alone; however, in direct comparison to other Ektachromes, the whites on EL look warm. Flesh tones are pleasing on 400 EL because of its warm neutral color balance. Skin tones on 400 EL also remain pleasing even without filtration under the bluish condition of open shade. Reds, oranges, yellows, and greens are faithfully reproduced on 400 EL with little color contamination, even under cool lighting conditions such as overcast skies.

Ektachrome 400 was also the first daylight-balanced high-speed color reversal film to produce acceptable results under tungsten illumination without using a light balancing filter. The results are warm to yellow-red and are quite pleasing, unlike earlier high speed films that tended toward a garish yellow or orange color cast. Ektachrome 400 produces a rather acceptable, though slightly greenish tinge when exposed without a filter under most types of fluorescent light. However, for correct color balance under tungsten light on 400 EL it is advisable to use an 80A light balancing filter, and a specialized filter such as the Tiffen FLD under fluorescent light.

Ektachrome 400 EL is composed of a multistructured emulsion having one blue-sensitive layer, three green-sensitive and three red-sensitive layers. The top green and red emulsion layers are highly responsive to low intensity light, while the bottom layers need high intensity light to be exposed. The bottom red and green layers are finer grained than the top layers, which is why 400 EL gives finer grained results under bright light than it produces under low light levels.

Ektachrome 400 EL has fine grain, good sharpness, medium resolving power, and very good color saturation at both high and low light levels. Due to these qualities, 400 EL was recognized as the first highly enlargeable high-speed color reversal film. At high magnifications 400 EL gives reasonable detail and sharpness, and good color satura-

tion. Other high speed color reversal films can now produce good looking images at even higher magnifications, but Ektachrome 400 EL was the film that showed the way.

Ektachrome 400 EL also opened new possibilities for photojournalists, as it allowed them to do in color what they could only do before in black-and-white—get the picture without disturbing the subject with extra lighting or bursts of electronic flash. It is listed as an amateur film because it is manufactured with a built-in aging process rather than being manufactured to peak performance at the time of purchase (and requiring refrigeration to maintain its characteristics). Nonetheless, it is widely used by professionals for stopping action at high shutter speeds even under less than ideal lighting conditions.

400 EL was the first high speed film to be introduced that could be push-processed one or two stops with good results. There is an increase in grain size, and contrast increases with each stop pushed, but color saturation remains very good for surprisingly acceptable overall results. In fact, 400 EL is push-processed by many sports photographers and photojournalists whenever conditions demand higher exposure indexes than those recommended by a film manufacturer. An example of such circumstances is night sports played under poor weather conditions.

PROCESSING Ektachrome 400 EL is sold without processing. Kodak mailers and Kodak service are available at local photo dealers. A standard one-stop push service from Kodak is available via a Kodak ESP-1 envelope in addition to the normal developing charge. 400 EL can also be processed by any color lab with E-6 type processing, and most labs will also push-process 400 EL if requested. 400 EL may be processed in a home darkroom in any E-6 type processing kit such as Kodak's Hobby-Pac Color Slide Processing Kit. 400 EL may be pull-or push-processed in this kit from exposure indexes of 100/21° to 3200/33° by following special directions in the instruction booklet.

APPLICATIONS 400 EL is useful in bright light where high shutter speeds and great depth of field are needed. It is also helpful when hand-holding slow telephoto or zoom lenses because 400 EL allows the use of sufficiently high shutter speeds. EL is widely used by professionals wherever light levels are low and when long lenses must be used. Professionals will also push EL to EIs of 800/30° and 1600/33° whenever the extra film speed is needed because they know they can get good, reproduceable results.

Konica Chrome/ Sakurachrome 100

MANUFACTURER: *Konishiroku Photo Company*
TYPE: *very fine-grain, medium-speed color reversal film (transparency)*
SIZES: *35mm cartridges*
FILM SPEED: *ISO 100/21°*
COLOR BALANCE: *daylight 5500K*
NOTES: *E-6 process; user may process in Konica Chrome Reversal Film Processing Chemicals Type 2, Unicolor Rapid E-6, Kodak E-6, other E-6 kits*
APPLICATIONS: *general purpose; printing, medical and scientific photography; low light and when long exposures are required, or when great depth of field and slow shutter speed is needed*

Konica Chrome 100 and Sakurachrome 100 are the same film under different names. In Europe it is known as Sakurachrome, and in the United States it is called Konica Chrome. Konica/Sakurachrome 100 is a medium-speed, fine-grain color reversal film. It is a general purpose film intended for exposures under good light levels though it has extremely good reciprocity characteristics: no filter or exposure adjustment is necessary from 1/1000 sec. down to 4 sec. Thus this film may be used under low light conditions without having to calculate filter/exposure adjustments.

Konica/Sakurachrome 100 is balanced for use in daylight quality light at 5500K and has a cool, neutral color balance. Color saturation is high due in good part to paired red-, green-, and blue-sensitive layers. When processed, the three resulting pairs of cyan, magenta, and yellow dyes produces rich color. In shadow areas color saturation remains good because of the color pairing and this emulsion's generous exposure latitude.

PROCESSING Konica/Sakurachrome 100 is sold without processing. Under private labels it may be sold with or without processing; for example, Fotomat sells it as Fotomat Color Film without processing, but offers processing services for their own and other brands of E-6 color slide films. The user can process it in Konica Chrome Reversal Film Processing Chemicals Type 2 or any E-6 process, such as Unicolor Rapid E-6 or Kodak E-6 kits.

APPLICATIONS Konica/Sakurachrome 100 is a general purpose film designed for amateur photography as well as for professional uses such as printing, medical, and scientific photography. It is a particularly useful film for photographs taken by the light of the rising or setting sun when the color temperature of the light is warm and the light intensity is low: the cool neutral balance keeps results from becoming too warm and its reciprocity characteristics allow the use of slow shutter speeds.

Peruchrome C19

MANUFACTURER: *Perutz*
TYPE: *very fine-grain, slow-speed color reversal film (transparency)*
SIZES: *35mm cartridges*
FILM SPEED: *ISO 64/19°*
COLOR BALANCE: *daylight 5500K*
NOTES: *sold with Agfa processing, either with or without mounting*
APPLICATIONS: *with flash; vacation and travel photography; in overcast outdoor conditions*

Peruchrome C19 is a slow-speed, very fine-grain color reversal film. C19 is a general purpose amateur film that, like most other amateur films, is good enough to be used as a professional film, and probably is used by some professional photographers.

Peruchrome C19 has excellent color saturation under dull, cloudy skies as well as in bright sunlight. A number of films lose saturation under dull, low light conditions, but C19 maintains its saturation. Because of its warmth and color saturation even under cool lighting, C19 is a good film to use with on-camera electronic flash units, which often have a cool color temperature.

Even though it is a warm film, C19 reproduces all colors from red to green to blue quite faithfully and with a good degree of saturation. Some warm films have a tendency to overcompensate blue, producing a greenish-tinged blue, especially when recording sky, but C19 produces a clean blue.

PROCESSING Peruchrome C19 comes with Agfa processing included in the price of the film. However, C19 can be purchased with or without slide mounts. Peruchrome has processing services in Europe, North and South America, Africa, the Middle East, and the Far East.

APPLICATIONS C19 falls in the class of general purpose films that are thought of as "good weather films" used on bright, sunny days for scenics, portraits and group pictures. Because of its slow speed, it is also thought of as a good film to record holidays because vacations tend to fall in periods of good weather. In fact, C19 is a fine choice for photographing skiing, fishing and swimming, as these situations are rather high in blue light content, and C19 counteracts the coolness because it is a warm film. It is also a very good film for photographing under overcast skies because of its warmth.

3M Color Slide 100

MANUFACTURER: *3M*
TYPE: *very fine-grain, medium-speed color reversal film (transparency)*
SIZES: *35mm cartridges*
FILM SPEED: *ISO 100/21°*
COLOR BALANCE: *daylight 5500K*
NOTES: *mailers from 3M sold separately; process E-6*
APPLICATIONS: *general purpose; high or low light levels; high contrast scenes; portraits; travel and family photography*

A medium speed, very fine-grain film, 3M Color Slide 100 is intended for use in fixed exposure cameras as well as more advanced, full control cameras. Until recently, 3M had not directly sold film for years, but had been selling its product under private labels. However, 3M is again selling its film under its own as well as private labels.

The film is a newly formulated emulsion with a very fine grain structure, excellent resolution and high edge sharpness. While primarily used by amateurs, 3M CS100 is of professional calibre. It employs multiple layers in the emulsion for optimum contrast, and has excellent reciprocity characteristics, with no compensation needed from $\frac{1}{1000}$ to $\frac{1}{2}$ sec.

This film has nearly neutral color balance with a tinge of warm magenta. It has very good color saturation and color brilliance due to new color coupler formulation and multiple color layers in the emulsion. The extended exposure latitude allows for excellent results under both high and low contrast lighting situations.

PROCESSING Like all 3M films, Color Slide 100 film is processed in E-6 color reversal chemistry. Under the 3M label it is sold without processing, but 3M processing mailers may be purchased separately. Color slide 100 may be processed by any photo dealer, any E-6 lab, or by the user in any E-6 type chemistry, such as Unicolor Rapid or Kodak E-6 kits.

APPLICATIONS Color Slide 100 is a general purpose film useful under high and low light levels because of its good contrast and long exposure capabilities. Color saturation is good under both direct and indirect lighting at high and low levels. Colors remain clean and pure, even under cool overcast skies. For best results with Color Slide 100 and other 3M films it is advisable to use a skylight filter over the lens to absorb the excess blue present when shooting under overcast skies or in open shade. Because of its extended exposure latitude, Color Slide 100 is excellent for rendering both shadow and highlight detail in the same picture. Flesh tones and all colors are faithfully reproduced.

3M Color Slide 400

MANUFACTURER: *3M*
TYPE: *fine-grain, high-speed color reversal film (transparency)*
SIZES: *35mm cartridges*
FILM SPEED: *ISO 400/27°*
COLOR BALANCE: *daylight 5500K*
NOTES: *mailers from 3M sold separately; process E-6*
APPLICATIONS: *general-purpose high-speed slide film; low light or available light; action and sports*

Color Slide 400 is a high speed, fine-grain, general purpose film for use in situations where extra film speed is an advantage. Color Slide 400 is a new formulation similar to Color Slide 100, but with a rating two stops higher. Its fine-grain rating comes from 3M's new film formulation for Color Slide 400. This new formulation also gives the film very good edge sharpness and resolution, plus good image contrast and color saturation due to new color couplers and a double layer technique used in each of the three color-sensitive layers. The essential differences between Color Slide 400 and its slower companion are that the 400 is a faster film, and does not have the very fine grain and high resolution for finely detailed subjects or high magnifications of the slower film.

Color Slide 400 has a neutral color balance and produces good flesh tones and generally very faithful rendition of all colors under direct and indirect lighting at high or low levels. Color saturation is also very good at low light levels as well as under high, direct lighting. It also has a wide exposure latitude, producing good color saturation in both direct light and shadow areas of the same picture.

PROCESSING Like all 3M films, Color Slide 400 Film is processed in E-6 color reversal chemistry. Under the 3M label it is sold without processing, but 3M processing mailers may be purchased separately. When sold under other labels, it may be sold with or without processing. Color Slide 400 can also be returned to your photo dealer for processing, or may be processed at any lab using E-6 chemistry, or by the user in any E-6 chemistry such as Unicolor Rapid E-6 or Kodak E-6 kits.

APPLICATIONS Color Slide 400 is excellent for photography at low light levels, capturing fast action, whenever high shutter speeds and great depth of field are needed, and whenever an extended range for flash work is needed. If results with flash are too blue, you can use an 81 or 81A warming filter on your camera lens.

Agfachrome 50T Professional

MANUFACTURER: *Agfa-Gevaert AG*
TYPE: *very fine-grain, slow-speed color reversal film (transparency)*
SIZES: *35mm cartridges, 120 rolls, and sheets*
FILM SPEED: *ISO 50/15°*
COLOR BALANCE: *3100K for tungsten illumination*
NOTES: *process at Agfa labs or in Agfa Process 41 (available in Europe)*
APPLICATIONS: *slow speed general purpose; night photography; studio and commercial; portraiture; images for extreme enlargement; firework displays*

Agfachrome 50T Professional is a very fine-grain, slow-speed film balanced at 3100K for photography under artificial light such as Nitraphot and Argaphoto tungsten lamps. With lamps that have another color temperature value, such as tungsten halogen 3200K lamps, Color Temperature Correcting (CTC) filters can be used for critical work. To match Agfachrome 50T exactly to 3200K, use a warming CTC filter with a +10 mired value such as a Tiffen or Kodak Wratten 81 on the camera lens to match the color temperature of the lighting to the color temperature balance of the film.

Long exposures are the forte of tungsten-balanced films because they are intentionally balanced for longer exposures. Daylight films are balanced for short exposures and encounter reciprocity failure at exposures of ¹⁄₁₀ sec. or slower. Agfachrome 50T in 35mm and rolls has a neutral color balance for 1 sec.; the sheet films have neutral color balance for up to 8 sec. The exposure range of 50T in 35mm and rolls is ⅛ to 16 sec. and the 50T sheet films have a range of ½ to 60 sec. Because of long ex-posure time capabilities, 50T is a good choice for photographing fireworks because the shutter can be left open for a few bursts to capture interesting patterns while maintaining good blacks.

All three formats of Agfachrome 50T Professional have identical emulsions, though the sheet films are balanced for slightly longer shutter speeds than are the roll films.

PROCESSING Agfachrome 50T Professional is sold without processing, but may be processed at any Agfa Lab or authorized custom lab. Agfachrome 50T can also be processed by the user in Process 41.

APPLICATIONS Agfachrome 50T Professional is a very warm film with good contrast and excellent color saturation. It is used for outdoor night shots requiring long exposures and in the studio under artificial lights where long exposures and great depth of field are needed. 50T is also useful for portraiture under tungsten illumination because its very fine grain, image sharpness, and warmth produce pleasing portraits that can be projected or enlarged to a high degree.

Kodachrome 40 Type A

MANUFACTURER: *Eastman Kodak*
TYPE: *very fine-grain, slow-speed color reversal film*
SIZES: *35mm cartridges*
FILM SPEED: *ISO 40/14°*
COLOR BALANCE: *tungsten 3400K*
NOTES: *sold with and without processing; Kodak mailers or processing service available at your dealer; process K-14*
APPLICATIONS: *copy and closeup work; advertising, commercial, portrait, food, and other studio photography; indoor or outdoor architectural photography*

Kodachrome 40 Type A is a slow-speed, very fine grain color reversal film that is balanced at 3400°K for exposure by photoflood, but can also be exposed under 3200°K tungsten lamps with a light balancing (also called color temperature correcting) filter, such as a Kodak or Tiffen 82A or black-and-white KB 1.5.

Kodachrome 40A is unusual in that it is a slow-speed artificial light film intended for exposure times similar to the Daylight-balanced Kodachrome 25: $\frac{1}{10,000}$ to $\frac{1}{10}$ sec. At one sec., Kodachrome 40A needs $\frac{1}{2}$ stop more exposure and one full stop more exposure at ten sec. It is because of its unusual exposure characteristics that Kodachrome 40A can easily be used for exposure under bright daylight conditions or by electronic flash by using a Kodak or Tiffen 85 or black-and-white KR 12 color temperature correcting filter on your camera lens. Other slow-speed artificial light films are intended for

long exposure times and thus cannot be used with electronic flash or under bright daylight conditions because there would be color shifts due to reciprocity failure that would be impossible to correct along with correcting for color temperature.

Kodachrome 40A has a warm, neutral color balance. It produces highly saturated images with particularly rich reds. Whites are clean and blacks are solid. Image contrast of 40A is similar to the other Kodachromes: a bit on the contrasty side.

PROCESSING Kodachrome 40A is sold with and without processing. The film can be processed using the K-14 process, which is available at your local dealership, or through Kodak mailers.

APPLICATIONS The extra contrast of Kodachrome 40A is particularly well suited to the studio and copy lighting under which it is primarily used. Studio lighting has a ten-

dency to be flat due to the use of multiple lights: K 40A puts a punch into the images shot under such lighting. In copy work, the closeness of the copy lights makes the lighting contrasty, but the flooding of light from both sides in equal proportions flattens out the lighting contrast making K 40A a particularly good film to use when copying low contrast subjects.

Kodachrome 40A is also excellent for copy and closeup work where slides need to be made for projection. It is also useful in advertising, commercial, portrait, food, and other types of studio photography where good contrast and high saturation are needed. It is a good choice for indoor or outdoor architectural photography as well, when the subjects are illuminated by tungsten lighting.

Ektachrome 50 Professional Tungsten

MANUFACTURER: *Eastman Kodak*
TYPE: *very fine-grain, slow-speed color reversal film (transparency)*
SIZES: *35mm cartridges, 120 rolls, and sheets*
FILM SPEED: *ISO 50/18°*
COLOR BALANCE: *tungsten 3200K*
NOTES: *sold without processing; processed via Kodak mailers, through your dealer or any lab with E-6 processing; may be processed by the user in E-6 kits*
APPLICATIONS: *studio use; portraiture; still life; advertising; food; nature; industrial uses*

Ektachrome 50 Professional (EPY) is a slow-speed, very fine-grain film balanced for 3200K tungsten illumination. Because of its slow speed and the fact that there is a Kodak medium speed available light tungsten film, (Ektachrome 160), Ektachrome 50 is only available as a professional film. Although primarily used by professionals, EPY is also used by amateurs who need to use a very fine-grain tungsten film.

EPY has a warm neutral color balance with very good color saturation. Warm colors are reproduced particularly well, and cooler colors are rendered with good saturation and brightness. Reds and yellows are particularly rich and greens tend slightly toward yellow.

EPY's contrast, while above average, is far more likely to be apparent because of the way photographers use studio lights to illuminate their subjects. Tungsten lights are generally low in power output because of the unit size needed to produce very high outputs. Another problem is high heat output of tungsten lights in relationship to their light output.

Tungsten lights are, therefore, small light sources, and photographers have a tendency to use them close to the subject, which increases contrast. Thus the results of EPY will actually appear with more contrast than they actually had. The professional's solution is to use tungsten light reflected off umbrellas or even white cardboard to spread the light and lower its contrast.

PROCESSING EPY is sold without processing. EPY can be processed by Kodak via mailers or through your dealer, at any lab or by the user in an E-6 type chemistry such as the Unicolor Rapid E-6 and Kodak E-6 kits.

APPLICATIONS Skin tones are warm and rich on Ektachrome 50 Professional Tungsten Film. The contrast of EPY is a bit above average, but this film has good exposure latitude and produces good saturation and detail in both highlights and shadow. EPY is useful for studio portraiture, still life, food and flower photography, as well as for commercial and industrial applications.

Ektachrome 160 ET
and 160 Professional EPT

MANUFACTURER: *Eastman Kodak*
TYPE: *fine-grain, medium-speed color reversal tungsten film (transparency)*
SIZES: *35mm cartridges, and rolls*
FILM SPEED: *ISO 160/23°*
COLOR BALANCE: *tungsten 3200K*
NOTES: *sold without processing; processing via Kodak mailers, through any dealer or any lab with E-6 processing; may be developed by the user in E-6 kits*
APPLICATIONS: *indoors and outdoors, day or night; indoor and outdoor sports; fireworks; theater; city lights at night*

Ektachrome 160 ET and Ektachrome 160 Professional EPT are medium speed, fine-grain color reversal films balanced for exposure under 3200K. The Ektachrome 160s, like other artificial light films, are balanced for tungsten illumination specifically, but may be used under ordinary household lights with slightly warm results. A cooling filter such as a Wratten 82B can be used with 100-Watt bulbs for correct color balance, but for general, non-critical photography, no filter is really needed because the 300K warming shift incurred without a filter only turns the warm neutral color balance of the Ektachrome 160s into a warm color balance.

The warm neutral color balance of ET and EPT are particularly good for skin tones and produce a healthy look. Warm colors are rendered bright while blues appear a bit dull. Color saturation is moderate with stronger warm colors than cool colors.

The Ektachrome 160s have fine grain, moderate sharpness, and medium resolving power. Magnification capabilities of ET and EPT are moderate. By today's standards, the features of the 160s seem to be somewhat under par. Even so, for almost a decade these films were the speed champs of tungsten type available light emulsions—until the introduction of 3M 640 T. Ektachrome 160 ET and EPT remain the only medium-speed tungsten films available, and are excellent available light films.

ET and EPT have reciprocity characteristics akin to those of the Ektachrome 200 daylight films. The 160s are designed for exposures from $\frac{1}{1000}$ to $\frac{1}{10}$ sec. At 1 sec. a color compensation filter of CC10 Red plus a $\frac{1}{2}$ stop increase in exposure are needed, while a CC15 Red and one stop exposure increase is required for a 10 sec. exposure. However, for B and T exposures (used when photographing several bursts of fireworks on a single frame), no filtration and no exposure correction are needed as the light sources recorded are of short duration.

INDOOR USE

PROCESSING The Ektachrome 160s are E-6 films that push-process very well to ISO 320/26° with only a slight increase in grain and slight loss in sharpness and saturation. When requesting push-processing by mail, include an ESP-1 envelope to pay for this additional Kodak service. When push processing in a home darkroom, the first developer time should be increased according to instructions included with the E-6 processing kit. Available kits include the Unicolor Rapid E-6 or Kodak Hobby-Pac Color Slide Processing kit.

APPLICATIONS Ektachrome 160 ET and EPT are useful for a wide variety of subjects photographed under tungsten lighting ranging from available light portraiture and portraits by tungsten studio lights, to commercial and industrial applications. They are also general purpose available light films for shooting many types of night scenes and indoor situations. With a CC30 Red or an FLD fluorescent filter, the 160s also make excellent available light films for use in fluorescent lighting. The following table lists common situations and recommended exposures:

Exposure Recommendations

in homes at night–bright light	1/30 sec. at f/2
in homes at night–average light	1/30 sec. at f/1.4
brightly lit downtown streets	1/30 sec. at f/2.8
brightly lit theatre districts	1/30 sec. at f/4
fairs, amusement parks, floodlit circuses	1/30 sec. at f/2.8
sports illuminated by tungsten	1/60 sec. at f/2.8
basketball, hockey and bowling	1/60 sec. at f/2
stage shows–bright light	1/60 sec. at f/4
stage shows–average light	1/30 sec. at f/2.8
floodlit ice shows	1/60 sec. at f/2.8
school auditoriums, church interiors	1/15 sec. at f/2
boxing and wrestling	1/125 sec. at f/2
neon and other illuminated signs	1/60 sec. at f/4
store windows at night	1/30 sec. at f/4
floodlit buildings, fountains, monuments	1/2 sec. at f/4
distant view of city skyline at night	1 sec. at f/2
indoor or outdoor Christmas lighting	1 sec. at f/5.6
candlelit close range portraits	1/8 sec. at f/2
aerial fireworks displays	B or T at f/11

Meters are notoriously inaccurate under such lighting conditions as those above, where lighting sources are often small or distant and scenes tend to be surrounded by large, dark areas. When using slow shutter speeds, always use a firm camera support for sharp pictures.

Ektachrome 160 ET and EPT are also very good films to use when using creative filters indoors. Daylight films and electronic flash may be used, but it is much easier to use tungsten lights and a tungsten film because with the use of photolamps the exact effects being recorded on film are visible to the photographer.

Ektachrome P 800/1600

MANUFACTURER: *Eastman Kodak*
TYPE: *very high-speed professional color reversal film (transparency)*
SIZES: *35mm cartridges*
FILM SPEED: *EI 800/30° to 3200/36°*
COLOR BALANCE: *daylight 5500K*
NOTES: *process E-6P only, special push processing in E-6 type chemistry*
APPLICATIONS: *excellent in very low to poor lighting situations; sports and wildlife photography*

Kodak Ektachrome P 800/1600 is an ultra high-speed professional film designed as a push process film rather than a standard process film. Since we know that Ektachrome 400 can be pushed to EIs of 800 and 1600, and even 3200 in an emergency, why do we need P 800/1600? The answer is simple. Ektachrome 400 is optimized for standard E-6 processing at a standard exposure index (EI) of 400/27°; thus when you process 400 at higher indexes, you are compromising the optimum quality of the emulsion. Ektachrome P 800/1600 is optimized to be push processed at EIs of 800/30° and 1600/33°; it is not designed to be exposed at 400/27° and undergoes a color shift and loss of quality when processed at standard E-6 times.

One of the most noticeable differences you will see between pushed Ektachrome 400 and the normal push processing of P 800/1600 will be in the black areas of the image (maximum density areas): when pushed, regular 400 has thin blacks and shadow areas that look smokey while P 800/1600 produces solid blacks and shadow areas.

Why are such high exposure indexes needed in a color reversal film? Ask the professionals who used P 800/1600 at the Winter Olympics at Sarajevo, Yugoslavia. They had to record high speed action with long lenses, and often under low light conditions. Ask those who used it at the Summer Olympics in Los Angeles where they used long lenses with maximum apertures of $f/8$ and $f/11$; ask them when evening approaches or when the clouds roll in. Ask the photojournalists who have to shoot whether the sun is out or heavy rain clouds leave them with available murk; ask those that have to shoot in the dark canyons of big cities. Ask the sports photographer who has to shoot in rain and snow and night games under daylight quality artificial light. Ask those who can shoot available light portraits by low window light even when the subject is 15–20 feet from the window.

P 800/1600 appears to have better grain structure, higher color saturation and higher color purity at an EI of 800 than Ektachrome 400 has at EI 400. While P 800/1600 exhibits a larger grain than a medium-speed film, it is

smooth and even, and intrudes very little into viewing the image. That is an excellent performance for a *very high speed* color reversal film.

At EI 1600 there is a slight grain increase, but this makes sense because P 800/1600 is designed for push processing and therefore does not pick up the large increase that we expect when we push a normal E-6 film. At EI 1600 there is a moderate increase in the contrast.

P 800/1600 has a neutral color balance at EI 800 that warms up a bit at EI 1600. This warming could be natural, or could be due to the special processing. Flesh tones are quite good and reds and greens are very good as are pastels under most light levels. Dark blues have a tendency to go black under low light levels, which is natural for a contrasty film.

P 800/1600 is a top class very high speed color reversal film. It goes without saying that its film speed will make life a lot easier for many photographers, especially since they will not be sacrificing image quality or color saturation.

P 800/1600 is a low light level film and an available light film. When exposed without a filter under standard household tungsten lights, it produces warm but acceptable results.

P 800/1600 has a very tight exposure latitude, which is broader under low contrast lighting than it is under normal or high-contrast lighting. Because P 800/1600 is a contrasty film with little exposure latitude, accurate exposure is important. If you are going to err at all, err on the overexposure side where the colors will remain bright and saturated; on the underexposure side, colors go quickly dark and dull and the contrast increases dramatically. If you want high contrast, use a higher exposure index or use high contrast lighting instead of underexposing P 800/1600.

At 3200/36°, P 800/1600 thins out producing thin, smokey blacks and shadow areas.

The grain pattern builds up a bit and color saturation thins out. Yet the results are still very good, especially for such a high exposure index. At an EI of 3200/36° you will be able to capture images that were never before possible.

PROCESSING Ektachrome P 800/1600 has four boxes on the film cassette, each marked with a separate film speed: 400/E-6, 800/P1, 1600/P2, 3200/P3. The photographer marks the box of the film speed used for that roll of film so that there will be no processing mistakes when it arrives at the lab. Kodak labs will only offer 400, 800 and 1600 processing, but professional labs and users who process the film themselves can push P 800/1600 to an EI of 3200/36°.

As we go to press there are no firm processing times available from Kodak. However by the time you read this, Kodak labs will be set up for E-6 P processing and information will be available for processing P 800/1600 in small E-6 kits such as the Kodak Hobby-Pac for processing color slides. Also available will be the Kodak Push Process Setup Strip for Process E-6 which you will use to determine exact processing times for processing P 800/1600.

APPLICATIONS Ektachrome P 800/1600 has scientific, technical, and industrial applications when the situation calls for very high film speeds in order to use high shutter speeds and/or small apertures. It will also be used wherever the light levels are low and extra illumination cannot be added. It will probably also find uses in the fashion and portrait fields as a tool of artistic expression. The amateur will find many uses for P 800/1600 too for it will give him the ability to use his slow speed zoom and telephoto lenses at low light levels. At an EI of 1600 it makes a good tungsten light film: using an 80A conversion filter, you still have an EI of 400.

3M Color Slide 1000— Daylight Film

MANUFACTURER: *3M*
TYPE: *very high-speed color reversal film (transparency)*
SIZES: *35mm cartridges, 120 rolls*
FILM SPEED: *ISO 1000/31°*
COLOR BALANCE: *daylight 5500K*
NOTES: *mailers from 3M sold separately; process E-6*
APPLICATIONS: *sports and action; photojournalism; very low light situations; commercial and scientific photography; acceptable results unfiltered in tungsten light; astrophotography*

Color Slide 1000–Daylight Film is ten times faster than the most commonly used films and three times faster than most other high speed films. A very high speed film 1000-D was developed by the 3M Company primarily for the professional market, although it is also used by amateurs.

A grainy film when compared to standard speed films, 1000-D is an available-light daylight film designed to be used in difficult and challenging situations; standard speed films are generally considered to be fair weather films.

Actually, 1000-D is not all that grainy for an extremely high-speed film. Its speed-to-grain ratio is very good thanks to 3M's use of tabular grain, a flat, tablet-shaped granule. When a number of tabular grains are deliberately placed together, they produce increased film sensitivity because their largest surfaces always face the light. The manufacturer has wisely used just enough tabular grain to produce a high film speed and medium graininess, but not so much that the film would be coarse-grained.

In direct sunlight 1000-D exhibits a warm color balance. But under the available natural light conditions for which it is most often used, 1000-D has a neutral color balance. Therefore no warming filters are needed when shooting in deep shade, on overcast days or in the rain. Even shooting sports with long telephoto lenses under such conditions requires no filtration because 1000-D gives neutral color rendition.

Using 3M 1000-D unfiltered in available tungsten light produces surprising pictures. The results are very warm but avoid the orange or yellow color cast many daylight films often produce without filtration. The manufacturer recommends the use of an 80A color conversion filter in tungsten light, which reduces the exposure index of 1000-D to EI 250/25°.

This is a film with good color saturation, good edge sharpness, and medium resolving power. While used in commercial and scientific photography when very high shutter speeds are needed, this film is not ordinarily used for finely detailed work. With 1000-D

think more in terms of overall shapes and colors rather than small detail. The good edge sharpness of 1000-D will give good separation between tones and good distinction between moderate-sized objects.

It is, however, interesting to note that 1000-D is used in astrophotography to record distant stars, constellations, and galaxies. It has been reported that 1000-D can record an image in ten minutes that would take an ISO 400/27° film an hour to record. This film is only 2¼ times faster than an ISO 400/27° film under normal exposure conditions, but it seems that it is 6 times faster when used for astrophotography. The grain is reported not to interfere very much in recording fine details of stellar subjects. This film is used for commercial and scientific photography, photojournalism, sports photography and wherever very high speed is needed to capture an image under daylight type lighting conditions. In fact, 1000-D is the champion existing natural light color slide film.

This film may be pushed one or two stops to EIs of 2000 and 4000 with a slight increase in grain and a corresponding lowering of color saturation. Push-processing is best thought of as an emergency measure, to be used only when extra film speed is the only way to get needed pictures. However, with films such as 1000-D or 640-T, push-processing may be used for creative effects. Increased grain size, lower color saturation and lower resolving power can emphasize either harshness or softness, depending upon lighting and subject matter.

Because of its very high speed, 1000-D is particularly susceptible to X-rays, chemical fumes, heat and humidity. It is advisable to store unexposed 1000-D in its original container in a refrigerator or freezer if the film is going to be kept for any length of time. The 1000-D is many times more sensitive to X-rays than high speed ISO 400/27° films. Even airport X-ray machines that are deemed "safe" for photographic films are not without risk for very high speed films such as 3M 1000-D. One pass through such a machine will have no visible effect on an ISO 400/27° film, but will compromise 1000-D. When travelling with this film, request hand inspection or use double strength Film Shield bags designed to protect very high speed films from X-rays.

PROCESSING Color Slide 1000-Daylight is sold without processing, but 3M processing mailers may be purchased from any photo dealer. Under private labels, 1000-D may be sold with or without processing. It may be returned to any dealer for processing, sent to any lab using E-6, or processed by the user in any E-6 type chemistry such as Unicolor Rapid E-6 or Kodak E-6 kits.

APPLICATIONS The obvious uses are in adverse daylight conditions, with long telephoto or zoom lenses, wherever high shutter speeds and/or great depth of field are needed, and for extended range flash work. But how about using its grain structure as an element of a composition? Think of using its grain as an artful touch in documentary photography. Think of soft, dreamy fashion or nude photography portraying shape and color rather than emphasizing detail. This film not only fulfills a practical need for a very high speed color reversal film for available daylight situations, but it also fills a creative and imaginative need.

3M Color Slide 640T

MANUFACTURER: *3M*
TYPE: *very high-speed color reversal film (transparency)*
SIZES: *35mm cartridges*
FILM SPEED: *ISO 640/29°*
COLOR BALANCE: *tungsten type B artificial light 3200K*
NOTES: *mailers from 3M sold separately; may be developed by the user in E-6 process*
APPLICATIONS: *sports; photojournalism; local and family events; low tungsten light levels; for publication and projection*

Color Slide 640T is a unique film, for it is two stops faster than Ektachrome 160, the next fastest tungsten balanced slide film, and is the only very high speed tungsten reversal film available. 640T was introduced a few years ago as 3M's first film designed specifically for the professional photographer. It is, indeed, widely used by professional photographers for shooting color under tungsten illumination at hand-holdable shutter speeds without flash.

One good example of this film's professional use is local newspaper sports and news photography. As publications moved toward increased use of color photos, the need arose for a high speed tungsten color slide film for shooting night sports and nighttime news events where flash could not be used. Sports arenas and stadiums in major cities may have daylight quality lights, but the vast majority still have old-fashioned tungsten illumination. Local sports, circuses, ice shows, fires, conventions, theatre, or whatever is now done in color with ease by newspaper photographers using 640T.

Even hand-held color pictures photographed by the light of a 100-Watt lightbulb are possible with 3M Color Slide 640T.

This film is not impressive when viewed through an 8 × loupe because of its very high speed nature. However, 640T projects and prints extremely well. In fact, 640T produces excellent enlargements (for a very high speed film) because its medium-fine grain is regular and very sharp. For instance, a 24 × 36-inch print will show rather obvious grain, but on the other hand, much of the detail will be defined as well because of the sharp, regular grain.

Color Slide 640T was the first film to employ tabular grain as part of its emulsion design. This allowed its very high speed along with a relatively fine-grain structure. Tabular grain is a flattened, roughly rectangular grain whose largest surface always faces the image for increased light sensitivity. Fortunately, 3M has not overused tabular grain for overuse could result in an increase in grain.

In general, 3M 640T may be push-pro-

cessed one or two stops to exposure indexes (EIs) of 1250/32° and 2500/35°, respectively. There will be some increase in grain and some color saturation loss, but when it comes to getting a picture or none at all, push-processed 640T is very acceptable. The color saturation loss is not drastic because 640T has a surprisingly high color saturation level for such a high speed film.

Because 3M 640T is designed for hand-held shooting, its reciprocity characteristics are not like most other artificial light films. Its color rendition remains balanced for exposures between 1/1000 and 1/10 sec. For an exposure of 1 sec., open the aperture 1/2 stop, and at 10 sec., open up one full stop; no filter correction is needed.

Though 640T is a stable film, it is nonetheless wise to store it in a refrigerator or freezer to keep it at peak performance. Because 640T

is a very high speed film, it is more sensitive to heat, humidity and chemical fumes than are slower films. It is also more sensitive to x-rays than most films, so it should be hand-inspected or stored in heavy duty Film Shield bags at airports or wherever x-ray equipment is used to check baggage.

PROCESSING While 3M Color Slide 640T is sold without processing, mailers can be purchased from any photo dealer. Under private labels, 640T may be sold with or without processing. It can also be processed by any lab using standard E-6 chemistry, or by the user in any E-6 type chemistry, such as Unicolor Rapid E-6 or Kodak E-6 kits.

APPLICATIONS The following table gives an idea of 3M 640T's importance as an available light film for hand-held shooting.

Representative Hand-Held Exposures

home interiors with average light	1/30 sec. f/2.8
bright street at night	1/60 sec. f/4
night sport events	1/125 sec. f/4
circuses and stage shows	1/60 sec. f/4
fairs, museums	1/60 sec. f/2.8
portraits by candlelight	1/30 sec. f/2

Light intensities may vary, but these recommendations will generally hold up for most such situations. Under fluorescent lighting, 640T can be used with a CC 30 Red filter, which will produce good to excellent results and give an effective exposure index (EI) of 400/27°.

Color Slide 640T is a useful very high speed available (tungsten) light film. However, it can also be used for imaginative, creative imagery, especially when push-processed to emphasize its added grain and lower color saturation for soft dreamy effects, or even harsh, realist effects.

Kodak Photomicrography Color Film 2483

MANUFACTURER: *Eastman Kodak*
TYPE: *extremely fine-grain, very high resolving power, high-contrast color reversal film (transparency)*
SIZES: *35mm cartridges, and sheets*
FILM SPEED: *daylight: EI 12/12°; 16/13° with CC20 Green filter may be preferred*
COLOR BALANCE: *daylight 5500K*
NOTES: *sold without processing; processing can be done by Kodak or any lab with E-4 processing*
APPLICATIONS: *photomicrography; science, medicine, industry; special effects; with soft focus lenses and filters; slide duplicating*

Kodak Photomicrography Color Film 2483 (PCF) is a highly specialized scientific and medical film with some unique properties that are of interest to pictorialists and art photographers. PCF is an Ektachrome film designed for the E-4 process.

PCF is an extremely fine-grain film with very high resolving power, high definition, high contrast, high saturation and very slow speed. It is designed for applications in photomicrography, science, medicine, biology, and industry, and where high definition or high contrast color photographic records are desired. Its high contrast, color saturation, and resolving power are particularly well-suited for photographing the low contrast specimens typical of photomicrography.

PCF is sensitized for 5500K daylight, but it has an unusual color balance that produces a strong pink color cast in daylight. This is not as strange as it may seem, for PCF is a daylight film used to make exposures under tungsten halogen microscope lamps. Most daylight films use an 80A color conversion filter for exposure under 3200K while PCF uses color compensating filters. PCF uses CC70 Cyan and CC40 Yellow for exposure durations of $\frac{1}{125}$ to $\frac{1}{2}$ sec.; from 1 to 8 sec., add a CC10 Yellow filter and increase the exposure by $\frac{1}{2}$ stop.

Kodak Photomicrography Color Film 2483 is a very good example of a film that needed testing and exploration before its potential was fully appreciated. Many photographers did this and Kodak now has a note on the instruction sheet passing on their findings: an EI of 16/13° plus a CC20 Green filter is a good starting point for exposing PCF under daylight illumination. In fact, it needs no color correction under daylight conditions with a CC20G down to at least 12 sec.

There are other good things about PCF that do not appear on the instruction sheet. For example, PCF maintains its D-Max (max-

imum density) under long exposure times. While the shadow and black areas of most daylight films becomes thin under long exposures, PCF maintains a rich, solid black. Thus PCF is an excellent color reversal film to use when portraying such subjects as moving water photographed with a slow shutter speed. Another use for PCF is long time exposures at night or indoors under tungsten illumination. It may also be used without a filter for motion studies of light sources and for general night scenes with excellent results.

PCF is a specialty film manufactured to precise tolerances. It should be refrigerated, or even frozen to preserve its superb qualities and to guarantee excellent and predictable results.

PROCESSING Kodak Photomicrography Color Film 2483 is an E-4 process film. It has a soft emulsion that will flake and break up in the high temperature E-6 process, so it must be processed with the E-4 process. PCF is sold without processing, but can be processed by Kodak labs via Kodak mailers or through your photo dealer.

APPLICATIONS PCF is not an ordinary daylight film, and it does not react like other daylight films. You may well like its color interpretation under streetlights and city lights at night without a filter. Try twilight photography without a filter. Use PCF without filtration under fluorescent lights. While the results may not be exact color reproductions of the originals, they certainly will be intriguing and often pleasing. The key to using PCF is to test and experiment with various subjects under various lighting conditions, with and without filters.

PCF's color saturation is very high, with especially strong reds and blues. It is probably the heavy blue saturation and blue reciprocity shift as exposure times lengthen that suppress yellow under tungsten lighting, leaving reds, oranges, and browns dominating the results. While it produces incredible reds and blues, PCF also renders delicate pastel colors very well, especially under low contrast lighting. It is also an excellent color film to use with soft focus lenses and filters because its high contrast and color saturation produce definition and good color within a soft image.

Ektachrome Infrared

MANUFACTURER: *Eastman Kodak*
TYPE: *false color reversal film (transparency)*
SIZES: *35mm cartridges*
FILM SPEED: *EI 200/24° for through-the-lens (TTL) meters; EI 100/21° for other meters with a Wratten No. 12 or Y52 filter, daylight green, red and infrared spectrums*
COLOR BALANCE: *daylight 5500K*
NOTES: *process in Kodak E-4, ME-4, EA-5 or equivalent only*
APPLICATIONS: *medicine, science, and industry; for special effects; slide duplication*

Kodak Ektachrome Infrared is a generally available "false color," i.e., modified color, film. Without a filter, Ektachrome Infrared produces a monochromatic, dull violet image. Ektachrome Infrared records its images in layers sensitive to green, red and infrared radiation instead of the usual blue, green and red. A filter must be used over the lens to block blue and ultraviolet (UV) rays, as all layers of this film are sensitive to blue and ultraviolet. The filter most commonly used with Ektachrome Infrared is a Wratten No. 12 or Y52; both are yellow filters that act as minus-blue and minus-ultraviolet. The following chart gives some idea of the colors to be obtained from subjects photographed with Ektachrome Infrared and a yellow filter:

How Infrared Film Alters Color

Natural Colors	Color as Rendered by Infrared Film with Yellow Filter	Natural Colors	Color as Rendered by Infrared Film with Yellow Filter
healthy green foliage	red	blue water	deep blue
diseased foliage	greenish to bluish	some blue flowers	yellow
badly stressed foliage	yellow	blue denim	magenta
evergreens	red-brown	red rose	yellow
conifers	dark purple	some red flowers	orange
some green pigments	purple	some yellow flowers	white
some green dyes	magenta	some black cloth	deep red
blue sky	blue	light flesh tones	greenish

The Wratten No. 12 or Y52 is always used for scientific and other critical applications where known color shifts are used for study and research.

With a Wratten 12, Y52 or equivalent yellow filter, rate Ektachrome Infrared at EI 100/21° for metering with hand-held meters or using the rule of "Sunny 16." If using a behind-the-lens meter (one built into the camera), set that meter to an EI of 200/24° no matter what filter is used over the lens. In either case, test the system thoroughly, as Ektachrome Infrared has a narrow exposure latitude. As amounts of infrared radiation are not proportional to levels of visible light, it is wise to bracket exposures.

Ektachrome Infrared may be exposed indoors or in the studio via electronic flash, photofloods or tungsten bulbs. Any light source should be placed at angles of 30°–60° from the axis of the lens to make available the infrared radiation contained in the light source. Maximum infrared effect is achieved in diffuse tent lighting used in medicine and science. When photographing people using tent lighting, veinous patterns of the subject will become prominent in the image.

Ektachrome Infrared is balanced for daylight (5500K) exposure. For use in Type A tungsten (3400K) illumination, Kodak recommends a Wratten No. 12 plus a CC20 Cyan plus a Corning Glass Filter CS No. 3966 for critical applications. But for pictorial work, 3200K (type B) tungsten bulbs and any filters may be used. Tungsten bulbs are rich in infrared radiation and produce different strong false color effects. For example, a Wratten No. 12 or Y52 filter and Ektachrome Infrared produce greenish skin under daylight conditions, while in tungsten lighting the same combination produces a bright pale green skin.

Unlike black-and-white infrared films, Ektachrome Infrared needs no focusing adjustment because two of the film's three emulsion layers, red and green, are sensitive to the visible spectrum. The filters suggested for use with this film are visible light pass filters, so focusing should be done through the filter for Ektachrome Infrared when using an SLR.

The exposure latitude of Ektachrome Infrared is a bit narrower than for other color transparency films, as infrared radiation has a narrower exposure latitude than visible light and because the false color effect drops off very rapidly on either side of the correct exposure.

PROCESSING Ektachrome Infrared may be processed in E-4, ME-4, EA-5 or any equivalent color reversal process only. Unexposed film should be stored in a refrigerator, or in a freezer if storage is necessary for a long period of time.

APPLICATIONS Ektachrome Infrared is an important film used under strict controls in science, medicine, and industry.

Photographing forests from the air on Ektachrome Infrared helps scientists determine trouble spots in foliage by the obvious color shift from healthy red to an unhealthy green or blue. Ektachrome Infrared is used in a wide variety of fields: medicine, biology, forestry, mineral research, fire fighting, archeology, document and art fraud, law enforcement, pathology, photomicrography and photomacrography.

When using Ektachrome Infrared for pictorial purposes, you are not bound to use a yellow filter, but can use any colored filter except blue.

Ektachrome Infrared may be used in a slide duplicator such as the Alpamaster, Bowens Copytran or Chromapro to get pictorial IR results from standard color slides. The results will vary according to the type of film used, the quality of the light source used to duplicate, and the filters used. Exposures on ordinary film stock may later be converted into false color infrared images.

COLOR NEGATIVE FILMS

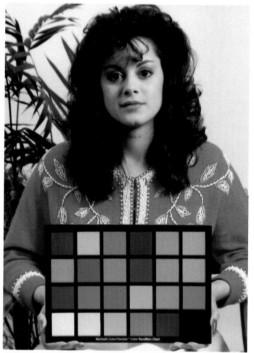

Agfacolor XR 100

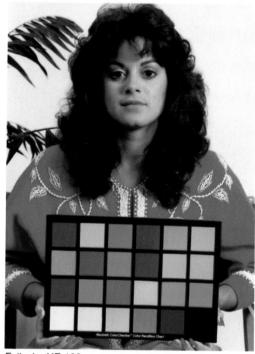

Fujicolor HR 100

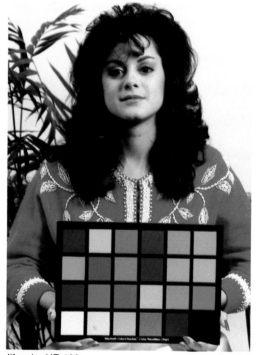

Ilfocolor HR 100

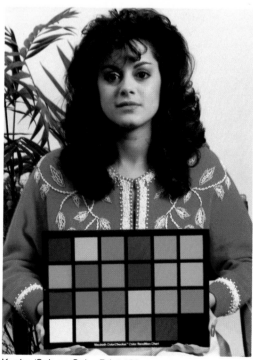

Konica/Sakura Color Print 100

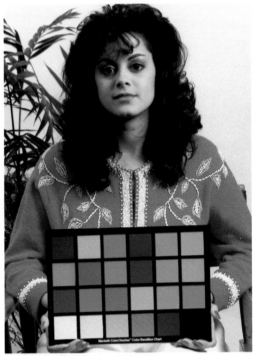

Kodacolor VR 100

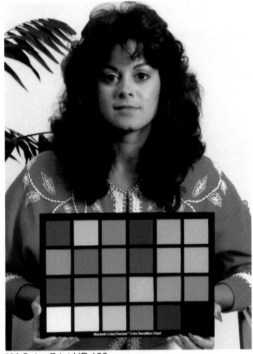

3M Color Print HR 100

Fujicolor HR 1600

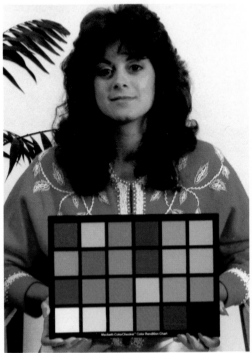

Kodacolor VR 1000

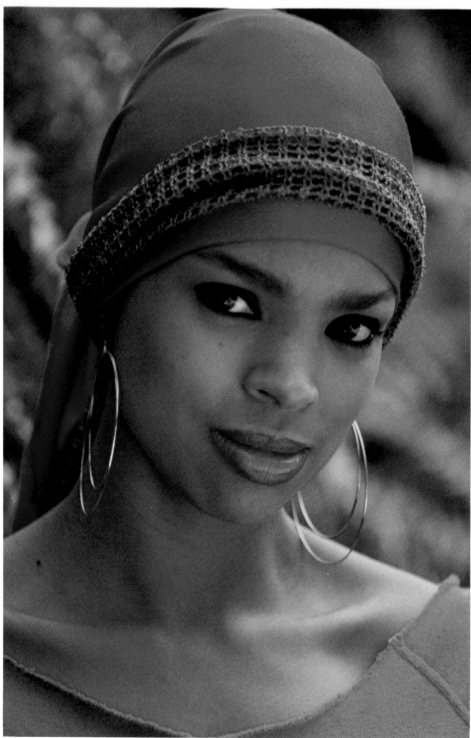

3M Color Print HR 400/courtesy 3M

Fujicolor HR 100/Dan O'Neill

Kodacolor VR 1000/courtesy Eastman Kodak

Fujicolor HR 100/Dan O'Neill

Introduction to
COLOR NEGATIVE FILMS

The amateur photographer, the snapshooter, the weekend and holiday photographer, and those who record family gatherings use color negative film more than any other type of film. The reasons are simple. Color negative film was at one time far easier to process and print than transparency film—this is no longer true, but color negative film is now firmly entrenched with the market. A second reason for wide amateur use is that color negative films have a wide exposure latitude that can produce decent prints even though the photographer makes many exposure errors; color transparency films require a high degree of exposure accuracy.

The majority of professional photographers use color transparency films in their work. However, there are two major exceptions to this, for the great majority of wedding and portrait photographers use color negative films in their work because they primarily produce prints for their customers.

Judging the differences among different color negative films is difficult because there are many variable factors involved in producing the final image, from the printer, to the color analizer set up, to the type of color paper used.

Whenever you test and compare two or more color negative films, make sure the lab you use prints each film with its proper color balance, for each film requires different color filtration settings to reach its proper color balance. This includes films of the same make, as an ISO 100/21° film requires different filtration than the same brand ISO 400/27° film.

Agfacolor XR 100,
XR 200, and XR 400

MANUFACTURER: *Agfa-Gevaert AG*
TYPE: *high resolution professional and amateur color negative films*
SIZES: *35mm, 110, and 126 cartridges; 120 roll film; and sheets*
FILM SPEEDS: *XR(S) 100: ISO 100/21°; XR(S) 200: ISO 200/24°; XR(S) 400: ISO 400/27°; XR(S) 1000: ISO 1000/31°*
COLOR BALANCE: *daylight 5500K*
NOTES: *process AP 70, C-41, Agfa Process F, Unicolor K-2, or similar process; XR denotes amateur and XRS, professional emulsions*
APPLICATIONS: *portraits; wedding and fashion photography; XR 400 and XR 1000 also excellent for low-light situations and action photography*

The Agfacolor XR and XRS color print films are available in both amateur and professional versions. The amateur version is available in 35mm, 110, and 126 sizes. The professional version is available in 35mm, roll film, and sheet film and is manufactured to tighter tolerances than the amateur version, supplying the color consistency from one emulsion batch to another that professionals need. Both versions have excellent shelf life due to a new hardening process whereby the film reaches its final state of hardness immediately after manufacture.

The Agfacolor XRs are the first color negative films that almost equal the sharpness produced by color transparency films. The XR 100 and XR 200 are so good that an 8 × 10 print made from a 35mm negtive will have excellent detail with razor-sharp edges.

The silver halide crystals that wind up in the emulsions of the XR films are of ideal size to produce an excellent light sensitivity-to-graininess ratio. The large surface area of the flat crystals hold large amounts of sensitizing dyes while the compact crystals produce especially good contour effects that create excellent sharpness.

The blue-, green-, and red-sensitive layers of the XR emulsions are divided into double layers. The top layer of each pair contains only highly sensitive large crystals and the lower layer the less-sensitive smaller ones. The top layer records the lower intensity areas of a picture, such as the shadow areas, while the brighter middle and light tones burn out the large crystals to be recorded by the smaller grains of the second layer. This keeps the graininess of the light and middle tones, the areas where graininess is most evident, to an absolute minimum.

Agfa employs new DIRs in their XR emulsions just as other film companies do to limit development action of exposed silver halides and to limit the developer action from spreading to unexposed crystals in the same and adjacent layers. Agfa has also designed a thinner, blue-sensitive, top layer, which greatly reduces light scatter through-

out the emulsion. Special new screening dyes included in the XR emulsions further inhibit light scatter by selectively absorbing light bouncing off crystals before it can reach other crystals.

Agfa also uses special filtration layers in the XR emulsions beyond the normal yellow filter layer, which enhances the already excellent color purity and color saturation produced by the new chemistry in XR and other high resolution films. The visible colors that films record are effected and changed by invisible radiations that we cannot see, especially ultraviolet (UV) radiation, which is above the blue spectrum and causes a serious deterioration of the film image. A UV blocking filter stops UV radiation from reaching any of the emulsion layers.

There is also a red filter placed over the red sensitive layers, which combines with new red sensitizers to produce pure, bright reds as well as subtle pastels, such as those found in flowers and fabrics. The red filter also helps to produce rich, pure greens and differentiate between their subtle shades.

The XR films have a neutral color balance and produce clean, neutral flesh tones, pure whites and rich blacks. Reds, greens and blues are rich, clean and natural and pastels are nicely subtle. Grays, particularly difficult tones to reproduce, are well reproduced by the XR films: they are clean grays with no tinges of blue or green in evidence.

To take full advantage of the sharpness that the Agfacolor XR films are capable of, you should practice good shooting habits. Make sure your lenses are clean and free of lint and fog. Use safe shutter speeds for hand-held shooting. A rule of thumb is to use only a shutter speed as fast, or faster, than the focal length of the lens: at least ¹⁄₆₀ sec. for a 50mm lens, ¹⁄₁₂₅ sec. for a 100mm lens, etc.

When you get into situations where you cannot use shutter speeds that equal the focal length of the lens and must hand-hold your camera, learn to hold your camera steady: keep your elbows in close to your body, breathe normally and squeeze, don't jerk, the shutter button with a smooth motion. Do not hold your breath before making an exposure because it tenses your muscles and causes camera shake. Breathe normally and squeeze the shutter release button as you reach the bottom of breathing out when your body is relaxed.

But you should also learn to use a tripod or other camera support whenever possible, especially when doing closeup work of subjects like flowers, and when using telephoto lenses. Compare hand-held shots to those taken with camera mounted on a tripod.

As we were going to press, Agfacolor XR/XRS 1000 was introduced. As with CT/RS 1000, this film is too new to review the new technologies that make this film work.

PROCESSING Agfacolor XR 100, XR 200, XR 400, and XR 1000 can be processed by using AP70, C-41, Agfa Process F, Unicolor K-2, or any equivalent process.

APPLICATIONS The Agfacolor XR films have moderate contrast and an excellent ability to hold detail in deep colors and shadow areas. They also have high color saturation and color purity when exposed under low-light levels as well as high-light levels. Thus all four films can be effectively used under low-level daylight conditions with excellent results. The XR films have excellent reciprocity characteristics with intended exposure times from ¹⁄₁₀₀₀ to ½ sec., giving you the ability to use slow shutter speeds and a tripod to capture naturally lit images at low-light levels. At 1 sec., exposure should be increase by ⅓ stop, and by 1½ stops at 10 secs.; no filtration is required. Any of the four XR films can be used under available light without filtration, but the special color balance and sensitivity of XR 400 and XR 1000 are particularly well-suited for unfiltered available light shooting.

Fujicolor HR 100,
HR 200, and HR 400

MANUFACTURER: *Fuji Photo Film Company*
TYPE: *high resolution color negative films*
SIZES: *35mm, 110, and 126 cartridges; 120 roll films; HR 200 also in disc*
FILM SPEED: *HR 100: ISO 100/21°; HR 200: ISO 200/24°; HR 400: ISO 400/27°*
COLOR BALANCE: *daylight 5500K*
NOTES: *process in CN-16, C-41 or equivalent*
APPLICATIONS: *portraits; wedding and fashion photography; HR 400 usable indoors and out, unfiltered in daylight as well as tungsten illumination*

The Fujicolor HR films are called amateur color negative films, but only the label is amateur, for these films are of professional calibre both in technology and in the prints they produce. In fact, "amateur" only means these films are manufactured with built-in aging so they do not need refrigeration, and that they are also available in disc, 110 and 126 formats. Like the Fujichromes, the Fujicolor films are improved color negative films, thanks to Fuji's newly developed HR (High Resolution) Emulsion Technique. This technique incorporates three technological advances: Double Structure Grain (DSG), L-Couplers, and Super Development Inhibitor Releasing (DIR) Couplers.

Double Structure Grain (DSG) is a new approach to the normal functions of silver halide grains: to trap photons, and to control and limit particle growth (and therefore, grain). The outer layer of the Fuji Double Structure Grain functions only to trap photons during exposure. The core of the DSG also has a single function, which is to control and limit grain during development. By separating these silver halide functions, Fuji has improved the efficiency of the silver halide and greatly increased the ratio of film sensitivity to grain in the image.

L-Couplers are newly designed latex-type color couplers, distributed in a polymer chain rather than in individual, scattered molecules. L-Couplers have a much greater density of dye forming parts than do scattered color couplers in a given emulsion space. The development of L-Couplers allowed Fuji to design thinner emulsion layers which serve to minimize light scatter throughout the entire emulsion, thus greatly improving sharpness.

Super DIR Couplers release "inhibitors" during development that diffuse throughout the emulsion, and function to "inhibit", or limit, development of unexposed grains in other layers of the film, thereby greatly increasing color purity and color saturation. Because these inhibitors limit silver halide development almost completely to exposed grains only, the DIRs have contributed to increased image sharpness.

The sum total of these improvements have produced three color negative films, labelled

Fujicolor HR 100, HR 200, and HR 400, that are among the best films available, whether called amateur or professional. Color purity is dramatically improved. Close inspection of a print made from a Fujicolor HR negative shows monochromatic dye clouds rather than the speckled, multicolored dye clouds visible in older types of emulsions. These monochromatic dye clouds contribute to increased color saturation, a certain richness of color in the prints and a feeling when viewed that the colors are *real*.

The Fujicolor HRs, along with the Agfacolor XRs, are among the sharpest color negative films available in their film speed classes. These films are easily capable of producing excellent 24 × 36-inch prints from a 35mm negative or an 8 × 10-inch print from the tiny disc negative. The three new technological advances combine to make Fujicolor prints sharp, detailed, and colorful.

HR 100 has the finest grain structure and highest resolving power of the three Fujicolor HR films. HR 200 is almost as fine-grained, and reproduces fine detail nearly as well as HR 100. In fact, it is only under close inspection that the difference between HR 100 and HR 200 becomes evident.

As a high speed film, HR 400 is not as fine-grained as HR 100 or HR 200, but it is still a fine-grained film. The slightly larger grains of HR 400 actually give it an appearance of great sharpness which is as good as real sharpness for all practical purposes. HR 400 may be enlarged as much as the slower films when the image is not dependent on fine detail. HR 400, like the other HR films, is balanced for daylight exposure and though Fuji recommends filtration for use with other types of light sources, HR 400 produces pleasant results when exposed under artificial illumination without filtration, making it an excellent indoor, as well as outdoor, available light film.

One advantage of the new Fujicolor HRs is that their results are so similar that they may be intermixed in a display of prints with no apparent color variation. It is a distinct advantage to be able to interchange two or three different speed films while shooting to cover almost all lighting and subject situations. In using HR 400, HR 200, and/or HR 100 as a complementary set of films, it is wise to spend a few rolls exploring their relationships and best applications. For instance, when the subject has fine detail and the light is low the photographer must choose between rendering fine detail on HR 100, or having more depth of field with HR 400.

The Fujicolor HR films are intended for exposures from $\frac{1}{1000}$ to $\frac{1}{10}$ sec. For longer exposure times, the HR films require an exposure increase to compensate for reciprocity. HR 100 and HR 200 require a ½ stop increase in exposure at 1 sec., a one stop increase at 10 sec. and an additional 2 stops at 100 sec. HR 400 requires a one stop increase at 1 sec., two stop increase at 10 sec., and a three stop increase at 100 sec. No color compensating filters are needed.

PROCESSING Fujicolor HR 100, HR 200, and HR 400 are processed in CN-16, C-41 or any equivalent chemistry.

APPLICATIONS The Fujicolor HRs have a warm neutral color balance and produce particularly rich skin tones. It is likely that Fuji has actually balanced these films for flesh tone reproduction because the skin tones are so good. This makes sense, because the vast majority of pictures taken with color negative films are of people. It also indicates that the Fujicolor HR films are good films for professional portraits, and for wedding and fashion photographers to use in pursuit of fine skin tones, excellent color saturation, color purity, and larger magnifications.

Ilfocolor HR 100,
HR 200, and HR 400

MANUFACTURER: *Ilford Ltd.*
TYPE: *high resolution color negative film*
SIZES: *35mm cartridges*
FILM SPEED: *HR 100: ISO 100/21°; HR 200: ISO 200/24°; HR 400: ISO 400/27°*
COLOR BALANCE: *daylight 5500K*
NOTES: *process in C-41 or similar process*
APPLICATIONS: *available light; sports events, theater, circuses; portraits, nudes and fashion; in mixed lighting situations; with flash for bounce lighting*

Ilfocolor HR 100, Hr 200, and HR 400 are Ilford's new high resolution color negative films. The Ilfocolor HR films use a new type of silver halide that is grown under a new crystalization process. By being able to control the growth of silver halide particles, Ilford is able to produce more uniform grain than ever before. The results are a finer grain structure and higher light-gathering sensitivity per any given area of film. More uniform grain also means a more uniform emulsion with less grain clumping, which could cause uneven results. Uniformity in the emulsion is further improved by newer methods of distributing the silver halides during manufacture of the emulsion.

The Ilfocolor HR films have all new chemistry to further enhance the abilities of the new silver halide crystals. DIR (Developer Inhibiting Release) couplers prevent silver halide crystals from growing too large during development. Other chemicals prevent developer action from spreading to unexposed crystals in the same or adjacent layers.

The emulsion is built of pairs of layers sensitized to each of the three primary colors, with the upper layer of each color pair containing larger, more sensitive crystals than the lower layer. Development interaction is restrained between the layers, for if oxidized developers were allowed to drift down into the slower layers, inappropriate dye clouds could build up, creating unsharpness.

PROCESSING Ilfocolor HR 100, 200, and 400 color print films are processed in C-41 chemistry.

APPLICATIONS Ilford is well known for black-and-white negative films, particularly HP5, a widely used high-speed film. With the new technology now being employed, the new ISO 400/27° high resolution Ilfocolor HR color negative films may become as well known as general purpose high speed color films. Ilfocolor HR 400 has many of the same capabilities as HP5 does in black-and-white. Ilfocolor HR 400 works very well in bright sunlight, deep shade, and under adverse lighting conditions such as heavy overcast and in the deep canyons of large cities.

HR 400 is also an excellent available light

film as it produces good color results in both tungsten and fluorescent lighting with some filter adjustments during printing. At ISO 400/27°, HR 400 allows hand-held exposures under low-intensity available light.

Not only does HR 400 give greater depth of field and greater shooting distance at the same aperture than slower speed films when using flash, but it also gives enough film speed to use bounce flash for producing soft, flattering lighting. Unless you have a very powerful flash such as the Agfatronic 643 CS, slower speed films do not have the capability of producing effective bounce flash pictures.

HR 400 does not have as fine grain or as high resolution as HR 200 or HR 100, but it does have the same high color saturation. While HR 400 does have a finer grain structure than older 400/27° color negative films, it still shows more grain than slower films. Do not avoid obvious grain, but rather, learn to use it. Grain often equals texture, giving flat and monocolored surfaces a feeling of life and reality. Thus HR 400 can add a good bit of life to many subjects, ranging from architecture to fashion, nudes to portraits.

Some photographers push-process black-and-white negative films and color transparency films to add texture to their images. Ilfocolor NR 400, like all color negative films, is essentially not "pushable" because little takes place with extended development. However, more grain may be added to HR 400 by under-exposing it to the point where the negative image becomes thin. The amount of under-exposure varies according to the quality and quantity of light, so is best to explore many possibilities by making test exposures under various lighting conditions and finding out what exposures are best for your purposes.

The following is an available light exposure guide for use with Ilfocolor HR 400. The guide is calculated for use without corrective filtration. Results will be on the warm side, but still pleasant and acceptable.

Available Light Exposure Guide for Ilfocolor HR 400

brightly lit streets	$1/60$ sec. at $f/2.8$
bright store windows	$1/60$ sec. at $f/4$
amusement parks and fairs	$1/30$ sec. at $f/2.8$
floodlit monuments and buildings	$1/15$ sec. at $f/2.8$
theatre, circuses, sports events	$1/25$ sec. at $f/2.8$
ice hockey and ice shows	$1/250$ sec. at $f/2.8$
theatre with bright colored lights	$1/60$ sec. at $f/2.8$
bright indoor fluorescent light	$1/30$ sec. at $f/2.8$
home interiors	$1/15$ sec. at $f/2$-$f/2.8$

Kodacolor VR 100,
VR 200, and VR 400

MANUFACTURER: *Eastman Kodak*
TYPE: *high color saturation color negative films*
SIZES: *35mm cartridges; VR 200 also in disc*
FILM SPEED: *VR 100: ISO 100/21°; VR 200: ISO 200/24°; VR 400: ISO 400/27°*
COLOR BALANCE: *daylight 5500K*
NOTES: *process in C-41*
APPLICATIONS: *VR 100 and VR 200 good for general purpose photography; VR 400 is excellent for low-light, sports, and action*

All three Kodacolor VR films have a high degree of color saturation and a very high degree of color purity. When inspecting an 8 × 10-inch print with an 8 × loupe made from another color negative film, such as Kodacolor II or Kodacolor 400, you will see that in these negatives tones are not solid, but are made up of a myriad of vari-colored dye clouds. The combination of different colored dye clouds plus a concentration of one or more dye cloud hues in any given area gives the impression of one color. As such a negative is enlarged, these dye clouds separate, causing color impurity and decreased image sharpness. However, when inspecting an 8 × 10-inch print made from a Kodacolor VR film with a loupe, you see essentially monochromatic dye clouds, which produce relatively pure colors that are maintained, even under a high degree of magnification.

Monochromatic dye clouds also contribute to the apparent edge sharpness of the Kodacolor VR images because the color purity produces a sharper differentiation between adjacent colors than did the old Kodacolor dye clouds. New couplers employed in the yellow layer of the emulsion are also responsible for the improved sharpness of these films, as these couplers make it possible for the yellow layer to be thinner. The thinner yellow layer diffuses less light, thereby increasing the sharpness in this and underlying layers of the emulsion.

The sharpness of the Kodacolor VR films is also due to the use of a new development inhibiting molecules of the DIR couplers, which help to compensate for light scattering and light diffusion effects within each emulsion layer. These new DIRs also contain chemicals incorporated into the fast magenta and fast cyan layers that help improve the film-speed-to-grain ratio, especially in underexposed areas such as shadows.

A third important improvement in the Kodacolor VR films is a new image coupler employed in the cyan layer, giving the VR-type films improved dark storage properties for processed negatives.

Kodacolor VR films produce rich, deep colors. Flesh tones in particular are excellent because the monochromatic dye clouds produce untainted skin tones. The VR films give

a good degree of color fidelity. Red is rendered as a true red and skin tones appear as they do in real life. Do not mistake the concept of color purity with block color, for the Kodacolor VR films are equally capable of capturing and reproducing subtle color changes.

The basic differences between the three Kodacolor VR films are in grain and resolution. The very fine grain of VR 100 produces exceptional resolving power, giving the film the ability to reproduce minute detail even when enlarged to very high magnifications. VR 200 is almost as good as VR 100 in its reproduction of fine detail and integrity at high magnification, yet gives an additional stop to achieve greater depth of field or to enable a photographer to use a higher shutter speed. Unless very fine detail needs to be reproduced at extreme magnifications, VR 100 and VR 200 are interchangeable for all general photographic situations.

There is a greater difference between VR 400 and VR 200 than there is between VR 100 and VR 200. VR 400 is only one stop faster than VR 200, but that one stop crosses over the threshold into the world of high speed film. VR 200 is a film to be used in good lighting situations while VR 400 is a low light film as well as a good choice for average lighting. VR 400 affords the option to hand-hold your camera at low light levels.

Kodacolor VR 400 has more apparent grain than the slower films, but it is relatively fine-grained for a high speed film. Because of the larger and sharper grain, VR 400 does not have the resolving power of the slower films, but it does have better edge sharpness. VR 400 has excellent enlarging power due to its color purity and high image sharpness but is not the best film choice for enlargements of finely detailed subjects. Scenics and portraits that do not depend on fine detail for impact enlarge well on VR 400.

Another important difference between VR 400 and the slower films is the fact that VR 400 is sensitized to yield acceptable results under available light sources without the use of conversion filters. VR 400 produces very good results without conversion filters for pictures that do not require critical color reproduction, and the professional photographer producing images for publication knows that the images can be color corrected when necessary during the printing process. However, for optimum in-camera results, Kodak does recommend the use of conversion filters with VR 400 when photographing under tungsten or fluorescent illumination.

The Kodacolor VR films, like most color negative films, are intended for exposures down to $\frac{1}{10}$ sec. At one second, the VR films need $\frac{1}{2}$ stop exposure increase, one stop increase at ten seconds, and a two stop increase at 100 seconds; no filter correction is recommended in natural light.

PROCESSING The VR films are processed in standard C-41 chemistry.

APPLICATIONS VR 400 is an excellent choice for available light shooting as well as when shooting action or sports. It is also the best choice whenever great depth of field is needed. VR 100 and VR 200 are general purpose films used for family snapshots, scenics, flowers, still life and holiday photography.

Kodak Vericolor III

MANUFACTURER: *Eastman Kodak Company*
TYPE: *very fine-grain color negative films*
SIZES: *35mm, 120, long rolls, and sheets*
FILM SPEED: *II 5 and III S: ISO 160/23° Commercial S: 100/21°; II L: 80/20°*
COLOR BALANCE: *III S and Commercial S—daylight 5500K; II L—tungsten 3200K*
NOTES: *Process C-41: best done at professional labs*
APPLICATIONS: *portraits, weddings; fashion, commercial, and advertising photography; architectural, commercial, and industrial photography*

The Kodak Vericolor films are professional films designed for portrait and wedding photographers. Because the Vericolor films are primarily used to portray people, they are not just warm neutral films, but are specifically balanced to produce warm, rich skin tones. Like all professional films, these color negative films are manufactured to precise tolerances of film speed and color balance and should be refrigerated or frozen until use to keep them at peak.

Vericolor III S is balanced for exposure in daylight and daylight-type electronic flash. It has an ISO rating of 160/23° which is medium range. Vericolor III S also has improved underexposure and shadow detail capabilities, so when a slight bit more depth of field or higher shutter speed would be helpful, slight underexposure may be safely employed. However, remember that the best prints always come from the best exposure for any given situation.

Most professionals use tripods or other camera supports with medium speed films like the Vericolors in order to get sharp pictures at slow shutter speeds. Wedding photographers use flash with Vericolor both indoors and outdoors to minimize camera shake and to fill in shadows.

Vericolor III S is faster than its predecessor, Vericolor II S, yet has much finer grain, better color saturation, greater color purity and is better suited to great enlargements. These improvements are of great benefit to portrait and wedding photographers because Vericolor III S allows larger and better color prints than ever before possible.

The new Vericolor III S has an improved speed-to-grain ratio. In the past, increased speed meant increased grain, but modern technology has developed ways to reduce granularity while improving film speed. Part of the secret is in new methods of manufacturing the silver halide grains themselves. But the most significant advance in Vericolor III S is in its chemistry. New couplers are used in the yellow layer, allowing this layer to be thinner. The thinner the emulsion layer, the less light can scatter and cause exposure of adjacent grains. Since the yellow layer is

the top layer of the emulsion and the first one light passes through its thinness also reduces light scatter in the magenta and cyan layers.

Vericolor III S also uses a new type of DIR, a Development Inhibiting Release coupler, which helps to limit the spread of development only to exposed grains. In earlier emulsions, one developing grain could spread its developing action to nearby grains in its own as well as adjacent layers, causing unsharpness and color contamination. The new DIR also contains chemicals that improve the recording capabilities of the magenta and cyan layers, giving Vericolor III S extra recording capability for dark colors and shadow areas.

Vericolor III S shows an amazing ability to capture detail in dark hair in a properly exposed negative. With Vericolor II, the earlier emulsion, a bit of overexposure was necessary when photographing detail in black and brunette hair. Vericolor III S has soft contrast which lends itself to recording dark details, further enhanced by the improved recording capabilities of the magenta and cyan layers.

When using Vericolor III S for the first time, take a model or friend and expose a roll under various lighting situations including direct sunlight, open and deep shade and with electronic flash. You will probably be pleased with the warm results in shade and the smooth, even contrast in direct sunlight and with electronic flash. Besides being used for portraiture, are Vericolor III S is also well-suited for illustrative, commercial, and fashion photography.

Sometimes there is a need for a negative with additional snap and sparkle (i.e., contrast). In such a case, use Vericolor II Commercial S, which has more contrast than III S. As its name implies, Commercial S is primarily for commercial and advertising photography, with uses ranging from food to glassware. However for some situations it is also well-suited to portraiture and fashion.

Vericolor II L has characteristics similar to Commercial III S except, unlike Commercial III S, it is intended for exposure under 3200K tungsten lamps and for exposure times from $\frac{1}{50}$ to 60 sec. Vericolor II L is useful when great depth of field is needed in the studio and when electronic flash is not powerful enough to allow this. These long exposure times also enable the use of small apertures. Vericolor II L is well-suited to architectural, industrial, and commercial photography, and when shooting outdoors at night or indoors by available light.

Vericolor III S and II Commercial S are intended for exposures between $\frac{1}{10,000}$ and $\frac{1}{10}$ sec. Exposure times of one second or longer are not recommended. Vericolor III S rarely needs filtration, even in open shade or with cool electronic flash. Commercial S, however, may need some warming with a Wratten 81 or 81A. Vericolor II L is not recommended for exposure times shorter than $\frac{1}{50}$ sec.

PROCESSING The Vericolor films are processed in standard C-41 or similar type chemistries. It is best to have Vericolor films printed by a lab familiar with the color balance of these films as they require a slightly different filter pack than do Kodacolor films.

APPLICATIONS Vericolor II Commercial S is ideal for commercial studio product photography ranging from food shots to glassware. Vericolor III S, a daylight film, is ideal for portraits, weddings, fashion photography and for use with electronic flash. Night photography and very long exposures are the forte of Vericolor II L.

Konica/Sakura Color Print Film SR 100,
SR 200, HR 200, and SR 400

MANUFACTURER: *Konishiroku Photo Company*
TYPE: *high resolution color negative films*
SIZES: *SR 100: 35mm cartridges, 110 and 126 cartridges; 120 rolls; SR 200: 35mm cartridges; HR 200: disc; SR 400: 35mm cartridges*
FILM SPEED: *SR 100: ISO 100/21°; SR 200 and HR 200: ISO 200/24°; SR 400: ISO 400/27°*
COLOR BALANCE: *daylight 5500K*
NOTES: *process in CNK-4A, C-41, or similar process*
APPLICATIONS: *general purpose; for bounce flash; SR 100 ideal for high magnification prints and reproduction of fine detail as well as large groups of people and closeups*

Konica Color Print Film and Sakura Color Print Film are the same. "Sakura" is the trade name used in Europe and "Konica" is the trade name used in North America. Fotomat is one of the private labels used on Konishiroku film, and as is the same film sold as Konica and Sakura, all the following comments apply to Fotomat brand film as well as other private labels that use Konishiroku film. Please note that private label film is not "second," but first-quality film.

The Konica/Sakura SR Color Print Films are high resolution films brought about by breakthroughs in color emulsion technology developed by Konishiroku. The SR films use a new form of silver halide crystallization Konishiroku calls Cubic Crystal. Under controlled growth, silver halide crystals are grown to uniformly sized cubes with corners shaved off, forming a 14-sided crystal. These multifaceted, uniform crystals produce higher light gathering efficiency with

smaller grains than could the random size particles in previous emulsions. These newer crystals are also more evenly distributed throughout the emulsion for smoother image reproductions.

Konishiroku has also developed new chemical technologies that it employs in its SR color print films. One of these is a Dye Compensator Layer which prevents undesirable dye cloud diffusion from layer to layer. Another innovation in chemistry is the Timing Precursor a type of DIR coupler which reduces developing action around each exposed silver halide crystal, thereby limiting grain growth and the size of dye clouds left behind when the silver is bleached out of the emulsion.

Also used in the SR and HR 200 films is a Compensating Precursor, a chemical that releases during storage to compensate loss in silver halide sensitivity. This chemical boosts silver halide sensitivity so initial sen-

99

sitivity is maintained over an extended period of time. This gives the SR films good shelf life even though it is not recommended that they be refrigerated.

To further preserve film stability and to provide more consistent image quality, Konishiroku built a Formalin Scavenger Layer into their SR films which protects the emulsion from dangerous gases such as industrial and automobile fumes, vapors from spray and solvent products, and formaldehyde often exuded by chemically treated new furniture. While care should be taken to protect all open rolls of film from such dangerous gases, the SR films should fare better if attacked by vapors and fumes because of the Formalin Scavenger layer.

PROCESSING Konica and Sakura Color Print Films SR 100, SR 200, HR 200 and SR 400 require process CNK-4A, C-41 or a similar process. Fotomat Color Print film is also developed in these chemistries.

APPLICATIONS SR 100 has the finest grain and highest resolution of the three SR color negative films. But new high resolution technology now used by Konishiroku and other film manufacturers has created an SR 200 an ISO 200/24° film that is better than older types of ISO 100/21° color negative films. Consequently, the new ISO 200/24° 35mm color print films could become more popular than older ISO 100/21° films. SR 200 is almost as fine-grained as SR 100, and its resolution is nearly as good. But SR 200 has one stop more film speed than SR 100, offering extra depth of field to achieve sharp focus of each person in a group, for example, or all the flowers in a bunch. SR 200 also gives an extra edge by making possible higher useable shutter speeds under low light levels than an ISO 100 film. In fact, the only circumstance in which SR 100 has a distinct advantage over SR 200 is in the reproduction of fine detail.

With the exception of reproducing fine detail for high magnification, SR 200 is probably a much better general purpose film than is SR 100. SR 200 gives an extra stop and will produce results under adverse conditions when SR 100 may not. SR 200 gives greater versatility than SR 100 when using flash, as it allows a one stop smaller aperture to use at the same flash setting for greater depth of field, and gives 40–50 percent more shooting range at the same aperture than the slower film. For instance, your auto distance with SR 100 and a Vivitar 5600 electronic flash is 42 feet at $f/2.8$. With SR 200 and an aperture of $f/2.8$, auto range is increased to 60 feet.

Just as any new film should be explored before using it for important pictures, SR 200 should be explored, particularly if you now use an ISO 100/21° color print film. Try it with all your favorite subjects under your usual shooting conditions with and without flash. Then push beyond a bit and experiment with it under low daylight conditions such as deep shade and overcast skies. Also use it indoors under available light, and with bounce flash. Enlarge some of your best pictures to 8 × 10 inches and study them. You may well find it is a great film and it might become your new general purpose film.

3M Color Print HR 100,
HR 200, and HR 400

MANUFACTURER: *3M*
TYPE: *high resolution color negative films*
SIZES: *35mm cartridges*
FILM SPEED: *HR 100: ISO 100/21°; HR 200: ISO 200/24°; HR 400: ISO 400/27°*
COLOR BALANCE: *daylight 5500K*
NOTES: *processing C-41*
APPLICATIONS: *general purpose for color prints; low light; artworks in museums; travel and vacation photography; nature and closeups*

The 3M HR 100, HR 200, and HR 400 are in 3M's words, "another milestone in the quest for more speed and less grain." Thus 3M has coded their three new color negative films "HR" which stands for High Resolution. Comparing the HR films to the preceding generation of color negative films, these new films exhibit great improvement in grain, resolution of detail, color purity, and color saturation.

The 3M Corporation has developed new techniques of silver halide crystal technology that allow the formulation of chemically pure composite crystal structures, consisting of progressive variations in the silver chloride, bromide and iodide composition of the crystals. Greater photosensitivity and light absorption efficiency have been achieved by using high sensitivity, of iodide-rich crystals with the transparency of silver bromide and silver chloride crystals. Controlled silver halide growth offers finer grain that is more sensitive to light than available in many older emulsions which characteristically employed larger crystals.

The finer grain structure and higher reso-lution are also attributable to 3M's new emulsion design, made up of thinner layers made possible thanks to smaller silver halide crystals, and to the use of advanced DIR (Development Inhibitor Release) couplers. The thinner the emulsion layers, the less light scatters throughout each emulsion layer and from layer to layer. Thus fewer adjacent silver halides are exposed, and diffusion, which could lower sharpness and resolution is minimized. The thinner emulsion layers of 3M's HR films help to make these sharp, high resolution color negative films.

Another potential problem resolved by 3M technology is deterioration of image sharpness and resolution due to developer action spreading from exposed silver halide crystals to inexposed adjacent ones. The DIRs 3M employs in these high resolution films limit developer activity almost entirely to exposed silver halides, creating sharper dye clouds, therefore producing high resolution.

The action of the DIR couplers also produces a very high degree of color purity because developer action does not cross over into adjacent layers, causing unexposed

GENERAL PURPOSE

grains in these layers to develop which would result in color distortion. It only takes a few dye clouds of the wrong color to change the intended color on a negative.

The 3M Color Print HR films also have improved exposure latitude beyond that of earlier 3M color print emulsions by enacting new techniques of chemical amplification of the optical signal using DIR couplers. The new chemicals literally magnify the intensity of the optically exposed halides during development to produce good color saturation of the image.

Color Print HR 100 has the finest grain and highest resolution of the three HR color negative films. HR 200 has grain structure and resolution fairly close to that of HR 100, and both are classified as medium speed, very fine-grain color negative films. HR 400 is a high speed, fine-grain color negative film with good sharpness and moderate resolving power. All three films produce very good detail in their respective speed classes. Color saturation for all three HR films is very high, with solid, clean colors.

PROCESSING All three Color Print HR films are developed in Process C-41. Exposed film may be processed by a local lab using this chemistry, or by sending it in a mailer to the manufacturer.

APPLICATIONS HR 100, HR 200 and HR 400 are fine general purpose color negative films designed for amateur as well as professional use. They exhibit good shadow detail and shadow saturation making them good films to use in bright, contrasty light. Because of the chemical amplification of the optical signal employed by 3M, the HR Color Print Films produce excellent detail and color saturation under low light levels. Thus all three 3M HR films are excellent films to use in low light situations that would be disturbed by electronic flash. Most museums now ban the use of flash because such bursts of light hasten the aging of irreplaceable works of art. So any of the three 3M color negative films is a good choice for photographing art objects without flash.

Because these films function well in low light levels, explore their low light capabilities in daylight and other available light conditions. Learn to use a tripod, monopod, or other camera support. Also learn to use any available object to steady you and your camera at slower shutter speeds when no camera support is available—a table, the back of a chair, a wall, a fence or a tree can help steady the camera when shutter speeds are too slow for sharp hand-held pictures. HR 400 performs best under available light because of its speed but keep in mind the extra fine grain resolution of HR 100 and HR 200. Explore these films' capabilities under tungsten and fluorescent lighting, as well.

The 3M HR films have good reciprocity characteristics, needing no correction for exposures from $\frac{1}{10,000}$ to $\frac{1}{2}$ sec. For exposures of one to four sec., increase exposure by $\frac{2}{3}$ stop, from eight to 15 sec. increase exposure by one stop and from 30 to 60 sec., increase exposure by two stops.

Fujicolor HR 1600

MANUFACTURER: *Fuji Photo Film Company*
TYPE: *ultra high-speed color negative film*
SIZES: *35mm cartridges*
FILM SPEED: *ISO 1600/33°*
COLOR BALANCE: *daylight 5500K*
NOTES: *standard process in Fujicolor CN-16, C-41, or similar color negative chemistry*
APPLICATIONS: *excellent for use in available light or low light situations; sports photography; wildlife photography*

Fujicolor HR 1600 is the fastest color negative film available at ISO 1600/33°. It is an ultra high-speed, general purpose color negative film that is unlike other films because of its great sensitivity to light. Like other color negative films, HR 1600 has a wide exposure latitude and can stand a certain amount of overexposure and underexposure. However, the overexposure and underexposure capabilities are best used to handle extremes in one scene rather than overexposing or underexposing a whole scene. This, of course, is true for any film and the best photographs come from properly exposed negatives. Exposures that vary from the best exposure index of a film can produce harsh, grainy, flat, or dull pictures.

Fujicolor HR 1600, and Kodacolor VR 1000, are films that you have to learn to use. The effort is worth it because HR 1600 can serve you well in difficult lighting situations as well as under good lighting conditions. You do not use HR 1600 in a camera that only has meter settings to ISO 400/27°; contrary to what anyone may tell you, HR 1600 cannot

improve your pictures in such a camera, for even in low light the camera sets the aperture and shutter speed as though you are using 400/27° film. The results will be overexposed by 2 stops, which lowers the quality of HR 1600 producing less than optimum results.

The same thing holds true when using flash, and especially an automatic electronic flash. You cannot expect the flash's sensor to reach out twice the distance that it is designed to do at ISO 400/27° to give you correct exposures for a 1600/33° film: the light from most flashes will reach out, but the sensor cannot function at those distances. You can, however, use HR 1600 and a electronic flash where the system uses through the lens (TTL) off the film (OTF) flash metering. Even though the flash may only list ISO settings to 400/27°, as long as the camera meter is set to 1600/33°, you will get correctly exposed pictures with HR 1600 and TTL-OTF. Other systems without automatic settings to 1600/33° must be used on manual and you have to calculate your exposures.

Speaking of flash, the ultra high-speed of

HIGH SPEED

HR 1600 makes the application of bounce flash an ideal way to get softly lit, attractive exposures even in large rooms with 10 to 12-foot high ceilings. If your subject is close enough and your automatic flash only goes up to 400/27°, you can try setting your lens 2 stops smaller than the flash calculator recommends and see if the flash sensor measures the light properly. If this does not work, a trial roll will tell you how to bounce your flash correctly with HR 1600.

Shooting outdoors in direct sunlight with HR 1600 not only requires a camera with metering at least to ISO 1600/33°, but also requires that camera to have high shutter speeds and small apertures. For instance, in direct sunlight you need an aperture of $f/22$ at $\frac{1}{1000}$ sec. or $f/16$ at $\frac{1}{2000}$ sec.; seashore, snow, and desert scenes need settings of $f/22$ at $\frac{1}{2000}$ sec. or $f/16$ at $\frac{1}{4000}$ sec. in direct sunlight. If you do not have such settings on your camera, you can use a neutral density filter over your camera lens to bring the light intensity down to the level of your camera's controls.

Of course you can use a slower speed film in such situations, but HR 1600 is a good film to use with such cameras as the Nikon F3 with a top shutter speed of $\frac{1}{2000}$ sec. or the Nikon FA, FM 2 or FE 2 with top shutter speeds of $\frac{1}{4000}$ sec.

HR 1600 employs an advanced version of the Fuji High Resolution Emulsion Technique introduced in their HR 100, HR 200, and HR 400 films. HR 1600 uses new, advanced DSG (Double Structure Grain) technology that has increased the light-gathering capabilities of the grains with a minimal increase in the grain size. The advanced DSGs also produce very good definition and sharpness for such a high-speed film. A blue reflection layer has been added below the high-speed blue sensitive layer, which helps to improve the recording capabilities of that layer, especially under low available light.

Finally, HR 1600 employs an entirely new coupler known as an A-coupler (image amplifier releasing coupler). This chemical is released to protect the latent image from oxidation during development. This is especially important for the shadow areas of the image, which develop more slowly than the brighter image areas.

The results of this Fuji technology is an ultra high-speed color negative film with fine grain, very good definition, very good sharpness, and excellent color saturation. Large prints, such as 11 × 14, and even 16 × 20 prints are well within the capabilities of Fujicolor HR 1600.

PROCESSING Fujicolor HR 1600 film employs standard processing in Fujicolor CN-16, C-41, or similar color chemistry.

APPLICATIONS Learning to use Fujicolor HR 1600 and other high speed films properly can be rewarding and often produce pictures for you that you would not be able to capture with slower speed films.

HR 1600 is the fastest color negative film available, and yet the pictures it produces are surprisingly rich in detail and color even under adverse lighting conditions. No special printing is needed for pictures shot under ordinary household tungsten illumination for the blue sensitive layers are designed to respond more strongly under the low light levels of tungsten illumination which is lacking in blue light. Shadow areas under tungsten lights are clean and open, showing good detail and color.

HR 1600 is particularly useful when photographing sports, birds, animals on the run, and other action pictures under high light levels.

Kodacolor VR 1000

MANUFACTURER: *Eastman Kodak*
TYPE: *very high-speed color negative film*
SIZES: *35mm cartridges*
FILM SPEED: *ISO 1000/31°*
COLOR BALANCE: *daylight 5500K*
NOTES: *process C-41 or similar process*
APPLICATIONS: *very high-speed, general purpose films, excellent for use with slow lenses and low-light or available light situations.*

Kodacolor VR 1000 is a very high-speed color negative film with an ISO of 1000/31°. This high-speed film index is achieved through the use of T-grain, a flat, tablet-like grain that faces its largest surface toward the incoming light. T-grains have always appeared naturally, though randomly, in emulsions. Until recently it was impossible to control T-grain crystals and employ them deliberately as the main light gathering force in an emulsion. Using T-grains in the emulsion of VR 1000 produces a film that is 1⅓ stops faster than a 400/27° film.

Kodak introduced VR 1000 and its specially designed T-grain emulsion in 1983. Along with the T-grain structure were new DIR (Developer Inhibitor Release) couplers, which limit the growth of grain so that it does not become objectionably large.

Kodak and other film manufacturers often improve their emulsions with little or no fanfare. But in the case of VR 1000, Kodak made some dramatic improvements only a year after it was introduced, and made these improvements public. The original VR 1000 had moderately coarse grain, medium low resolving power, and poor sharpness. Its performance under available light indoors left a lot to be desired for it produced weak, bluish shadows and heavy grain.

The improved version of VR 1000 has medium-fine grain, good resolving power for better rendering of detail, and good image sharpness. It produces nicely detailed 8 × 10 prints and can produce surprisingly good 16 × 20 prints as long as the images depend upon shape, form, color, or action for their impact. VR 1000 does produce reasonably good detail, but it is not a film to use when you want to reproduce very fine or delicate detail.

The new VR 1000 also has a greatly improved performance under available light conditions, which is achieved by changing the exposure curve of the blue sensitive layer to respond more strongly under blue-deficient tungsten light. The exposure latitude of VR 1000 has also increased, especially in the underexposure region. The new blue sensitivity coupled with better shadow sight pro-

duces more natural looking available light pictures with good density, detail, and color in the shadow areas.

Because of its high film speed and high sensitivity to light, VR 1000 must be loaded and unloaded in subdued light. When outdoors, shield the camera from the sun; when indoors, do not load or unload your camera right under a lamp. VR 1000 is also highly sensitive to heat, humidity, and noxious fumes. Under no circumstances should VR 1000 pass through an X-ray machine unless properly protected in lead bags.

PROCESSING Kodak VR 1000 can be processed using C-41 or any other similar commercial process.

APPLICATIONS VR 1000 is a very high-speed, general purpose film used in situations where slower speed general purpose films cannot do the job. It is a film to be used with slow-speed zoom and telephoto lenses where high shutter speeds must be used in order to get shake free pictures. It is excellent for use in cloudy and rainy weather, and in winter time when the light levels are often low. VR 1000 can be used in the deep forests and the deep canyons of city streets where light levels are often low, and is an excellent film for stopping action. One of its best uses is as a film for available light when flash or other supplementary lighting cannot be used or would disturb the subject or change the character of the subject. It is also a film to use when you need to extend the shooting range of flash, increasing your shooting distance over an ISO 400/27° film by 40 percent.

Forget about using your flash the next time you have a party or other gathering of clan or friends and expose a roll of VR 1000 by the available light. Use your camera's meter, being sure not to include a light source in your reading area which would give you a false reading. You can also use the following exposure guide for many low light and available light situations.

Exposure Guide for Available and Low-Light Photography

dull, rainy days	$1/500$ sec. at $f/5.6$
brightly lit theater and nightclub districts	$1/125$ sec. at $f/5.6$
night sports, indoor boxing, and wrestling	$1/125$ sec. at $f/5.6$
brightly lit streets at night	$1/125$ sec. at $f/4$
basketball, hockey, bowling	$1/125$ sec. at $f/4$
floodlit stage and circus	$1/125$ sec. at $f/4$
bright home interiors at night	$1/125$ sec. at $f/4$
average home interiors at night	$1/30$ sec. at $f/4$
school stages and auditoriums	$1/30$ sec. at $f/4$
candlelit closeups	$1/30$ sec. at $f/2.8$

BLACK-AND-WHITE FILMS

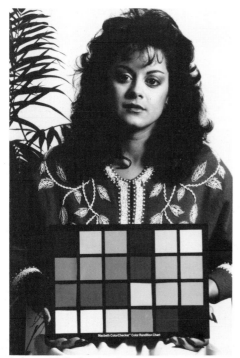

Agfapan 25 Professional

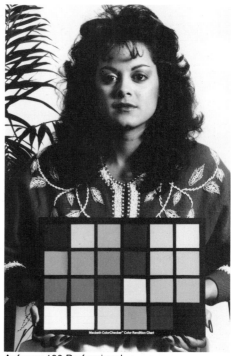

Agfapan 100 Professional

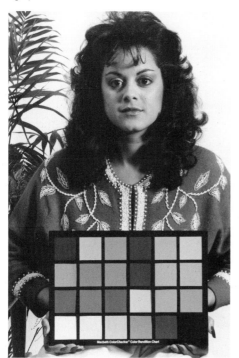

Agfapan 400 Professional

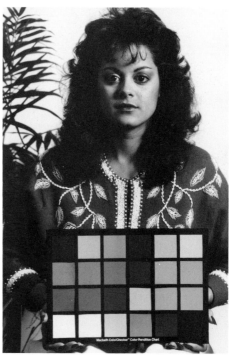

Ilford Pan F

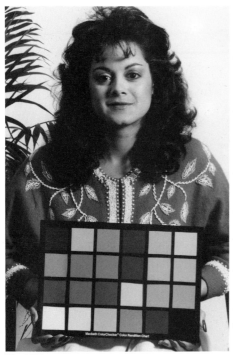

Ilford FP4

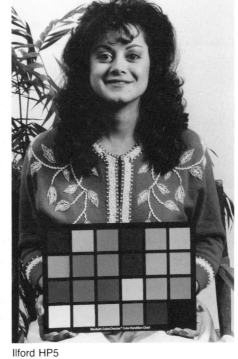

Ilford HP5

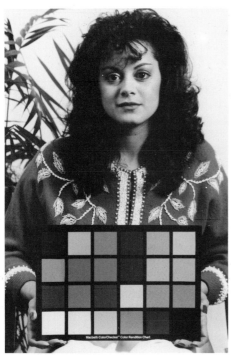

Kodak Panatomic-X

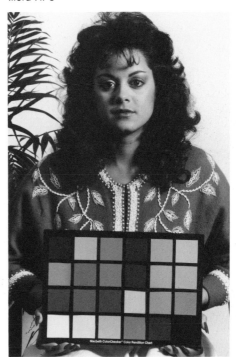

Kodak Plus-X

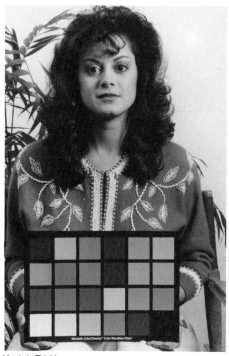

Kodak Tri-X

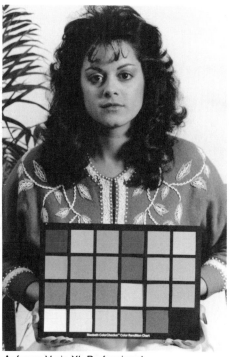

Agfapan Vario XL Professional

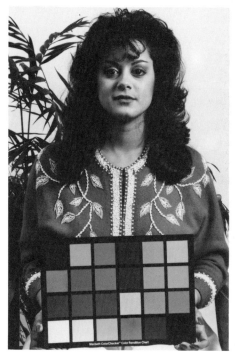

Ilford XP1

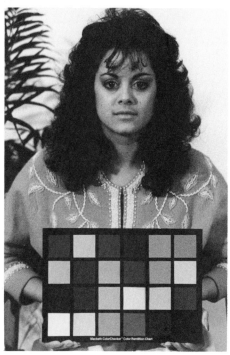

Kodak High Speed Recording Film 2475

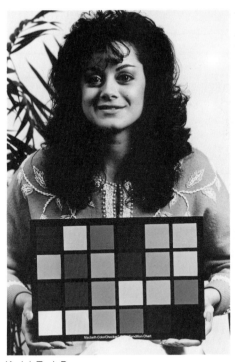

Kodak Tech Pan

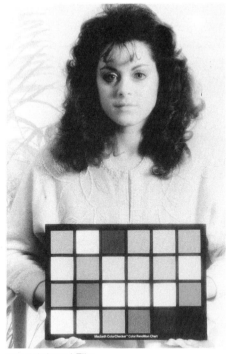

Kodak Infrared Film

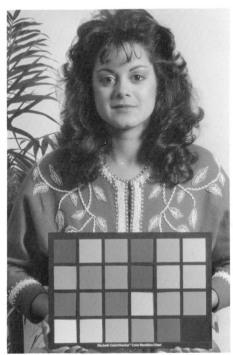

Agfa Dia-Direct

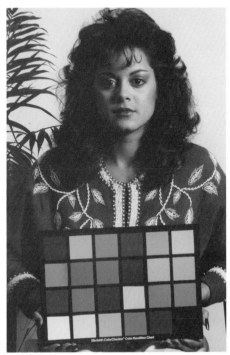

Kodak Direct Positive

Agfapan Vario-XL 120/courtesy Agfa-Gavaert

Ilford FP4/Dan O'Neill

Ilford HP5/courtesy Ilford Ltd.

Ilford FP4/ courtesy Ilford Ltd.

Ilford XP1/courtesy Ilford Ltd.

Kodak Plus-X/Dan O'Neill

Kodak Tri-X/Dan O'Neill

Kodak Tri-X/Dan O'Neill

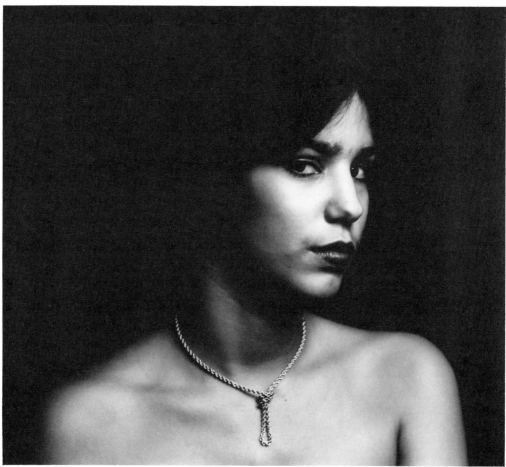

Kodak Tech Pan/Dan O'Neill

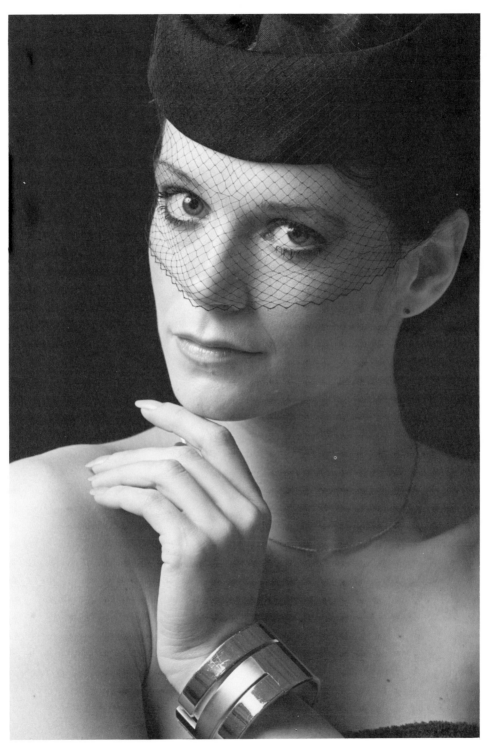

Kodak Tech Pan/courtesy Eastman Kodak

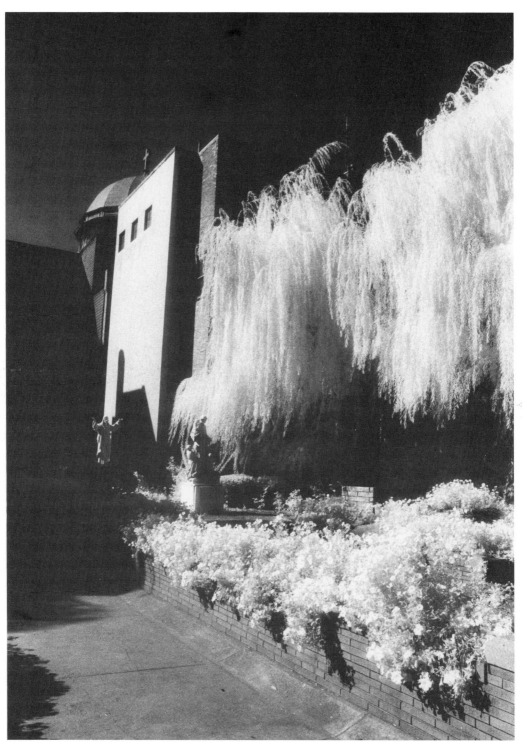

Kodak Infrared Film/Dan O'Neill

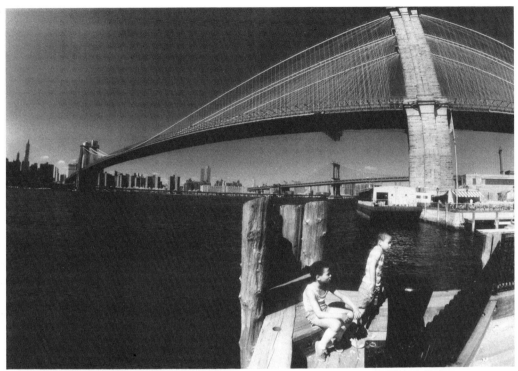

Kodak Infrared Film/Dan O'Neill

Kodak Infrared Film/Dan O'Neill

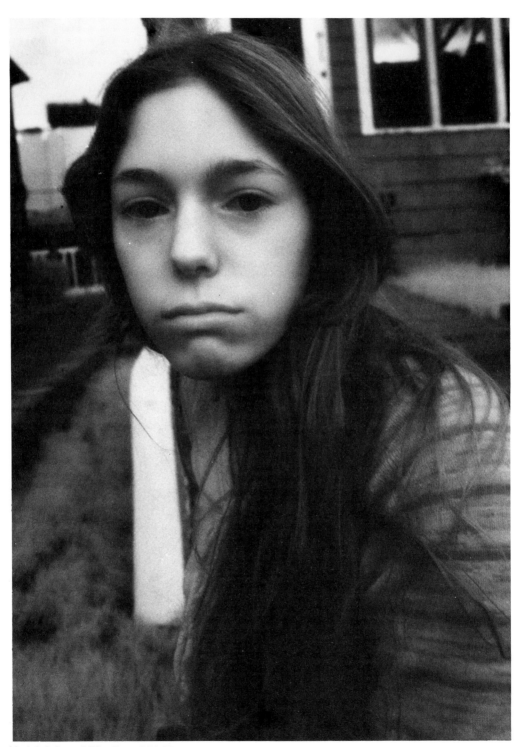

Kodak Infrared Film/Dan O'Neill

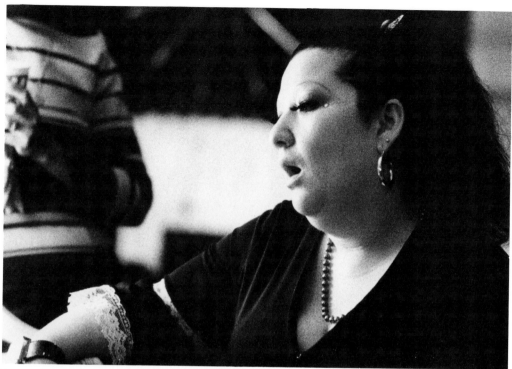

Kodak High Speed Recording Film/Dan O'Neill

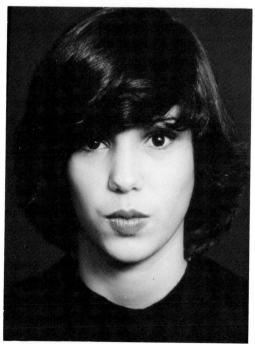

Kodak Direct Positive Film/Dan O'Neill

Introduction to
BLACK-AND-WHITE FILMS

Almost all black-and-white films are negative films that record their images in silver. Silver has a high degree of permanence as witnessed by the fact that many of the images taken in the beginning days of photography are still with us. In fact, important color images are preserved by converting them into three black-and-white separation images from which the color image can then be recreated at any time.

There are two black-and-white films, Agfapan Vario-XL and Ilford XP-1, that use color technology to form their images. Because they have more than one light sensitive layer, and because their final images are formed of translucent dyes, Vario-XL and XP-1 give you a wide range of exposure indexes on one roll of film.

Black-and-white films range from an ultra fine grain at an exposure index of 25/15° that can reproduce extremely fine detail to an ultra high-speed at an exposure index of 4000/37° for shooting under extremely low light conditions. There are numerous developers that can produce a wide range of effects on various black-and-white films, and in large measure, a film's description depends upon the developer it is processed in. A black-and-white film's characteristics also depends upon the enlarging paper it is printed on, for there are a variety of paper contrasts from very soft to very hard and contrasty: you can take one negative and make it look soft with a broad contrast on one grade of paper, and hard with narrow contrast on another grade of paper.

Creating images in black-and-white and shades of gray is a challenging task, but once learned, the photographs you make will be rewarding and satisfying.

Agfapan 25 Professional

MANUFACTURER: *Agfa-Gevaert AG*
TYPE: *ultrafine-grain black-and-white negative film*
SIZES: *35mm cartridges, 120 rolls, and sheets*
FILM SPEED: *ISO 20/15°*
SENSITIVITY: *panchromatic*
NOTES: *develop in Atomal, Rodinal or other standard black-and-white developer*
APPLICATIONS: *images for extreme enlargement; for exquisite rendition of texture; very slow general purpose film; nature and close-ups*

Agfapan 25 Professional, ISO 25/15°, is the slowest of all the slow speed general purpose films available. Afgapan 25 has an extra anti-halation undercoating to supress light from spreading in this thin base, ultrafine-grain film. Agfapan 25 Professional has extremely high resolving power, and produces outstanding definition even at very high magnifications.

Agfapan 25 Professional is considered a medium contrast film, as are most other panchromatic films, and like other slow films, Agfapan 25 Professional has more contrast than medium and high speed films. Thus the tonal scale reproduced by Agfapan 25 Professional is slightly compressed when compared to that of films such as Agfapan 100 Professional and Agfapan 400 Professional. This does not mean that one film is better or worse than another, just that each is different and must be explored to discover its best uses. Agfapan 25 Professional will at first appear very contrasty, but given some experimentation, it will prove its exceptional ability to record minute detail of most subjects.

PROCESSING Agfapan 25's contrast is easily controlled during development in Agfa Rodinal or Agfa Atomal. For normal or low contrast situations, use a dilution of 1:25 and increase developing time to increase contrast. To lower Agfapan 25 Professional's contrast, use a dilute Rodinal solution of 1:50.

Atomal is an active ultrafine-grain developer which produces more contrast than other fine-grain developers, though Atomal acts like a compensating developer and produces thinner, unblocked highlights which are easier to print.

APPLICATIONS Agfapan 25 is the film to use when photographing anything that is rich in fine detail. Agfapan 25 Professional, like all-fine grain films, is a perfect film to show textures. A leaf is all one color and photographed with a high speed film has a mottled effect; photographed with a slow speed film with the precision of Agfapan 25 Professional, you can almost feel the texture of the leaf with your eyes.

Agfapan 100 Professional

MANUFACTURER: *Agfa-Gevaert AG*
TYPE: *very fine-grain, medium-speed black-and-white negative film*
SIZES: *35mm cartridges, 120 rolls, and sheets*
FILM SPEED: *ISO 100/21°*
SENSITIVITY: *panchromatic*
NOTES: *develop in Atomal, Rodinal, or other standard black-and-white developer*
APPLICATIONS: *photojournalism; nature and travel; portraiture; industry*

Agfapan 100 Professional is a versatile medium-speed film with very fine grain, very high resolving power, and very high magnification capabilities. Agfapan 100 has such good definition and fine grain that in many cases it can be used in place of slower speed films to produce richly detailed high magnification prints. One of the advantages of Agfapan 100 Professional over slow speed films is that it is lower in contrast so it is more effective in high contrast situations where fine detail and high magnification prints are needed. Agfapan 100 is also moderately "pushable" if absolutely necessary, whereas slow films are not.

Agfapan 100 has a wide exposure latitude and good processing latitude, which helps to cover a lot of mistakes. Although overcoming mistakes is not its primary purpose, Agfapan 100 will do so if you over- or under-exposed by one or two stops. For a skillful photographer, the exposure and processing latitudes of Agfapan 100 may be used to get the maximum picture value from a wide variety of lighting and contrast situations. If there are important deep shadow values in a scene, the exposure value may be precisely chosen for the shadow detail and the exposed film will still be normally processed; the wide exposure latitude of Agfapan 100 will hold the bright exposure values and allow them to be printed with good separation. Using this same situation but this time with very high contrast, again expose for the shadows but process Agfapan 100 for a shorter time to keep the highlights from becoming too dense. Agfapan 100 also responds well to extended development for increasing contrast.

The ISO rating of Agfapan 100 is the same for all sources of lighting from daylight to tungsten to fluorescent. Most modern black-and-white films have the same light source consistency. Earlier black-and-white films lost a certain amount of efficiency and film speed under artificial lighting.

Agfapan 100 has two emulsion layers. The top layer, the one nearest to the incoming light, is slightly more sensitive to lower light levels than is the lower emulsion layer. The more sensitive top layer records shadow detail that single coated emulsions cannot.

PROCESSING Developed in Agfa Rodinal, Agfapan 100 is a very fine, sharp-grained film. Rodinal is a highly concentrated developer that uses different solution strengths for contrast control: a 1:25 dilution is used for both high and normal negative contrast by processing for different times, while a 1:50 dilution is used in cases of low negative contrast.

Agfa Atomal is the only ultrafine-grain developer that gives both the advantages of full film speed and ultrafine-grain. Atomal is not, strictly speaking, a compensating developer, yet it acts very much like one by producing excellent shadow detail and highlights that do not block up even when the film is overdeveloped or overagitated. Atomal gets the most out of Agfapan 100, producing a grain structure that rivals that of slow speed films and a broad spectrum of tones with beautiful, subtle gradations. Agfapan 100 developed in Atomal produces fine detail that is maintained even at great magnifications.

APPLICATIONS Agfapan 100 is a medium-speed, general-purpose film used wherever the lighting is good to moderate. Because its grain structure and resolution are almost as good as Agfapan 25, Agfapan 100 is often used for photographing finely detailed subjects where the light is too low to use the slower speed film. Agfapan 100 is an excellent film for portraiture and nature studies because of its ability to record fine detail in both the highlights and the shadows. Agfapan 100 is used by professionals to record architectural details and is thus a good film to take on holiday when you intend to take pictures of old buildings and other finely detailed subjects.

Agfapan 400 Professional

MANUFACTURER: *Agfa-Gevaert AG*
TYPE: *high-speed black-and-white negative film*
SIZES: *35mm cartridges, 120 rolls, and sheets*
FILM SPEED: *ISO 400/27°*
SENSITIVITY: *panchromatic*
NOTES: *develop in Atomal, Rodinal or other standard black-and-white developer*
APPLICATIONS: *general purpose, available light film; photojournalism; indoor photography; sports; movie stills; with flash; portraiture by window light; with long lenses*

Agfapan 400 Professional is a general purpose high speed film with fine grain, medium contrast that may be enlarged to a high degree. Agfapan 400 Professional is an unusual film in that its sheet film is an identical emulsion with the same film speed as the 35mm and 120 roll film versions. All sizes use the same developers and identical processing times so that switching from one format to another does not entail emulsion or processing differences.

Because the grain particles of Agfapan 400 Professional are only slightly larger than those of most medium or slow speed films, it has a good edge sharpness. This plus fine grain make Agfapan 400 a good film for extra large enlargements. High quality 16 × 20-inch prints are easily made from 35mm Agfapan 400 Professional negatives.

Agfapan 400 Professional is described as an "available light film" because its high film speed allows indoor photography under ordinary fluorescent and tungsten lighting as well as daylight conditions. Agfapan 400 Professional is commonly used by photojournalists because its high speed allows hand-held shooting both indoors and outdoors, under good to poor lighting conditions.

Agfapan 400 Professional is much more than just an available light film because it is a fine-grain film with very high resolving power, even at high magnifications. Thus Agfapan 400 is also a general purpose film to be used in place of a medium speed film the latter is too slow for the job.

Agfapan 400 Professional is an excellent film for hand-held available light work, but it also extends the capabilities of electronic flash. For example, with the Agfatronic Professional Flash 643CS at an ISO of 100/21° the flash will cover up to 75 feet; but the same unit will cover 151 feet at ISO 400/27°. Agfapan 400 Professional will also give greater depth of field than a slower film at the same aperture.

PROCESSING Agfapan 400 Professional may be processed in any standard black-and-white developer, but there are two Agfa developers which are notable: Rodinal and Atomal. Rodinal is a highly concentrated liquid developer, and probably the oldest developer still in use. With Agfapan 400 Professional it produces very sharp images though the grain structure is slightly larger than with other developers. However the prints Agfapan 400 produces when developed in Rodinal have a silvery quality that can be especially beautiful for such subjects as portraits and nature studies.

Atomal is the only ultrafine developer that reproduces the full film speed of fast films. Thus Agfapan 400 Professional retains its high speed (ISO 400/27°) when processed in Atomal, and its grain rating moves up from fine to very fine when processed in this developer. Atomal acts like a compensating developer, producing excellent shadow detail and sparkling, unblocked highlights even in over-exposed areas. Agfapan 400 and Atomal are an excellent combination for all types of photography under high contrast or normal lighting situations.

Agfa does not particularly recommend push-processing film, but Agfapan 400 actually push-processes very well up to an exposure index (EI) of 3200/36°. A one stop push works well in Atomal while in a developer like Ilford Microphen, Agfapan 400 can be pushed one, two or even three stops. There is an increase in grain and contrast, but push-processed Agfapan 400 Professional negatives make surprisingly fine enlargements.

APPLICATIONS Agfapan 400 Professional is used in all areas of photography, from architectural and commercial to industrial and publicity photography. It is also used in sheet and roll formats in the studio for it affords the use of smaller apertures for greater depth of field, eliminating the need for many view camera image corrections, very long exposures or multiple flash work.

Think of Agfapan 400 Professional as a film designed for hand-held shooting under almost any type of lighting. It is a film to be used for candid portraits taken by window light, and for studio portraiture where extra depth of field is desired.

Agfapan 400 Professional is used by movie still photographers because it allows them to use long lenses and offers film speed to allow hand-holdable shutter speeds and good depth of field. It is also used by sports photographers with long, slow telephoto lenses and for shooting indoor sports. In short, Agfapan 400 Professional is used wherever action-stopping high shutter speeds or great depth of field are needed. Agfapan 400 Professional offers high shutter speeds and great depth of field under good lighting conditions, and it enables shooting when lighting levels are too low for slower films to record an image.

Ilford Pan F

MANUFACTURER: *Ilford Ltd.*
TYPE: *ultrafine-grain, slow-speed black-and-white negative film*
SIZES: *35mm cartridges, 120 rolls*
FILM SPEED: *ISO 50/18°; varies with developer*
SENSITIVITY: *panchromatic*
NOTES: *develop in Perceptol, ID-11 Plus, Microphen or any other standard black-and-white developer*
APPLICATIONS: *reproduction of fine detail; closeups and nature; industrial and commercial uses; for extreme enlargement*

Ilford Pan F is an ultrafine-grain film with extremely high resolving power. It is recommended for daylight and artificial light photography where image sharpness and detail are more important than film speed.

PROCESSING Pan F has an exposure index (EI) of 50/18° when developed in Ilford ID-11 Plus or Kodak D-76. When developed in fine-grain developers such as Ilford Perceptol or Kodak Microdol-X, Pan F has an EI of 25/15° at full strength and 32/16° diluted; however when developed in Atomal, Agfa's fine-grain developer, Pan F retains its EI of 50/18°. In a high activity developer such as Ilford Microphen, Pan F has an EI of 64/19° at full strength and EI 80/20° diluted. Selecting one of these exposure indexes depends on the choice of developer rather than the light available. Since the results are somewhat different in each developer, it would not be wise to change your EI and developer without having first tested the combination. For example, Microphen produces higher contrast than ID-11 Plus, and Perceptol produces much softer contrast than ID-11 Plus.

If for some reason a slightly higher contrast is needed in negatives, for example when the subjects were shot under flat lighting conditions, increase development time by 5 or 10 percent rather than switching to a different, unknown developer.

Push-processing of Pan F, as with all slow speed, fine-grain films, is not recommended by the manufacturer. Push processing of Pan F defeats the concept of a high resolution film and Pan F's very fine silver halide particles do not particularly respond very well to underexposure and extended development.

APPLICATIONS Because of its fine grain and image sharpness, Pan F is an excellent choice for photographing any scene that has fine details which must be reproduced in the final print. Closeups of plants, flowers, industrial and commercial products as well as landscapes and portraits are all appropriate subjects for the fine grain of Pan F. Pan F is also a good choice when a small area of the negative has to be enlarged, or when a full-frame negative is to be enlarged to a high degree of magnification.

Ilford FP4
and FP4 Professional Sheet Film

MANUFACTURER: *Ilford Ltd.*
TYPE: *very fine-grain, medium-speed black-and-white negative film*
SIZES: *FP4: 35mm cartridges and 120 rolls; FP4 Professional: sheets*
FILM SPEED: *ISO 125/22°*
SENSITIVITY: *panchromatic*
NOTES: *develop in Perceptol, ID-11 Plus, Microphen or other standard black-and-white developer*
APPLICATIONS: *general purpose, indoor and outdoor; high contrast situations and with electronic flash; sports; studio and available light portraiture*

Ilford FP4 and FP4 Professional are the same emulsions and are medium-speed, very fine-grain films with very high resolving power. FP4 is nearly identical to Ilford Pan F in grain structure, and produces enlargements nearly as detailed and grain-free as most slow speed films though has a faster film speed at ISO 125/22° and has less contrast than slow speed films. FP4 also lends itself more readily to push-processing.

FP4 is a thin base film with a wide exposure latitude that can handle five or six stops of over-exposure, or two stops of under-exposure, and produce good prints. Of course, the best results will be produced at its rated exposure index (EI) of 125/22°. However, the wide exposure latitude serves more than one purpose, for FP4 is an excellent film for use in high contrast situations where shadow detail is also needed such as direct sunlight. FP4 is also a good choice when using direct electronic flash as its wide latitude can accommodate direct light from the flash while recording shadow detail other films might miss.

PROCESSING FP4 has a film speed of ISO 125/22° when developed in Ilford ID-11 Plus or Kodak D-76. When processed in a fine-grain developer such as Ilford Perceptol or Kodak Microdol-X, FP4 has an EI of 64/19° used full strength and EI 100/21° when diluted. In a high activity developer such as Ilford Microphen, FP4 has an EI of 200/24°. Microphen increases the standard contrast of FP4 while Perceptol and Microdol-X lower it slightly. FP4 may be push-processed in Microphen or ID-11 Plus to EIs of 320/26° to 800/30°.

APPLICATIONS FP4 is an excellent general purpose film for indoor and outdoor photography wherever high quality, finely-detailed images are needed. FP4 is often used for sports in good lighting conditions and when small areas of the negative will be used for the final print. It is also a good choice for outdoor and studio portraiture because of its medium speed and moderate contrast, which produces soft highlights and shadows.

Ilford HP5
and HP5 Professional Sheet Film

MANUFACTURER: *Ilford Ltd.*
TYPE: *high-speed black-and-white negative film*
SIZES: *35mm cartridges, 120 rolls, and sheets*
FILM SPEED: *35mm and rolls: ISO 400/27°; sheets: ISO 320/26°*
SENSITIVITY: *panchromatic*
NOTES: *develop in Perceptol, ID-11 Plus, Microphen or other standard black-and-white developer*
APPLICATIONS: *general purpose indoors and outdoors; photojournalism, sports and action; studio and available light portraiture; commercial, industrial, publicity and architectural photography; with flash*

Ilford HP5 is a general purpose high speed film with fine grain, medium contrast and high potential for enlargement. The grain of HP5 is a slight bit more coarse than in many medium and slow speed films, but because of this slightly coarse grain, HP5 has a high degree of edge sharpness. The fine grain and high edge sharpness make HP5 a good negative to use for substantial enlargements. High quality 16 × 20-inch prints are possible with a 35mm HP5 negative.

HP5 is a modern version of HP4 and HP3. Although they were all ISO 400/27° emulsions designated "HP", HP5 is a far different and superior film. Compared to HP5, HP4 and HP3 were coarse-grained, did not enlarge very well, and could not be push-processed more than one stop.

Like all high speed films, HP5 is thought of as an available light film because its sensitivity is sufficient for ordinary indoor lighting conditions. HP5 is one of the standard films used by photojournalists because its high speed enables hand held-shooting both indoors and outdoors under high and low lighting conditions.

PROCESSING For standard processing, HP5 in 35mm and 120 rolls has an ISO of 400/27° when developed in ID-11 Plus or D-76. Its speed is 200/24° when developed in Ilford Perceptol or Kodak Microdol-X, and 640/29° in Microphen. HP5 Professional Sheet Film has an effective film speed of 320/26° in ID-11 Plus, D-76 or Microphen and 160/23° in Perceptol.

HP5, unlike its Ilford predecessors, is a very light sensitive film that can be push-processed to exposure indexes (EIs) of 800/30°, 1600/33° and even 3200/36°. Ilford Microphen, a fine-grain, high energy developer, is particularly well-suited to push-processing HP5, as Microphen gives an effective increase in film speed with prolonged development while keeping grain size and grain clumping to a minimum due to its low alkalinity. Microphen gives HP5 its greatest EI, but this film may also be push-processed

in Ilford ID-11 Plus or Kodak D-76 to EI 800/30° or EI 1600/33° with very good results.

Push-processing of high speed films used to be recommended only when necessary, but HP5 is so excellent, even when push-processed that it produces finer results when pushed than earlier high speed films produced at standard ISO ratings. Many newspaper photographers regularly expose HP5 at EIs of 1200 and 1600 because of its fine quality and the extra edge it gives photographers shooting under adverse lighting conditions.

APPLICATIONS Fine grain and high speed make HP5 a perfect choice for candid and available light portraiture, and also for low light studio portraiture. Ilford HP5 is often used wherever hand-held candids are done, from street photography to movie stills. It is used in industrial, commercial, publicity, and architectural photography. HP5 is the general purpose film to use for indoor photography without flash. HP5 Professional in sheets is equally important in the studio, for it allows the use of smaller apertures for greater depth of field often, and often eliminates complicated view camera movements.

Flash photography is also a forte of the high speed films. Using HP5 with flash doubles the reach of medium speed films. An ISO 100 film has flash coverage of 50 feet at $f/2.8$ while HP5 gives you 100 feet at the same aperture or greater depth of field at $f/5.6$. The flash used for this example is a Vivitar 5600 with its zoom head set at "telephoto".

Ilford HP5 is used by sports photographers when using long, slow telephoto lenses as well as for indoor sports. HP5 is also used whenever maximized depth of field is needed in low light, or when action-stopping high shutter speeds are a necessity. HP5 is about two stops faster than medium speed films, which often makes the difference between getting the picture or not. The most important aspect to note concerning HP5, is that it may give a bit more of an edge than needed outdoors on bright days, but in deep shade and indoors it offers enough film speed to capture almost any image.

Kodak Panatomic-X
and Panatomic-X Professional

MANUFACTURER: *Eastman Kodak*
TYPE: *ultrafine-grain black-and-white film*
SIZES: *35mm and 70mm; Panatomic-X Professional: 120 rolls*
FILM SPEED: *ISO 32/16°; when exposed and processed as transparency: daylight—EI 80/20° and tungsten—EI 64/19°*
SENSITIVITY: *panchromatic*
NOTES: *develop in D-76, Microdol-X, HC-110, Hobby Pac or other standard black-and-white developer*
APPLICATIONS: *general purpose; closeups; nature; portraits; industrial and commercial photography; may be used to create black-and-white transparencies*

Kodak Panatomic-X and Panatomic-X Professional are ultrafine-grain black-and-white films with extremely high resolving power. Because they are exceptional in both grain and resolving power, these films are especially useful in making negatives that must be enlarged to very high magnifications. "Panatomic-X" is used to designate 35mm cassettes, 35mm long rolls and 70mm long rolls while "Panatomic-X Professional" is the designation for 120 roll sizes, though all are the same emulsion.

Panatomic-X, like other slow speed films, is useful in the professional studio and for the amateur doing closeup or copy work and using electronic flash for illumination. Panatomic-X is slow enough so the flash exposure will not exceed the limits of your camera's smallest apertures. Panatomic-X is also good for closeups for another reason, as its ultrafine grain and very high resolving power record the fine detail closeup of macro subjects such as stamps, coins, and flowers.

PROCESSING As a standard negative film, Panatomic-X processes very well in all Kodak and other brands of standard developers. D-76 has excellent development latitude which makes it a particularly good developer for controlling the contrast of Panatomic-X. You underdevelop negatives exposed in contrasty light and extend development to increase the contrast of subjects exposed in flat lighting. D-76, HC-110 and Hobby Pac maintain the film speed of Panatomic-X while producing a typically fine grain. Microdol-X produces the finest grain structure, but you should probably increase the EI to 25/18° for best results. When processing Panatomic-X that has positive copies made from duplicating black-and-white negatives, you are better off using D-76 or HC-110 because they produce snappier slides.

APPLICATIONS Panatomic-X is an excellent choice for detailed closeup work indoors

and outdoors, as well as an ideal film to use for any finely detailed subject such as nature, portraits, finely detailed and industrial and commercial subjects.

Panatomic-X in 35mm is also used to create black-and-white transparencies for projection. When used for this purpose, Panatomic-X must be processed in Kodak Direct Positive Film Developing Outfit where the film is developed to a negative, bleached and redeveloped to reverse the negative image to a positive image. The exposure indexes when exposing Panatomic-X as a transparency are 80/20° in daylight and 64/19° under tungsten light.

Panatomic-X can be used to make black-and-white slides partly because of its slow speed and fine grain. But the most important factor is Panatomic-X's strong contrast, which produces good, clean whites and strong blacks in the reversal process. Higher speed films produce mostly dull gray tones when processed to a slide. The final reason that Panatomic-X makes a good slide film is the fact that it has a negligible base fog, while Plus-X and Tri-X have much higher base fogs, which lower the already low contrast of these films if they were to be processed to a slide.

Because Panatomic-X has strong contrast and low base fog, it is also the film to use to make transparencies from black-and-white negatives. Making black-and-white slides from negatives is a much simpler process than making original black-and-white slides. Any duplicating setup can be used. The negative to be copied is placed in the duplicator and exposed at the ISO rating at which you normally rate Panatomic-X. What you are doing is making a negative of a negative, which gives you a positive. After making your exposures, you process the roll normally in your standard black-and-white negative developer.

Kodak Plus-X,
Plus-X Pan Professional, Plus-X Portrait, and Verichrome Pan

MANUFACTURER: *Eastman Kodak*
TYPE: *very fine-grain, medium-speed black-and-white negative films*
SIZES: *Plus-X Pan: 35mm cartridges; Verichrome Pan: 120 rolls, 110 and 126 cartridges; Plus-X Professionals 2147 and 4147: rolls, packs and sheets; Plus-X Portrait: rolls, packs and sheets*
FILM SPEED: *ISO 125/22°*
SENSITIVITY: *panchromatic*
NOTES: *develop in D-76, Microdol-X, HC-110, Hobby-Pac or other standard black-and-white developer*
APPLICATIONS: *general purpose indoor and outdoor photography; commercial, industrial and studio photography; portraits, landscapes and nature; in high contrast situations*

Kodak Plus-X Pan, Plus-X Pan Professional, Plus-X Portrait, and Verichrome Pan are similar medium-speed, general purpose films used in a wide range of applications. Two emulsions of the Plus-X family have different characteristics, however; Plus-X Pan Professional 2147 and Plus-X Pan Professional 4147 are low flare emulsions designed mainly for low flare studio or outdoor use and produce very good highlight tone separation. The other Plus-X films are well-suited to outdoor as well as studio work under good levels of either tungsten or electronic flash lighting.

The Plus-X Pan Professionals and Portrait films come in rolls, packs, and sheets and have retouchable surfaces. Plus-X Pan comes in 35mm only and has no retouching surface. Verichrome Pan is sold as 120 rolls and 110 and 126 cartridges and, like 35mm Plus-X, has no retouching surface.

Plus-X Pan, Plus-X Professional, Plus-X Portrait, and Verichrome Pan have very fine grain structure, very high resolving power and may be enlarged to a high degree. Verichrome Pan and 35mm Plus-X are often thought of as amateur films, though they are also used by professionals. Verichrome Pan is used exclusively by amateurs in 110 and 126 sizes, but is often used by professionals in the form of 120 rolls. Think of Verichrome Pan as Plus-X Pan Professional without a retouching surface. In fact, the retouching surface and slightly different developing times are the only basic differences between Verichrome Pan and Plus-X Pan Professional.

PROCESSING Plus-X and Verichrome process well in Kodak and all other standard black-and-white developers. D-76 produces a broad tonal range and very good edge sharpness, especially when diluted 1:1. Microdol-X gives Plus-X and Verichrome its finest grain, but to achieve this the films

must be rated at an exposure index of 80/20° instead of their normal ISO of 125/22°. Where the speed of Plus-X and Verichrome need to be maintained and even finer grain than produced by D-76 is needed, Agfa Atomal may be used, as it maintains full film speed while producing ultrafine grain.

Even though it is not generally recommended, Plus-X and Verichrome may be push-processed EI 250/25° or EI 500/28° in D-76. Contrast is controlled by decreasing or extending the development times of Plus-X and Verichrome. To lower contrast, under-develop by 25- to 50-percent; to increase contrast, lengthen development time 25- to 50-percent.

APPLICATIONS As general purpose films, Plus-X, Plus-X Pan Professional, Plus-X Portrait (hereafter all referred to as "Plus-X") and Verichrome Pan are well-suited to indoor and outdoor photography as well as studio and flash photography, whenever there are reasonable light levels. In other words, they are useful outdoors from about an hour after sunrise until near sunset on clear or lightly overcast days.

Plus-X and Verichrome are used for all types of professional, commercial and industrial applications. Plus-X comes in 35mm and 70mm long rolls which are used in long roll portrait cameras and in bulk backs for such applications as unmanned extended time photography (intervalometry) and rapid sequence photography. Plus-X and Verichrome are excellent films for portraits and scenics because their very fine grain, high resolving power and wide exposure range produce finely detailed images with a good tonal range.

Plus-X and Verichrome are medium contrast emulsions that are better choices in high contrast situations than slow speed films. Plus-X and Verichrome are almost as fine-grained as slow speed films and have nearly the resolving power of the latter so they may be used in place of slow speed films where lower contrast and extra film speed are needed. Plus-X and Verichrome are also good choices for capturing motion when light levels are high, especially when only a part of the negative will be used for the final print.

Kodak Tri-X Pan
and Tri-X Pan Professional

MANUFACTURER: *Eastman Kodak*
TYPE: *high-speed, black-and-white negative films*
SIZES: *35mm cartridges, 120 rolls, and sheets*
FILM SPEED: *35mm and rolls: ISO 400/27°; Tri-X Pan Professional rolls and sheets: ISO 320/26°*
SENSITIVITY: *panchromatic*
NOTES: *develop in D-76, Microdol-X, HC-110, Hobby-Pac, or other standard black-and-white developer*
APPLICATIONS: *general purpose; photojournalism; candid and family photography; low light situations; with flash; architectural, commercial, and industrial photography; portraiture*

Kodak Tri-X Pan and Tri-X Pan Professional are general purpose high-speed films with fine grain, medium contrast whose negatives may be enlarged with great magnification. The essential difference between Tri-X Pan and Tri-X Pan Professional is that Tri-X Professional is designed for low flare, low contrast situations outdoors and in the studio. In such conditions it gives excellent highlight separation. Tri-X is designed as a general purpose film for all types of lighting conditions and has a wide exposure latitude. Tri-X Pro comes in rolls and sheets and has a retouching surface on both sides of the emulsion. Tri-X Professional is commonly used for commercial, portrait, and other professional applications. Tri-X comes in 35mm and rolls, and is very widely used as a general purpose film by professional as well as amateur photographers.

Tri-X has been around for a long time. Years ago it exhibited far more grain than the modern version, and did not have the exposure latitude or ability to be push-processed of today's emulsion. The Tri-X of today is really a new film, but Kodak has chosen to keep the well-known name "Tri-X" while incorporating without fanfare the many improvements this emulsion has undergone. Even when compared to the emulsion of the same name only five years ago, today's Tri-X is an entirely new film with image qualities close to those of medium speed films though it possesses the available light capabilities of the high speed film it is.

Tri-X's high speed makes photographing under ordinary indoor lighting conditions possible without using an electronic flash or a tripod. Being able to hand-hold Tri-X under low light levels it is one of the films used regularly by photojournalists who must shoot a wide spectrum of lighting conditions, from direct sunlight to deep shade to tungsten lighting. Photojournalists also use Tri-X with flash because its high speed increases the depth of flash coverage or, alter-

natively, gives greater depth of field at shorter distances than a slower film could.

PROCESSING Kodak lists Tri-X at an ISO of 400/27° when developed in D-76, Microdol-X and HC-110, though many professional photographers choose to rate this film one stop slower, at an exposure index (EI) of 200/24°. D-76 and HC-110 are high activity developers that produce the full film speed of Tri-X at normal development times. Microdol-X is a fine-grain developer of low activity which does not quite get the rated speed out of Tri-X or Tri-X Pro. However if use of a fine-grain developer is desired, process Tri-X in Agfa Atomal, an active ultra-fine-grain developer that reproduces the full EI of high speed films.

Tri-X also push-processes very well one or two stops in D-76 or HC-110, although this increases both grain and contrast. Tri-X can also be pushed three stops to an EI of 3200/36° in Ilford Microphen with very good results.

Many newspapers regularly ask photographers to rate Tri-X at an EI of 1200 to give them as much of an edge as possible when they come up against adverse lighting conditions. The results of push-processing any film are not optimum, but they are adequate for some uses, such as reproduction in newspapers. At EIs of 800/30° to 1600/33°, grain structure becomes coarser and there is a buildup of contrast, but surprisingly good enlargements may be made from these negatives.

APPLICATIONS Tri-X is used in all fields of photography, from architectural, commercial, and industrial photography to portraiture. It is used in the field, indoors and in the studio. In sheet form it gives the view camera operator an extra stop and a half over medium speed films which often eliminates the effort of deriving extra depth of field by adjusting the camera's image controls; it also can eliminate the need to do multiple flash work and copes with the reciprocity problems of long exposures.

Tri-X gives both good depth of field and high shutter speeds at high light levels. It is an ideal film to use when using long, slow telephoto lenses as its speed helps avoid blurring images due to camera shake. It is a good film to choose when action-stopping shutter speeds are needed, or to achieve great depth of field, especially when light levels are less than optimum. Tri-X is often used by sports photographers with long lenses outdoors, and for action-stopping high shutter speeds in the lower light levels of indoor sports.

Tri-X is an excellent general purpose film to use even with only an occasional need for its extra speed, though it is exceptional for capturing an image under low light levels such as on an overcast day, in deep shadow, or indoors. It is a fine film to use for candid photography and available light portraiture. Regardless of the lighting conditions, Tri-X will produce negatives detailed enough to make 16 × 20-inch prints from a 35mm negative.

VARIABLE SPEED

Agfapan Vario-XL Professional

MANUFACTURER: *Agfa-Gevaert AG*
TYPE: *black-and-white chromogenic negative film*
SIZES: *35mm cartridges, 120 rolls, and sheets*
FILM SPEED: *variable: ISO 100/21° to ISO 3200/36°*
SENSITIVITY: *panchromatic*
NOTES: *processed as color film; Agfacolor Process F, Kodak Flexicolor, Unicolor K-2, Ilford XP-1 or other C-41 process*
APPLICATIONS: *ideal for mixing lighting situations and exposure indexes; photos for publication; photojournalism; sports; architecture; industrial photography*

Agfapan Vario-XL Professional is a black-and-white negative film that uses color film technology to achieve variable film speeds without changing processing times. On one roll of Vario-XL Professional both a portrait taken in bright sunlight at ISO 100 and another taken by candlelight at ISO 1600 will result in excellent prints. The variable speed comes from the fact that Vario-XL has two light-sensitive emulsion layers: one sensitive to low light levels and the other sensitive to bright light levels. In bright light, both layers are exposed, while in dim light only one layer is exposed. Since Vario-XL is a chromagenic film like all color negative films, it is processed in color chemistry that chromogenically develops the dyes as the silver develops. The final negative is a dye image rather than composed of silver. The translucent dye images make the wide tonal range of Vario-XL negatives easy to print.

Agfapan Vario-XL could be called a "zoom film" in that it covers a variety of exposure situations much like a zoom lens covers a variety of image magnifications. Vario-XL can be exposed at exposure indexes as low as ISO 25/15° with very good results with normal processing. Exposure indexes as high as ISO 3200/36° are possible with push-processing, provided the whole roll is exposed at the higher indexes of ISO 800, 1600, and 3200. Vario-XL will not turn poor images into great ones, but in the hands of photographers who know what they are doing, it can solve a lot of exposure problems.

PROCESSING Agfapan Vario-XL Professional film can be processed worldwide by any photofinishing lab that processes standard color negatives. The processor can develop only negatives, or produce black-and-white prints on color paper. Color processing and printing of Vario-XL is used by newspapers, magazines and in advertising as a method of obtaining high quality black-and-white prints for publication.

Vario-XL may also be processed by the user with any of a number of color negative

developing kits, such as the Agfacolor Process F, Kodak Flexicolor, or Unicolor K-2. Vario-XL may also be processed in Ilford's XP-1 chemistry, which is specifically made to process black-and-white chromogenic films, and is particularly well-suited for push-processing Vario-XL. For push-processing Vario-XL in standard color developers, development time must be increased by 45 seconds.

APPLICATIONS Agfapan Vario-XL Professional gives professionals and amateur photographers a range of exposure choices never before possible on one roll of film. One roll can combine exposures made under bright, high contrast sunlight and indoor exposures made under the dimmest of available light. A photographer using Vario-XL Professional may switch from an easily hand-holdable wide-angle or standard lens to a slower telephoto lens and still hand-hold the long lens, simply by adjusting the film speed on the ISO dial. Thus Vario-XL is an excellent film for photojournalism, sports, street photography and any time a photographer must include additional light sources in the scene. Flash photography outdoors or in large, dark rooms is easily handled by the wide exposure range of Vario-XL. Fine grain and wide tonal range make it an excellent choice for advertising, architectural and industrial photography. It is also excellent for portraiture because of the fine but soft grain. Obviously, Vario-XL is an excellent general purpose film that covers a vast array of lighting situations.

Ilford XP1 400

MANUFACTURER: *Ilford Ltd.*
TYPE: *fine-grain, wide latitude, chromogenic black-and-white negative film*
SIZES: *35mm cartridges, 120 rolls*
FILM SPEED: *standard ISO 400/27°, wide range EI 100/21°–EI 3200/36°*
SENSITIVITY: *panchromatic*
NOTES: *process in C-41 or any compatible color negative chemistry*
APPLICATIONS: *varied lighting situations requiring a selection of EIs; high- or low-contrast circumstances; in flat lighting such as fluorescent or overcast; photojournalism; advertising and commercial photography*

Ilford XP1 400, like Agfapan Vario-XL, is a black-and-white negative film that uses color technology to form its image. At its rated speed of ISO 400/27°, XP1 is a very fine-grain film comparable to ISO 100/21° films. The very fine grain is due to two light-sensitive layers in the film, new chromogenic color coupler technology and the specially formulated XP1 chemistry. One of the two film layers is sensitive to low light and the other responds to bright light. Both layers are exposed in bright light while only the high speed layer is exposed at low light levels. The special DIR (Developer Inhibitor Releasing) couplers inhibit diffusion of the dyes to produce a very fine, sharp, grain structure and very high resolving power. The XP1 chemistry is specially formulated for developing this, and other black-and-white chromogenic films.

Exposure latitude of XP1 development time is very wide, EI 100/21° to EI 800/30°. Higher exposure indexes (EIs) of 1600/33° and 3200/36° are easily obtainable with push-processing in XP1 chemistry with ex-

cellent results. Because of its wide latitude, Ilford XP1 400 is an excellent film for subjects and scenes with very high brightness ratios. One method for exposing such scenes is to rate XP1 at an EI of 100 or 200, metering the highlights for the exposure, as the wide latitude of the film will also record lower exposure values. A second method is to use an EI of 400, metering a middle for the exposure. Because the final negative form is a dye image, printing dense highlight areas is quite easy.

When using higher exposure indexes and push processing in XP-1 chemistry, keep all exposures from EI 800 to EI 3200—EIs any lower than that will tend to become very dense and require very long printing times. Higher ISO ratings will tend to show more grain than lower ones. In fact, the lower exposure indexes, down to a minimum of 100/21°, have very fine grain. When exposing at higher EIs, it is best to expose under flat lighting conditions such as fluorescent lights and overcast days because push-processing in XP1 chemistry tends to build contrast.

However, contrast is often high in available light situations, and XP1 negatives exposed at high EIs and push-processed will print well if soft printing paper is used with some burning in of highlight details.

Rating XP1 at lower EIs lowers scene contrast and produces a finer grain structure. At EI 800/30° there is an increase in contrast and only a slight increase in grain. With the ability to fine-tune exposures on each roll of XP1, the extremes of high contrast subjects may be minimized or the contrast of low contrast scenes increased, all on one roll of film.

PROCESSING XP1 chemistry is designed to produce optimum results at a temperature of 100 F/38 C. XP1 film may be processed at lower temperatures, but results will be less than optimum. The contrast of XP1 negatives may be further fine tuned by adjusting the developing time in XP1 chemistry. Standard developing time is five minutes. When a whole roll has been shot of high contrast subjects, stop development at 4½ minutes to keep contrast from building up. With an entire roll of low contrast subjects, extend development time to 5½ minutes to increase contrast.

When XP1 is exposed at EI 1600/33° under high contrast available light, process the film for 6 to 6½ minutes. EIs of 1600/33° and 3200/36°, when exposed under flat lighting should be processed for 7½ minutes to strengthen contrast.

If the film is being processed without a water jacket in a steel tank, or in a plastic tank, use a presoak with water at 104 F/40 C for one minute and the developer at 104 F/40 C; this temperature will average out to 100 F/38 C over the five-minute development time.

APPLICATIONS Ilford XP1 400 is an excellent black-and-white film for a variety of applications from general photography to flash photography to a variety of professional applications. XP1 is particularly well-suited to flash photography because of its wide exposure latitude as an EI of 200/24° will give enough latitude to compensate for any overexposed areas while recording shadow details other films might miss.

SPECIAL USE

Kodak Recording Film 2475

MANUFACTURER: *Eastman Kodak*
TYPE: *coarse-grain, very high-speed panchromatic black-and-white negative*
SIZES: *35mm cartridges*
FILM SPEED: *EI 3200/36°*
SENSITIVITY: *panchromatic black-and-white with extended red sensitivity*
NOTES: *develop in DK-50 or HC-110; always use fresh developer*
APPLICATIONS: *surveillance and forensic photography; in tungsten light; for special effects: photojournalism; indoor sports*

Compared to other high-speed films, Kodak Recording Film 2475 is very coarse grained. But it can do things that other films cannot because of its extremely high speed and extended red sensitivity. Kodak Recording Film 2475 is a 35mm film designed for available light work where electronic flash cannot be used. This emulsion is especially useful for surveillance and law enforcement (forensic) photography, where light levels are often very low. The extended red sensitivity of this film is particularly useful in such applications because it records detail in tungsten illumination that other films might miss due to a lesser sensitivity to strong red light emitted from the light source.

We do not see the red in tungsten light because our eyes compensate for the imbalance and we tend to "read" colors as we would in daylight. Film cannot make such adjustments and can only see what it was designed to "see". Thus if you take two films of equal speed, one with extended red sensitivity (i.e., 2475) and one without, 2475 will give an extra stop or two when exposed by

red rich light sources. Kodak Recording Film 2475 can record a subject's face by the light of a single candle with an exposure of $1/30$–$1/60$ sec. at $f/4$–$f/5.6$, depending on the subject's distance from the candle and the candle's brightness. A film with less red sensitivity and/or speed would require a larger aperture to achieve an image under the same conditions.

Results under low available lighting from candles to street lamps are rendered with heavy contrast on 2475, but in surveillance and law enforcement work this is more than sufficient, because usually all that is needed is a recognizable face, for example. An exposure index (EI) of 3200/36° is usually used for surveillance work.

PROCESSING Kodak Recording Film 2475 processes very well in Kodak DK-50, HC-110 dilution A or dilution B in temperatures from 65 F/18.5 C to 95 F/35 C. Other developers may be used. Make a series of test exposures under simulated conditions committing any important images to 2475 and a

different developer. No matter what developer used, always use a fresh solution, as partially used developer can create dichroic fog in this emulsion.

APPLICATIONS Kodak Recording Film 2475 is very useful for street photography when the photographer is working in dark areas, at night or under heavy overcast skies. It is also very useful in photojournalism, especially under low available light conditions, for indoor sports photography and under any conditions where high shutter speeds and small lens apertures must be used. One situation where 2475 comes in handy is when a long, slow telephoto lens must be used under overcast or rainy skies. This is the film to use when it means the difference between getting the picture or getting no picture at all.

Kodak Recording Film 2475 is also a good special effects emulsion when soft, misty, grainy effects are desired. This film has very good edge sharpness, but low resolving power. Thus there is good separation between contrasting tones, but similar tones tend to conglomerate into large blocks. This is a good film to use when shape and form without detail is sufficient.

Kodak Technical Pan 2415

MANUFACTURER: *Eastman Kodak*

TYPE: *extremely fine-grain, moderate to extreme contrast black-and-white negative film*

SIZES: *35mm cartridges, sheets*

FILM SPEED: *ISO 25/15° to EI 320/26° depending upon application and developer extended red panchromatic*

SENSITIVITY: *develop in Technidol LC or POTA for normal contrast, or HC-110 and D-19 for high contrast*

NOTES: *photomicrography; scientific and industrial uses; creative uses, including special effect portraiture*

APPLICATIONS:

Kodak Technical Pan Film 2415, usually called "Tech Pan," is a unique film in the photographic world for it was originally designed only as a high contrast film with extremely high contrast capabilities and intended to replace Kodak Solar Flare Patrol Film and Kodak Photomicrography Monochrome Film in extremely specialized applications, such as photographing holographic images where the playback illuminant is a helium-neon laser (633NM) and recording light emitting diodes (LEDs) peaking at 640 to 660 nanometers. Other high technical uses are for registering plasma displays, solar disk recording, photomicrography and other applications where high definition photographic records are required. But somehow it was discovered that Tech Pan could also be used as a full-toned slow speed film for pictorial applications.

Kodak Tech Pan has extremely fine grain, extremely high resolving power and extremely high magnification capabilities.

Tech Pan responds to ultraviolet (UV) light and has a fairly straight response curve all the way through the visible spectrum right down to 700NM, which is the lower limit. In comparison, all general purpose panchromatic films have a limit of about 625NM. Tech Pan is actually more sensitive to UV light than it is to visible light, so a UV or skylight filter should be used over the lens using Tech Pan outdoors.

PROCESSING Contrast is controlled through the choice of developer, so it is best to understand film developer combinations before beginning to use this film.

Tech Pan is processed to a contrast index (CI) of .6 in Kodak Technidol LC (low contrast) developer or POTA. A CI of .6 is what is normally recommended for pictorial and general photography and offers a full scale of tonal values from black and shadow detail to white detail and highlights. In HC-110 Dilution F, Tech Pan produces a contrast index of

.80 to .95, depending upon development time and exposure index (EI). In HC-110 Dilution B, Tech Pan has a CI of 1.20 to 2.10 and reaches its highest contrast index of 2.25 to 2.50 in D-19.

Of special significance is the fact that Tech Pan has no visual base fog when developed. For this reason it is important to develop and agitate according to strict procedures when processing Tech Pan in Technidol LC or POTA. First, when processing in a small reel tank, drop loaded reels into an already filled tank, rap the tank to dislodge any air bubbles and agitate slightly by tipping the tank back and forth—all within the first five seconds. Then replace the top of the tank, turn on the lights and agitate for five seconds during every 30 seconds of development.

The correct method of agitation for this film is to hold the tank between your thumb and fingers and rotate the tank as though there were an axis through the tank half-way between the top and the bottom.

If you do not follow these procedures, you will get uneven, mottled development and very poor image sharpness with Kodak Technical Pan 2145. Somewhat sloppy agitation with most panchromatic films may still achieve acceptable and usable results. But with Tech Pan film developed in Technidol LC or POTA, sloppy agitation is disastrous. Dropping the film into the developer is not necessary when developing Tech Pan in D-19 or HC-110. Either of these developers may be poured into the loaded tank through the light trap in the top as is done with standard panchromatic films. However, the agitation technique described above should be used with any type of film for optimum results.

APPLICATIONS Because of the contrast control capabilities of Technical Pan 2145 as well as its extremely fine grain and extremely high resolving power, this is a useful photomicrographic film, especially for monochromatic and low contrast specimens. Tech Pan is used for solar disk recording of phenomena occurring in the green wavelengths as well as at the H-alpha line. It also is often used in copy work for the reproduction of line drawings and typeset text as well as for making reverse text title slides.

As a medium contrast, general purpose film, Tech Pan records the red spectrum better than ordinary panchromatic films. Tech Pan may be adapted so that it approximates the spectral response of other general purpose emulsions by using a CC50 Cyan color compensating filter over the camera lens. This filter serves to limit the red response to 655NM which is still more efficient red recording than possible with other panchromatic films. Tech Pan is excellent for photographing any subject, ranging from landscapes to portraits. Its extremely fine grain and high resolving power produce smooth, grainless prints full of detail. Extremely large prints can be made from Tech Pan negatives.

An interesting application for Tech Pan film is high contrast portraiture. When portraits are made on Tech Pan film and processed in D-19, HC-110D or HC-110F, the results are eerie, high contrast portraits with smooth, creamy, velvet-like skin. The following are suggested starting points for trial exposures: EI 100/21°–200/24° developed in D-19 for four minutes at 68 F/20 C; EI 100/21° developed in HC-110D for 5½ minutes at 68 F/20 C; EI 50/18°–80/20° developed in HC-110F for six minutes at 68 F/20 C.

SPECIAL USE

Kodak High Speed Infrared Film

MANUFACTURER: *Eastman Kodak*
TYPE: *medium-speed, black-and-white negative film*
SIZES: *35mm cartridges, and sheets*
FILM SPEED: *see table below*
SENSITIVITY: *infrared and visible light*
NOTES: *develop in D-76, HC-110 or D-19; other developers also yield good results, but testing must be done*
APPLICATIONS: *special effects; industrial, commercial, and medical photography; to reveal art forgeries; forensic photography; photomicrography and photomacrography*

Kodak High Speed Infrared Film is a black-and-white, infrared-and visible light-sensitive film with a wide range of applications, that originated in camouflage detection efforts during World War II. On infrared (IR) film, healthy foliage has a high infrared reflectance, while painted camouflage or branches cut from trees have low infrared reflectance and photograph dark.

The difficulty in working with High Speed Infrared is the nature of the emulsion, as it is sensitive to visible as well as infrared radia-tion. Thus you must use a filter over the camera lens to block out most, or all, visible radiation in order to record infrared radiation. Kodak and Tiffen make the following IR transmission filters which cut off all visible light rays: 87, 87C, 88A and 89B. For general photography, a red filter number 25, 29 or 70 may be used to limit visible light to the red (and infrared) spectrum. Following is a chart of exposure indexes (EI) to use as trial settings for tests:

Suggested EIs and Filters for Use with High Speed Infrared Film

Filter	daylight	tungsten
no filter	80/20°	200/24°
25, 29, 70, 89B	50/18°	125/22°
87, 88A	25/15°	64/19°
87C	10/11°	25/15°

Filters with variable intensity such as Spiratone's Red Colorflow and Tiffen's Variflow Red are also useful in general infrared photography as a light red setting may be used for focusing and then maximum red for the actual exposure. EI ratings with these filters are the same as those for a number 25 red filter.

Following are general recommendations for outdoor exposures with visible red filter over the lens:

Recommended Outdoor Exposure

bright or hazy sun (distinct shadows)	f/11 at $\frac{1}{125}$ sec.
cloudy bright (no shadows)	f/11 at $\frac{1}{30}$ sec.
overcast and open shade	f/11 at $\frac{1}{15}$ sec.
heavy overcast	f/11 at $\frac{1}{8}$ sec.

Keep in mind that infrared radiation varies considerably during the day, from season to season and from location to location. The amount of infrared radiation present also bears little relationship to the visible light present, so it is wise to experiment with High Speed Infrared before committing any important images to this film. Tungsten lights are a rich source of infrared radiation while infrared heat lamps are not: it takes a 6,350-watt infrared heat lamp to produce as much actinic infrared radiation as a 500-watt tungsten bulb.

The purpose of an infrared flash is to produce invisible radiation allowing pictures to be taken in dark areas without any awareness on the part of the subject. Sunpak manufactures an electronic flash called the "Nocto," which produces only infrared radiation. Ordinary flash units may be converted into infrared flash units by placing an infrared filter over the flash head.

When illuminating subjects with any light source for High Speed Infrared film, the light(s) must be placed at a 30- 45-degree angle from the camera, especially for portraiture. If the light source is at an angle too close to the axis of the lens, most subject detail will be lost. For medical applications, tent lighting is used for soft, even illumination. This type of lighting emphasizes veinous patterns below the surface of the skin. While this may not be desirable for most portraits, there may be occasions when it can be used for special effects. With 30–45-degree lighting extraordinary separation between the iris and pupil of the eye is achieved, even if the iris is very dark, because the iris reflects infrared to a high degree.

High Speed Infrared is not particularly well-suited for either push-or pull-processing. High Speed Infrared is a film with high contrast, and infrared radiation, being very directional, does not produce much variation in tone. Also, exposure variations offer very little control over infrared images. Thus it is very important to test High Speed Infrared thoroughly under actual, or accurately simulated, conditions before use, in order to standardize exposure and processing procedures.

Infrared waves focus at a different point than do visible light waves. Most camera lenses have infrared focusing marks allowing the photographer to first focus on the subject visually, later shifting to the infrared

mark. If a lens has no infrared focus mark, focus on the near side of the subject, then change the focus to a point 25-percent beyond the visible focus point (for example, if visible focus is four feet, the infrared focus would be five feet), and use an aperture of f/11 or smaller to make the exposure.

PROCESSING The developers recommended for use with High Speed Infrared are the best means of controlling this film's contrast and image quality. D-76 produces moderately high contrast and is used for pictorial photography and portraits. AC-110 dilution B is used for scientific imagery and produces a higher contrast index than D-76. D-19 produces very high contrast for great separation of tone or dramatic effects.

Care must be taken in handling and storing High Speed Infrared because the IR waves it is sensitive to are, in fact, heat waves. The film comes in an all-black cannister to protect it from stray infrared radiation. This film must be loaded and unloaded in total darkness as the light trap on the cassette does not block infrared. When working in the field, use a changing bag when loading and unloading High Speed Infrared. Processing should also be light-tight. If processing in a daylight tank, it should be made of stainless steel or black plastic, with a black cap that completely seals off the inside of the tank. Unprocessed film should be stored in a refrigerator or freezer to preserve its infrared sensitivity.

APPLICATIONS Today High Speed Infrared is used in aerial surveys for pollution, timber, minerals, and natural phenomena. This film is used to reveal the writings on ancient documents and to reveal forgeries in the art world. It is applied in law enforcement, botany, zoology, medicine, industry, archaeology, photomicrography and photomacrography. It is also an intriguing pictorial and portrait film.

Agfa Dia/Direct

MANUFACTURER: *Agfa-Gevaert AG*
TYPE: *slow-speed, black-and-white reversal film for projection (transparency)*
SIZES: *35mm cartridges*
FILM SPEED: *ISO 32/16°*
SENSITIVITY: *panchromatic black-and-white*
NOTES: *processing included in the price of the film at designated Agfacolor Labs, or may be developed in any standard direct positive developing outfit*
APPLICATIONS: *slide shows; documentary; scientific, commercial, industrial, and medical photography; architecture; art*

Agfa Dia/Direct is a slow-speed, black-and-white reversal film used for projection in slide projectors. It is an ultrafine-grain film with excellent resolution and a good tonal scale. This is a black-and-white slide film, and should not be treated as a black-and-white negative film.

After shooting general purpose subjects such as portraits and landscapes for projection, black-and-white prints may later be made from a Dia-Direct slide by making a black-and-white internegative. Only simple equipment is needed to produce black-and-white internegatives. Using a macro lens with 1:1 (lifesize) capabilities, tape a Dia-Direct slide to a piece of glass and use a white card to reflect either daylight or tungsten light through the slide.

When using Dia-Direct as a general purpose film, remember that accurate exposure is essential to producing good black-and-white slides for projection or printing. Many photographers working with black-and-white negative films count on correcting for under- or over-exposure by printing on

harder or softer paper. But Dia-Direct is a slide film, and, like any other direct positive film, is the end result.

PROCESSING Dia-Direct comes with processing included at designated Agfacolor labs. However, Dia-Direct may be processed by any lab that has direct positive processing capabilities. It can also be processed by the user in any direct positive processing outfit, such as the Kodak Direct Positive Film Developing Outfit (see Kodak Direct Positive Pan Film for details).

APPLICATIONS Agfa Dia-Direct is an excellent film to use when black-and-white slides are desired for a slide show. This emulsion may be used to create black-and-white copies of color transparencies, for slide records of documents or publications, and the resulting slides converted to internegatives and used to make high quality black-and-white prints. Dia-Direct is useful in scientific, medical, industrial, and architectural photography.

Kodak Direct Positive Pan

MANUFACTURER: *Eastman Kodak*
TYPE: *medium-speed, black-and-white reversal film for projection (transparency)*
SIZES: *35mm cartridges*
FILM SPEED: *daylight EI 80/20°; tungsten EI 64/19°*
SENSITIVITY: *panchromatic*
NOTES: *process in Kodak Direct Positive Film Developing Outfit or similar direct positive black-and-white direct positive processing system*
APPLICATIONS: *audiovisual presentations; copying artworks; b/w slide shows; portraits; nature*

Kodak Direct Positive Pan Film is a very fine-grain high resolving power with black-and-white reversal film for projection. Prints can be made from Direct Positive transparencies by making black-and-white internegatives.

When using Direct Positive Pan for either reproduction or general purpose work, exposure must be accurate for best results. Always keep in mind that Direct Positive, though it has a good exposure latitude, does not have the latitude of black-and-white negative films, which allow correction during printing. Direct Positive should be exposed as meticulously as color transparency films.

PROCESSING Direct Positive may be processed by any lab that has a direct positive processing system. Direct Positive Pan Film may be developed by the user in Kodak's Direct Positive Film Developing Outfit, any similar direct developing outfit, or it is even possible to make an appropriate chemistry from formulas given in Kodak publication No. J-6, "Small-Batch Reversal Processing of Kodak Black-and-White Films". Try a test roll using 7.5 minutes in the first developer at 68 F/20 C. If results are too thin, increase first the developer time by 10–20-percent with dense results, decrease the first developer time by 10–20-percent. All other processing durations remain constant. Always use water as a rinse between the first developer and the bleach, and do a thorough rinse: fill, agitate and dump the rinse water seven or eight times. Do not expose the film to light until it has been fixed. Kodak states that a dim greenish-yellow safelight may be used after the bleach step has been completed, but the safelight serves no purpose when using a daylight tank.

APPLICATIONS Direct Positive Pan is used in audiovisual applications and other areas where photographs, drawings, illustrations, or text must be copied for slide shows. Direct Positive Pan is also a general purpose film suitable for portraits, landscapes, candids or almost any subject.

INSTANT PRINT AND RAPID ACCESS FILMS

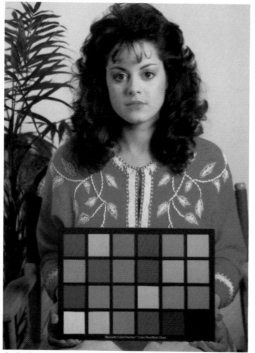

Agfachrome Speed

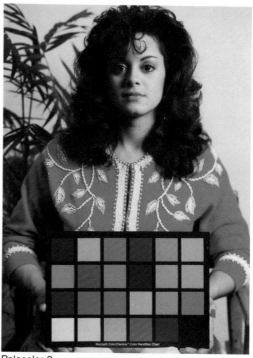

Polacolor 2

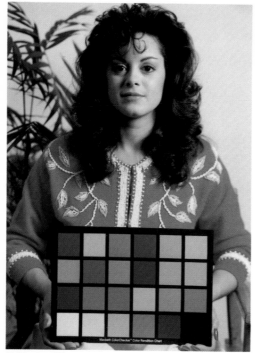

Polacolor ER

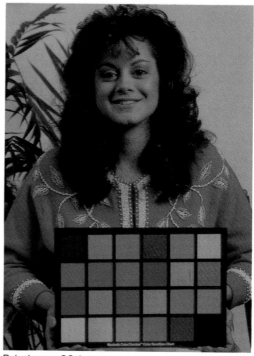

Polachrome CS Autoprocess

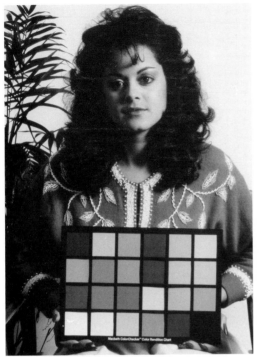

Polapan CT Autoprocess

Polagraph HC Autoprocess

Polachrome/Bill Gallery, courtesy Polaroid Corporation

Polacolor ER/Dan O'Neill

Polachrome/Dan O'Neill

Polachrome/Jim Boudreau, courtesy Polaroid Corporation

Polaroid SX-70/courtesy Polaroid Corporation

Polapan/Dan O'Neill

Polaroid Type 51 HC/Dan O'Neill

Introduction to INSTANT PRINT and RAPID ACCESS FILMS

Instant print and rapid access films process themselves without a darkroom within a few minutes. The only exception to this is Agfachrome Speed, a color-reversal enlarging paper with unique properties that make it an excellent in-camera print film, and only requires a single solution for processing.

Kodak makes two instant print films, and Polaroid makes all the rest, including the rapid access 35mm Polachrome, Polapan, and Polagraph, which produce transparencies in a couple of minutes in a small Polaroid Autoprocesser. Some instant films are self-contained and are primarily used by amateurs. Others are the peel-apart kind of instant print and are widely used by professionals as well as some amateurs. Pros use instant print films both as final products and as intermediary prints to check lighting, exposures, subject relationships, etc., before producing final results on conventional films.

Instant print films satisfy one of human nature's basic needs: instant gratification. They also provide instant confirmation that you have taken a correctly composed and exposed picture.

Instant print and rapid access films include both color and black-and-white films. The 35mm Polapan and Polagraph produce black-and-white slides, while Polacolor produces color slides (Polacolor can be found under color transparency films; Polapan and Polagraph are in the section on black-and-white films). The rest of the instant print films produce prints, and one, Polaroid P/N film, produces a negative as well as a positive print. Instant print films are used in special machines to produce instant prints from color and black-and-white slides. Instant print and rapid access films are also used extensively in the teaching of photography because the results can be seen and discussed in minutes while the images and what they did to get them are fresh in the students' minds.

Instant print and rapid access films are used in a wide range of fields from photomicrography, science, and medicine to computer recording, real estate, and recording family events.

Agfachrome Speed

MANUFACTURER: *Agfa-Gevaert AG*
TYPE: *color reversal printing paper that can be used as an in-camera print film*
SIZES: *5 × 7 to 20 × 24 sheets*
FILM SPEED: *EI 3/6° to 12/12°*
COLOR BALANCE: *tungsten 3200K*
NOTES: *processed in one step process in Agfachrome Speed Activator*
APPLICATIONS: *general purpose; used by museums and commercial artists, and in advertising for rapid access color tests and proofs*

Agfachrome Speed was originally designed as a reversal paper for making prints directly from slides. However, it has an unusual property that makes it an invaluable in-camera print film under certain circumstances. Agfa applied the dye transfer technology used in instant print films and developed a color enlarging paper incorporating both the exposure layers and the receiving layers in the same sheet of paper. Agfachrome Speed can be used in-camera because the exposing surface is on the back of the paper and the dyes migrate to the front of the paper. When you print a slide in an enlarger, the slide must be reversed from the way you normally print an image on most enlarging papers because of the image migration. However, when Agfachrome Speed is used in-camera, it produces a correctly oriented picture because of the image migration.

When an image passes through a lens, the image reverses so that left becomes right and top becomes bottom. Normal camera films are transparent so that you can view the image from the other side to view it correctly.

Opaque papers however would produce a reversed image because you would have to view the image from the side that it was exposed. Agfachrome Speed allows you to view the final image from the side that is opposite to the exposing surface so that you have a correctly oriented image.

Print emulsions vary more than film emulsions in speed and color balance, so run a few tests before committing important images to film.

PROCESSING Agfachrome Speed is the first and only color paper whose contrast can be controlled. Normally the activator is used full strength. If the image is too soft, you can increase the contrast by diluting the activator with 10-, 15-, or 20-percent water. If the image is too contrasty, you can lower it by adding two grams of potassium bromide per litre of activator being used. Processing time is 90 seconds, after which the print is washed for five minutes in running water and dried.

When using Agfachrome Speed activator

use your hands instead of print tongs, which could mar the surface of the print. Always wear rubber gloves when processing in Agfachrome Speed Activator for it has about the same alkalinity as straight bleach.

APPLICATIONS Agfachrome Speed produces strong, rich, slightly warm colors with a high degree of color purity when used in-camera. The value of Agfachrome Speed comes into play when a photographer needs a method of producing images that can be checked on the spot and needs coloration not available in instant print materials. Valuable museum pieces that must be photographed in a limited space of time and which cannot be removed from the museum are perfect subjects for Agfachrome Speed as produces colors and image quality like that of standard color sheet films. The objects are exposed on Ag-

fachrome Speed and processed that day to confirm that lighting, exposure, and color balance is just right. Any remakes can then be done immediately.

Because of its size range of 5 × 7 to 20 × 24, Agfachrome Speed is also being used in graphic arts, advertising and other areas where rapid-access color proofs and camera-ready final color prints are needed. There is no 4 × 5 size available, but it is easy to cut up an 8 × 10-inch sheet into four 4 × 5-inch sheets.

There are many potential applications for Agfachrome Speed from original portraiture to artistic still life and architectural studies. The uses of Agfachrome Speed are only limited by your imagination and the availability of a view camera.

Kodak PR 144
and Kodamatic HS 144 Trimprint

MANUFACTURER: *Eastman Kodak*

TYPE: *instant color print films for amateur and professional applications*

SIZES: *3¾ × 4 sheets; Trimprint is 3½ × 4½ when peeled*

FILM SPEED: *PR 144: ISO 160/23°; HS 144: ISO 320/26°*

COLOR BALANCE: *daylight 5500K*

NOTES: *processing is self contained*

APPLICATIONS: *general purpose; widely used by amateurs for candid portraits; insurance records; instant professional portraits; scientific, industrial, and medical photography; laminated identification cards*

Kodak PR 144 and Kodamatic HS 144 are amateur and professional instant color print films for use in Kodak Colorburst and Kodamatic cameras and in Kodak Instant Film Backs for view cameras with Graflok-type mounting. The Trimprint looks the same as a standard Kodak Instant Print except that it has a slit across the large white border. After one hour has elapsed, you can separate the Trimprint from the backing, which is then discarded. The Trimprint is a white bordered, flexible light final print. Three of the untrimmed prints weigh as much as seven trimmed prints do and take up a lot less room making the Trimprint easier and more practical to mail to family and friends.

PR 144 and HS 144 are exposed through the back of the film. When the film is ejected it passes through two rollers that break the chemical pod and spreads the reagent evenly throughout the emulsion. The dyes released by the complex process migrate through the opacification layer and the white reflection layer to the image receiving layer where the final image is formed. The Trimprint has two opacification layers with the separation layer between them; thus when you separate the Trimprint, the final print is opaque instead of transparent.

PR 144 has an ISO of 160/23° while HS 144 is twice as fast with an ISO of 320/26°. PR 144 has a slightly cool color balance and has good saturation. HS 144 is slightly on the warm side with good color saturation. Most colors are similar on both films, but HS 144 produces a stronger and truer blue than PR 144. Contrast of both films are similar and a bit above average.

PROCESSING Since processing is self-contained, there is no peeling to be done and no messy chemicals to get on your hands or clothing and no chemical laden negative image receiver to throw away. All the chemicals are sealed inside and the chemicals are neutralized once they have done their job. The processes in PR 144 and HR 144 are self

timing so that the photographer does not have to time the process. The Trimprint can be peeled away from the backing and inert chemical agents, but the development does not depend on this separation and the backing can be left on permanently. If you intend peeling away the backing, it should be done within a week; after a week, the chemicals solidify, making separation difficult.

APPLICATIONS Both films are widely used as general purpose amateur films. There are many snapshot photographers who cannot wait, or do not want to wait to see the results of their photographs. Others just do not want to be bothered taking rolls of film to their local dealer or lab or sending it out in the mail. There are also the occasional snapshooters who have never developed confidence in their photographic abilities and instant prints provide them with quick confirmation that they have made the pictures they want.

This last point also carries over into the business world. When a used car is bought, the insurance company often records its physical condition on instant film. Have an accident with your car and the damage is recorded on instant film. Homes, both interiors and exteriors, are recorded on instant print film both for insurance purposes and by real estate agents to show their clients. Kodak instant films are often used for these purposes because they have a rectangular format which many people prefer over a square format.

Commercial applications for PR 144 and HS 144 are also very good for enterprising photographers. Children visiting Santa Claus, couples at a prom, in a club or restaurant, and any other festive occasion where people would want a picture as a memento. The appeal of the instant print is that the customer can not only see the results quickly, but also he does not have to give out his name or address nor does he need to come back for the pictures another day.

The Trimprint in particular can be used for laminated ID cards. Both films can also be used via their professional backs for rapid access photography, laboratory and experimentation recording, as well as scientific, industrial, and medical recording. The Kodak Instant Film Back is deeper than other view camera backs, so that you must either adjust the focus manually ½ inches nearer if you use the focusing screen of the view camera. The easiest focusing method though is to use a ground glass designed by Kodak for the Instant Film Back, which focuses the camera at the film plane of the Kodak back.

Kodak PR 144 and HS 144 can also be used to make instant copies of color transparencies.

Polaroid 600,
Time Zero, Type 778, and Type 779

MANUFACTURER: *Polaroid Corporation*
TYPE: *integral self developing color print films for amateur and professional*
SIZES: *3½ × 4½ sheets*
FILM SPEED: *Time Zero and 778: ISO 150/23°; 600 and 779: 600/29°*
COLOR BALANCE: *daylight 5500K*
NOTES: *processing is self contained*
APPLICATIONS: *general purpose; widely used by amateurs for candid portraits; real estate and insurance records; professional test shots; scientific, industrial, and medical photography*

Polaroid 600 and Polaroid Time Zero are amateur instant color print films for use in Polaroid 600 series cameras and Polaroid SX 70 cameras. Polaroid Type 778 and Type 779 are professional versions of the Time Zero and 600 films manufactured to tighter tolerances to produce consistent color balance from one emulsion batch to the next. Essentially, 600 and Type 779, and Time Zero and Type 778 are the same emulsions, so that the following comments apply equally to the professional as well as the amateur versions.

Time Zero has a cool neutral color balance while the 600 is neutral leaning slightly towards warmth. 600 has higher color saturation and color intensity than Time Zero. For instance, reds look good in Time Zero prints, but have an extra brightness in 600 prints when you compare matching prints side by side. This does not make one better than the other, just different. Time Zero is used to produce soft subdued prints, while 600 is chosen when bright colors are wanted.

Time Zero is more contrasty than the 600. The 600 has an ISO of 600/29°, which is four time faster than Time Zero with an ISO of 150/23°. The 600 film was specifically designed with a lower contrast than the Time Zero emulsion and with a higher film speed to open up the shadows under the many contrasty light situations that snapshots are often taken under. It is amazing how many snapshots are taken against the light to produce silhouettes against a bright sky. To help eliminate the backlighting problem and the deep shadows produced by sidelighting, many of the Polaroid 600 cameras incorporate full time electronic flashes, which provide fill flash in contrasty lighting and main lighting when light levels are too low for good exposures.

PROCESSING All four films produce well-developed images in about 90 seconds with final saturation being reached in about five minutes. The image is exposed through the front of the film, which would mean that the image would be reversed if the print film were exposed directly to the image coming through the lens. There is a mirror directly

behind the lens that reverses the image the right way around as it reflects the image to the film in the base of the camera.

The technology that produces a Polaroid image is amazing. After the exposure is made, the film is automatically ejected from the camera. The film is passed through two rollers that break the chemical pod and spreads the reagent through the emulsion which starts the processing. A negative image quickly develops in each layer, which acts as a filter that passes or absorbs the dyes heading for the positive image layer at the top of the film. For example, blue light exposes a negative yellow image that blocks the yellow dyes in a layer below it. However, the yellow negative image allows the migrating magenta and cyan dyes to pass to the upper positive image receiving layer where they combine to form blue. Just below the positive receiving layer is the layer where the reagent entered and deposited a white pigment that gives you the white in your picture.

APPLICATIONS Both films are general purpose films widely used to produce snapshots of many family functions from parties and visits by relatives and friends, to weddings and graduations. They also serve to record trips and vacations. They are also used by real estate and insurance people in their businesses. The instant results allows them, as amateur photographers, to have confirmation that they recorded the necessary details.

But one of the most interesting applications of Time Zero and 600 is their use by professional and advanced amateurs as give away pictures. When they meet people they want to take pictures of, they take out their Polaroid and produce an instant picture that they give to the person. This serves as an ice breaker and the people are then usually willing to pose for pictures because the Polaroid print shows them who the photographer is and what he or she is up to. Try it yourself, even if you use a different film format. If you are interested in taking pictures of people, you will find that it is worth the effort to carry a Polaroid with you; those give away snapshots will produce a lot of fine pictures.

Time Zero and 600 can also be used to produce some very fine artistic pictures. Time Zero is particularly good with soft pastel colors, while 600 is good for recording bright, colorful flowers. For such images, it is best to use ambient light rather than electronic flash. Either of the folding Polaroid SLRs, the SLR 680 or the SX-70 Time Zero, are best suited for these purposes. Use a good tripod and a Polaroid cable release and start taking pictures of some of your favorite subjects. Try soft lighting of open and deep shade, and even the soft illumination of window light.

The professional films have photomicrography, industrial, medical, and scientific applications. They are also used in copy and documentation work. Polaroid has special backs and cameras available for various applications, plus copy and closeups stands and microscope adapters for the SLR 680 and SX-70 Time Zero cameras.

Polacolor ER Type 809,
Type 59, Type 559, and Type 669

MANUFACTURER: *Polaroid Corporation*
TYPE: *extended range instant color print film*
SIZES: *8 × 10 sheets, 4 × 5 sheets and packs, 3¼ × 4¼ packs*
FILM SPEED: *ISO 80/20°*
COLOR BALANCE: *daylight 5500K*
NOTES: *processing is instant; processing time of 1 minute can be extended to 1½ or 2 minutes to slightly increase color saturation*
APPLICATIONS: *general purpose, slow, instant-print film; medical, scientific, industrial, commercial photography; studio tests; portraits; art; prints from slides*

Polacolor ER films are extended range instant color films. They are designed to handle brightness ranges up to 1:48, which are normally found outdoors and in commercial studios. With such an extended exposure range, Polacolor ER films are capable of holding both rich shadow detail and delicate highlight detail under most exposure situations. The ERs have strong color saturation and produce brilliant colors right across the color spectrum. Flesh tones, while quite good on Polacolor 2, are even more natural on the newer Polacolor ER. The extended range also produces good exposure latitude, allowing the photographer to key in on a subject off the center of the tonal scale and still get good color and detail in both shadows and highlights.

The best results for Polacolor ER are obtained at temperatures in the range of 70–80 F. Temperatures of 55–90 F will produce acceptable to good results. Note that it is not the exposure temperature that is critical for the Polacolor ER films; instead, it is the processing temperature that is critical. Be careful when processing ER around 90 F, as the negative frame and processing fluid have a tendency to stick to the print at this temperature. Try to avoid this by smoothly peeling the print and the negative diagonally from corner to corner, or taking the precaution of photographing in a cooler environment.

Polacolor ER has an intended exposure range of $\frac{1}{1000}$–$\frac{1}{60}$ sec. Full information on reciprocity corrections for other shutter speeds and for tungsten illumination are contained on the information sheet packed with each box of film. Suffice it to say that thorough tests should be made before committing important images to this film.

Polacolor ER and Polacolor 2 instant prints are easily protected when stored in Polaroid Transparent Protective covers (order #81–33). These stiff acetate covers protect large instant prints from scratches, fingerprints, bending, and allow the photographer to indicate cropping and give other in-

structions on the plastic cover without marring the print.

PROCESSING Polacolor ER instant color print film also has a good development latitude. It is intended for a 60-second development time at approximately 75 F (24 C). When the lighting or scene contrast is high, or the exposure is a bit off, processing time may be extended to 1½ or 2 minutes, which increases color saturation slightly, especially in the highlights, effectively lowering the contrast of Polacolor ER. The changes are slight and subtle, and therefore will not work with extreme contrast or major exposure errors; but with minor or delicate exposure differences, extended processing can improve the results. Polaroid advises that overextended processing will yield more saturated colors and deeper blacks, but may cause a slight cyan bias requiring red-yellow filtration.

APPLICATIONS Polacolor ER is the best instant color print film that Polaroid has developed. ER's excellent color saturation, brilliant colors, and extended range capabilities have greatly broadened the appeal and use of instant color print film in many fields. In particular, Polacolor ER has extended the use of instant color print films in the fields of medical, scientific, industrial, and commercial photography. The extended range makes ER an excellent film to test color setups because it has roughly the same range as many color films.

ER is useful in the studio to show new models how they look on film before a session. The model can see immediately what he or she is doing, and correct mistakes right away. Often the photographer or the model will spot minor flaws in such test shots that might be missed with the naked eye.

Polacolor ER is also an excellent film to make final color portraits, especially with Type 809 in the 8 × 10 size. A customer can walk into a portrait studio and walk out a little while later with a finished print. Speaking of portraits, Polacolor ER Type 559 3¼″ × 4¼″ pack film is now widely used in passport cameras to make color pair pictures.

Polacolor ER is also made in 20 × 24-inch size for two special Polaroid cameras. These large cameras and 20 × 24-inch Polacolor ER were used to record the paintings in the Sistine Chapel for critical examination. The standard size ER films are excellent choices for photographing art and artifacts in museums or other places where the objects cannot be removed and the time for photographing them is short. An instant film such as Polacolor ER assures that you have exactly the right color and exposure before you leave the job. The accidents that can, and do happen in such situations to cameras, exposure meters and films can be avoided by using Polacolor ER which gives the final print on the spot.

Polacolor ER is also an excellent film for producing instant prints from slides because its extended range helps control the buildup of contrast inherent in the reproduction process.

Polacolor 2 Type 808,
Type 58, Type 108, Type 668, and Type 88

MANUFACTURER: *Polaroid Corporation*
TYPE: *contrasty, warm, subdued color instant print film; no useable negative*
SIZES: *8 × 10 sheets, 4 × 5 sheets, 3¼ × 4¼ packs, 3¼ × 3⅛ packs*
FILM SPEED: *ISO 80/20°*
COLOR BALANCE: *daylight 5500K*
NOTES: *instant print processing*
APPLICATIONS: *Antiques, old houses, old documents; under flat, even lighting; I.D. photos; advertising; photomicrography; scientific or medical photography*

Polacolor 2 is an older emulsion than Polacolor ER. Neither is better than the other; rather, they are different types of instant color print films. Polacolor 2 exhibits more contrast than Polacolor ER, and also has more subdued colors than ER. In effect, each emulsion has its own photographic interpretation of the world and a good photographer knows when, where, and how to use each one. Do not dismiss Polacolor 2 because it is older. Learn to use both Polacolor 2 and Polacolor ER and which is the better film to best capture a specific mood or situation.

Polacolor 2 has one unique feature that no other color film has: it corrects itself for 3200K tungsten exposures. At four seconds Polacolor 2 has an exposure index (EI) of 25/15°, and no filtration is necessary. It thus is an excellent film to use in tungsten illumination for exposure durations of four to about 20 seconds as well as for making prints of slides in an enlarger.

Polaroid Colorgraph 891 is an instant color transparency film designed primarily for use in overhead projector systems. It has the same exposure characteristics as Polacolor 2, but is primarily used to make prints from slides and copies of other color materials used for overhead projection systems.

PROCESSING Polacolor 2 Types 808, 108, 668 and 88 are instant print films. Processing time of one minute can be extended to 1½ to two minutes to slightly lower contrast.

APPLICATIONS Polacolor 2 is slightly warmer than Polacolor ER and produces rich, warm coloration although the overall impression is one of subdued, mute colors. Polacolor 2 is the ideal choice when photographing antiques, old houses, old documents and the like, as it adds an atmosphere of older and softer times because of its warm, subtle tones. Polacolor 2 is also a good film to use under flat, even lighting because its strong contrast adds snap to the image.

Polacolor 2 is still widely used wherever contrast enhancement and/or subdued colors are needed in areas as diverse as advertising photography, photo-micrography, scientific, and medical photography.

Polachrome CS Autoprocess Film

MANUFACTURER: *Polaroid Corporation*
TYPE: *general purpose, slow speed color transparency film*
SIZES: *35mm cartridges*
FILM SPEED: *ISO 40/17°*
COLOR BALANCE: *daylight 5500K*
NOTES: *use Polaroid Autoprocessor only*
APPLICATIONS: *general purpose color slide film; industrial, commercial, advertising and other professional uses; teaching/learning photography; photojournalism*

Polachrome CS is an entirely new concept in color transparency film. Polaroid, drawing on its years of instant print experience, has developed a series of 35mm films, including Polachrome CS, that can be processed by the user. Within a few minutes after a shooting a roll of Polachrome, a processed, unmounted, roll of color slides is ready to look at and use.

Polachrome is actually a black-and-white emulsion that derives its color from an additive color screen located next to the clear polyester backing. The Polachrome emulsion actually goes into the camera backwards, with the glossy back of the film facing the camera's lens, while with most traditional films the emulsion faces the lens. With the backing toward the lens, light passes through the color screen before reaching the Polachrome emulsion. The screen consists of 394 triplets of alternating red, green, and blue filtering stripes. Each stripe passes the colors it sees, so only the negative silver halide particles directly behind the color stripe passing light of that color are exposed. For example, light from a red object will only pass through red filters and be recorded by the negative silver particles underlying red stripes; the blue and green filters will block this red light and the silver halides behind them will remain unexposed. After processing, positive silver halides left behind the blue and green stripes block light so viewing light passes only through the red filter stripes, and the original object appears red.

Because of the striped triplet filter construction of Polachrome, this film has only medium grain structure and resolving power, which are unusual for a slow film. Polachrome's color saturation is very high, producing brilliant pictures in direct light such as sunlight and strong pastel-like colors in soft light. Polaroid lists Polachrome as having a ±1½ stop exposure latitude, though actual use indicates that exposure latitude is less generous than specified by the manufacturer, about +1½ stops and −⅓ stop.

When holding a Polachrome slide to light, two characteristics are obvious. First, a Polachrome transparency is denser than other slides; this is because the Polachrome image

contains silver while other transparency materials contain only dyes. The other unusual trait is a stroboscopic red-green-blue pattern much like the one on a weak or disrupted television screen. When the Polachrome image is projected, printed or looked at on a slide viewer, this stroboscopic effect disappears.

Only in very large-scale projections or enlargements will the filter stripe pattern begin to appear, but even then only under close inspection. For example, in a 16×20-inch print the filter pattern will probably begin to emerge in areas where all three primary colors appear, such as skin tones. But view the print from a normal viewing distance of approximately ten feet, and the filter pattern will not be evident. When projecting a Polachrome, for best results do not use a lenticular screen, but rather a beaded or flat surface screen.

Polachrome has an unusual aspect insofar as metering is concerned when used in the camera. Because the glossy back of the film faces front, Polachrome should not be used with off the film (OTF) metering for either ambient light or flash. The reason for this is that the glossy backing has a much higher reflectivity than the matte emulsion side and will produce false readings. So, when using Polachrome with an OTF metering system, meter the subject manually and make manual exposures. With flash, use the flash unit's built-in sensor or manual flash operation.

PROCESSING Every roll of Polachrome comes with its own processing pack. The processing pack contains a processing fluid coated on a strip sheet which becomes temporarily laminated to the film inside the Polaroid Autoprocessor. The processing fluid activates development of negative silver halide grains and the transfer of undeveloped grains to the positive layer. In only 60 seconds the process is completed and the strip sheet and the film are rewound. During rewinding, the negative film layer is stripped

away with the strip sheet leaving the positive image layer affixed to the filter screen and the clear polyester support. You now have a finished color transparency that is dry, ready to be put in a slide mount, and used for projection or printing.

The processing of the film is done inside the Polaroid Autoprocessor, which measures a compact $4 \times 3.8 \times 8.5$-inches. The processing pack and roll of film are inserted in their appropriate places in the Autoprocessor and the die cuts on the film and strip sheet leaders are fastened to appropriate pins on the processor's take-up spool. With the top closed, a manual crank winds the film and strip sheet onto the take-up spool. After 60 seconds the film and strip sheet are rewound by means of the hand crank.

APPLICATIONS The Polachrome CS is a fast and easy way to produce color slides. It is rapidly finding its way into amateur as well as professional photography, advertising, industry, photojournalism and teaching.

Polachrome is a general purpose film with slightly warm color balance. It is suitable for most subjects with the exception of finely detailed subjects or pictures intended for very high magnifications. It is an excellent film for companies developing new products and other businesses requiring confidentiality, as the user may process the film himself in minutes with no need for a darkroom, other personnel, chemistry or running water. Polachrome is useful in newspaper and magazine work where color images are needed quickly to meet deadlines. It is also a very useful film for making quick slide duplicates for submission to agents, publishers, and other potential buyers. Polachrome is excellent for photographic classes and workshops because it is available in 35mm and may be processed by anyone in minutes, even by those without any knowledge of film processing, giving students rapid feedback.

Polapan CT Autoprocess Film

MANUFACTURER: *Polaroid Corporation*
TYPE: *medium-speed, continuous-tone, black-and-white positive transparency film*
SIZES: *35mm cartridges*
FILM SPEED: *ISO 125/22°*
SENSITIVITY: *panchromatic black-and-white*
NOTES: *use Polaroid Autoprocessor only*
APPLICATIONS: *learning photography; slide shows; audiovisual uses; advertising, publishing, industrial and commercial uses*

Polapan CT is the result of an entirely new concept in black-and-white films. After years of experience with peel-apart black-and-white instant films, Polaroid has developed a method of producing nearly instantaneous black-and-white positive transparencies.

Polapan is a continuous tone (CT) medium speed fine-grain, black-and-white transparency film with high resolving power.

Polapan, like all Polaroid Autoprocess films, has no processing latitude because of the nature of the process. The final results must be controlled before processing via exposure and lighting. This film has a good exposure latitude of about +1½ stops and −1 stop. It has a good tonal range and produces both clean highlights and deep blacks.

Black-and-white is the best medium to use when learning about photography because it allows the photographer to concentrate on shape and form and content without the complex elements of color relationships and their effects on viewers. Thus Polapan is an excellent film both for teaching and studying photography, as it provides rapid feedback. It also cuts down on darkroom time so that more time may be spent on imagery and less time on the mechanics of photography. Polapan is available in the popular 35mm size so that special cameras are not needed to benefit from the quick results of this Autoprocess film.

Polapan, like other Polaroid Autoprocess films, is inserted into the camera with its glossy backing facing the incoming image whereas standard films have their dull emulsion side facing forward towards the lens. Most built-in camera meters can, be used however, with both standard and Autoprocess films. One exception, however, is through-the-lens, off-the-film (TTL-OTF) metering used for ambient light and/or flash measurement, as the glossy backing of the Autoprocess films reflects too much light back to the OTF metering cells, creating false readings and badly exposed images. If your camera has OTF metering, use manual metering and set aperture and shutter speed manually when using Polapan and other Au-

toprocess films. If your flash unit has its own built-in sensor, use this instead of its OTF capabilities with Autoprocess films, and if the flash has no self-sensor, use manual flash control.

Because of its newness and unique nature, Polapan is still being discovered by many photographers and its uses are being explored in many fields. Its handling is different than that of standard films, but it takes little time to learn how to use Polapan. It can be processed by anyone, even those who have never previously processed a roll of film.

PROCESSING Like all Polaroid Autoprocess films, each roll of Polapan is supplied with its own processing pack containing processing chemicals and a strip sheet which applies the chemicals to the film's emulsion. An exposed roll of film is loaded in the Autoprocessor together with its matching processing pack. With the cover of the Autoprocessor closed, the film and the strip sheet are laminated together as they are wound on the take-up spool. One minute later the direction lever is flipped to "Rewind" and a

hand crank is used to rewind the film back into its cassette and the strip sheet back into the processing pack.

During the 60 second self-processing of Polapan and other Autoprocess films, a soluble silver complex formed by unexposed silver halide is converted to a high covering power positive silver image. During the rewinding of the film, unused silver and developer are peeled away with the strip sheet, leaving the positive image on a polyester film base. The processing temperature range for Autoprocess films is a wide 60 F–84 F (15 C–29 C).

APPLICATIONS With its panchromatic sensitivity, Polapan is a general purpose film useful for creating original work or making copies for projection in audiovisual or general purpose slide shows. Polapan is also a good film to use when making quick black-and-white originals or copies of color works or when creating black-and-white slides of photographs for advertising, publishing, industrial and commercial use. Prints can also be made directly on Polaroid Print Films or via black-and-white internegatives.

Polagraph HC Autoprocess Film

MANUFACTURER: *Polaroid Corporation*
TYPE: *high-speed, high-contrast positive transparency film*
SIZES: *35mm cartridges*
FILM SPEED: *ISO 400/27°*
SENSITIVITY: *panchromatic*
NOTES: *use Polaroid Autoprocessor only*
APPLICATIONS: *black-and-white positive transparencies for slide shows and audiovisual purposes; printing; graphic arts; creative special effects*

Polagraph HC is a high contrast, high speed black-and-white film with panchromatic sensitivity. It is a Polaroid Autoprocess film, similar to Polapan CT and Polachrome CS. Polagraph HC produces high contrast positive black-and-white transparencies.

Because of its high speed, Polagraph HC should be handled only in subdued light. Polagraph and other Autoprocess films are loaded, advanced and rewound normally in 35mm cameras. Two points of caution should be noted here: do not insert the film leader more than is necessary into the take-up spool lest the die cut hole in the leader get caught up inside the spool, and do not rewind the film completely into its cassette because the leader must be hooked onto the take up-spool in the Autoprocessor. If the leader is accidentally rewound into the cassette, a film retriever is used for pulling the leader back out of the cassette. This retriever is supplied with the Autoprocessor.

Polagraph, like the other Autoprocess films, is a rapid access film needing no darkroom and no knowledge of film processing to be used and processed. It only takes a few minutes to learn how to use and process this film. Polagraph is one of few 35mm high contrast films, and the only one to produce a positive, high contrast image.

PROCESSING Each roll of Polagraph HC Autoprocess Film comes with its own processing pack for use in the Polaroid Autoprocessor only. The film and pack are loaded simultaneously in the Processor. Processing takes only 60 seconds, at the end of which time a roll of uncut, positive transparencies emerges from the processing unit. Excess developer and silver are stored in the depleted processing pack.

APPLICATIONS Polagraph is suitable for reproducing line art, hand-written and typed copy for printing for slide shows. It is also apropos for special effects work in the graphic arts field and for creative photography where high contrast abstractions are desired. Prints can also be made directly on Polaroid Instant Print films.

Polaroid Type 51 High Contrast Print Film

MANUFACTURER: *Polaroid Corporation*
TYPE: *high-contrast black-and-white print film; no useable negative*
SIZES: *4 × 5 sheets*
FILM SPEED: *tungsten—EI 125/20°; daylight—EI 320/26°*
SENSITIVITY: *blue-sensitive*
NOTES: *processing is instant; prints must be coated*
APPLICATIONS: *High contrast, graphic photography; architecture; photomicrography; scientific, medical and industrial photography; copy work; graphic arts; creative photography; printing*

Polaroid Type 51 High Contrast Print Film is a blue-sensitive black-and-white instant print film. Raw silver halide grains in any emulsion are only sensitive to blue and ultraviolet light; sensitizers must be added to the emulsion to sensitize silver halide particles to red and green light. In Polaroid Type 51, these sensitizers have not been added. With blue sensitive films, only record blue light and objects that reflect blue light are recorded which results in high contrast prints of most normal scenes. Type 51 produces rich, deep blacks, clean whites and very little in between.

Because it is a blue-sensitive film, Type 51 is more sensitive when exposed to daylight quality light than to tungsten light, which is low in blue light. Type 51 has the following approximate exposure indexes: EI 125/20° at 3200K, EI 320/26° at 5500K, EI 500/28° at 7500K, and EI 640/29° at 10,000K. Type 51 has rather normal reciprocity characteristics, with an intended exposure range of $\frac{1}{1000}$ to $\frac{1}{10}$ sec. At one second increase the exposure by $\frac{1}{3}$ stop, ten seconds needs an increase of $\frac{2}{3}$ stop and 100 seconds requires a $1\frac{1}{3}$ stop exposure increase.

Though 51 is a blue-sensitive film, this does not mean only blue light or blue subjects may be photographed. Any subject that looks as though it will look good as a high contrast print will reproduce well on Polaroid High Contrast Print Film.

PROCESSING Type 51 is an instant film, processed in-camera. All prints must be coated for permanence and protection from contamination and abrasion.

APPLICATIONS Type 51 is useful for making strong, graphic pictorial pictures of people, buildings, and nature. It is useful in copy work where low and medium contrast subjects need contrast enhancement. It is used in the graphic arts for tone separation prints and other special effects. Type 51 has applications in photomicrography, metallography, as well as in scientific, medical, industrial, and commercial photography. It is also an excellent film for quickly making screened halftone prints for reproduction.

BLACK-AND-WHITE

Polaroid Type 55
and Type 665 P/N Films

MANUFACTURER: *Polaroid Corporation*
TYPE: *ultra fine-grain, slow-speed negative plus positive black-and-white film*
SIZES: *Type 55: 4 × 5 sheets; Type 665: 3¼ × 4¼ sheets*
FILM SPEED: *Type 55: tungsten—EI 37/17°; daylight—EI 50/18°; Type 665: tungsten—EI 50/18°*
SENSITIVITY: *daylight—EI 75/20° panchromatic*
NOTES: *processing is instant, black-and-white print with useable negative*
APPLICATIONS: *Type 55—medical, scientific, and industrial photography; MP-4 copy system; O+ER Proprinters I and II; studio tests. Both types useful for copy work, documentary, product shots, architecture, medicine, science, portraits*

Polaroid Type 55 and Type 665 are instant print films that produce ultrafine-grain black-and-white negatives plus black-and-white instant prints. After a processing time of 20 to 35 seconds at normal room temperature, the print is peeled from the negative, and is then coated with an applicator that comes with the film to preserve the image against fading. Within a few minutes the negative must be cleared in a sodium sulfite solution to prevent residual developing agents from staining the negative. Rinsing in water is not sufficient to dissolve and remove expended processing agents from the negative, even though it might appear as if the negative is cleared to the naked eye; any remaining agents may stain the negative and cause image degradation. Never use standard film fixers with a Type 55 or 665 P/N negative as these negatives are not designed to withstand such concentrated chemicals.

The instructions for Type 55 and Type 665

specify different strengths for dilute sodium sulfite solutions—12% and 18%, respectively. However the 12-percent solution may be used for both films with equal effectiveness. To make a 12-percent solution, mix one dry ounce of sodium sulfite with seven ounces of warm water. To make a pint, mix two ounces of sodium sulfite with 14 ounces of water, and double both to make a quart. When using either type of Polaroid P/N in the field, carry a plastic tank with an airtight top filled with sodium sulfite solution and place each negative in the solution. Negatives may be left in the solution up to 72 hours without being damaged.

When the negative is separated from the positive image, reagent chemicals are peeled away with the negative, leaving a damp dry print. This is the way all Polaroid peel-apart films work, but the P/N films are the only materials that produce both prints and useable negatives. P/N prints do not have to be

coated immediately, but the sooner the better, especially if they are taken in strong light. After the print has been coated, it will dry in 15 minutes to an hour or so, depending on the relative humidity.

Type 55 comes in packs of 20 4 × 5 sheet films to a box. It has an exposure index (EI) of 50/18° for both daylight and electronic flash. Under tungsten light, Type 55 is ½ stop slower, with an EI of 37/17°. Type 55 sheet film is used in a Polaroid Model 545 4 × 5 sheet film holder which fits most 4 × 5 large format cameras and can be used on larger cameras that have 4 × 5 adapters. Type 55 film and the Model 545 holder also fit special cameras designed for medical, scientific and industrial uses as well as the O/ER Proprinter Models I and II for making instant prints from slides. Type 55 is also used in the Polaroid MP-4 copy system.

Type 665 is a 3¼ × 4¼ pack film with eight exposures to a pack. Type 665 has a daylight EI of 75/20° and a tungsten EI of 50/18°. Type 665 is used in Polaroid's Model 405 Pack Film Holder, which fits most 4 × 5 large format cameras as well as special cameras designed for medical, scientific, and industrial applications. Type 665 is used in many instant-print-from-slides units. Most makers of medium format cameras have pack film holders for their cameras useable with Type 665 P/N, although the actual image size is smaller than the full 665 negative size of 2⅞ × 3¾.

Although Type 55 and Type 665 have different film speeds, they are essentially the same. They produce simultaneously a panchromatic black-and-white print and a fully developed ultrafine-grain negative without a darkroom. The prints have medium contrast, moderate exposure latitude and very fine grain. The negatives have ultrafine grain, good contrast, very high resolution, and will produce very high magnification prints.

Types 55 and 665 are particularly useful whenever a photographer needs a black-and-white instant print, multiple copies of a print, and/or enlargements.

Because these emulsions approximate the contrast and tonal range of slow and medium speed black-and-white negative films, Types 55 and 665 are often used by professional photographers to test lighting and other studio arrangements before making their final exposures. But many others use these films for the final images because the negative gives them the ability to make enlargements often required by their clients.

Not enough photographers take the negative seriously. It is a high quality negative as good as any black-and-white negative available. Some photographers use these films in medium format cameras only to check lighting, and setups. Thus they tend to ignore the 3¼ × 4¼ negative as a product because it is too large for their 120 roll and smaller-sized enlargers. But the P/N negative will fit into such an enlarger. All that has to be done is to trim off the excess and unused portions of the 665 negative to make it the same width as a 120 negative.

PROCESSING Both Polaroid Type 55 and Type 665 are instant print films. Positives must be coated and negatives cleared in the appropriate dilution of sodium sulfite solution.

APPLICATIONS The Polaroid P/N films are very useful for portraits, product shots, copy and restoration prints, nature and scenic studies, and documentary work. They are used in the fields of architecture, industry, fashion, medicine, and science. In fact, Types 55 and 665 are widely used whenever instant confirmation of the image is desireable and a negative is also needed to make duplicate prints or enlargements.

Polapan Type 52
and Type 552

MANUFACTURER: *Polaroid Corporation*
TYPE: *fine-grain, high-speed, wide tonal range, black-and-white instant print films; produce no useable negatives*
SIZES: *4 × 5 sheets and packs*
FILM SPEED: *tungsten: EI 300/26°; daylight: EI 400/27°*
SENSITIVITY: *panchromatic black-and-white*
NOTES: *processing is instant; prints must be coated*
APPLICATIONS: *rendering full tonal range in high contrast situations; publications; architectural, commercial, scientific, industrial and documentary photography*

Polapan Type 52 and Type 552 are very fine-grain, high speed black-and-white instant print films with long tonal ranges and moderate contrast. Type 52 is a 4 × 5 sheet film packed 20 to a box and used in a Polaroid Model 545 Sheet Film Holder or its equivalent. Type 552 is a 4 × 5 pack film with eight exposures to a pack and is used in the Polaroid Model 550 Pack Film Holder. Pack film is less expensive than sheet film and is ideal for volume and rapid speed shooting.

These Polapan films are panchromatic, with an EI of 400/27° in daylight and electronic flash, and an EI of 300/26° in tungsten light. Both Types 52 and 552 have good reciprocity characteristics and require no exposure correction from $\frac{1}{1000}$ to one sec.

PROCESSING Polapan Type 52 and Type 552 are instant print films which require coating.

APPLICATIONS The Polapans have excellent tonal renditions, and moderate contrast, making them particularly well-suited for general purpose photography. They are very good for recording shadow detail and the full range of tones in a high contrast scene. Types 52 and 552 are particularly useful in making black-and-white prints from slides because their lower contrast keeps the contrast gained during the reproduction process from blocking up the print, thereby making such prints very useful for newspaper and magazine reproduction.

The Polapans are especially useful in photomicrography when black-and-white prints are needed of high contrast specimens. Types 52 and 552 are widely used for architectural, commercial, scientific, industrial and record photography. They produce excellent detail in product and still life photography. Their moderate contrast and fine grain make them excellent films for portraits and illustrations in newspapers, magazines and journals. They are also very useful in copy setups such as the Polaroid MP-4 for keeping high contrast subjects under control.

Polaroid High Speed Print Films:
Type 57, Type 107, Type 107C, Type 667, Type 87, and Type 47

MANUFACTURER: *Polaroid Corporation*

TYPE: *fine-grain, very high-speed black-and-white instant print film; no useable negative*

SIZES: *type 57: 4 × 5 sheets; Type 87: 3¾ × 3⅜ sheets; Types 107, 107C, 667: 3¼ × 4¼ sheets; Type 47: 3¼ × 4¼ roll film*

FILM SPEED: *EI 2000/34°, daylight–EI 3000/35°*

SENSITIVITY: *tungsten–panchromatic black-and-white*

NOTES: *processing is instant print; Types 57, 107 and 47 require coating, others do not*

APPLICATIONS: *photojournalism; field work; scientific and medical photography; industrial, architectural and commercial photography; low light photography*

Polaroid calls these films "High Speed," but at EI 3000/35° in daylight and EI 2000/34° under tungsten light, they are actually *very* high speed films that offer available light capabilities under low light conditions and high shutter speeds with great depth of field at good light levels. Types 107, 107C and 667 are 3¼ × 4¼ pack films that are especially well-suited for use in Polaroid's 600SE camera. This is a press/field camera which, when combined with one of the 3¼ × 4¼ pack films, is an excellent general purpose combination for newspaper, real estate, and other types of press or field work where instant black-and-white prints are needed for reproduction or display.

The Polaroid High Speed Films have average reciprocity characteristics intended for exposures from ¹⁄₁₀₀₀ to ¹⁄₁₀ sec. At one second, increase exposure by ½ stop, at ten seconds increase by one stop and at 100 seconds increase exposure by 1½ stops. When exposing Polaroid High Speed Films under light with high color temperatures such as open shade or overcast skies, decrease the exposure by ⅓ stop.

PROCESSING All of the Polaroid High Speed Films are instant print materials. Types 57, 107 and 47 require coating to make the image permanent. The coater liquid neutralizes alkalinity and removes any residual processing reagent left on the print. The coater dries to a hard plastic coating which protects the print from fading, atmospheric contamination and abrasion. The rest of the High Speed Print Films are coaterless because the image forms deep enough within a regenerated cellulose receiving layer to be protected from light, contamination, and scratches. The

coaterless emulsions are particularly useful for press and field work because the prints are already nearly dry when the negatives are peeled away, making rapid shooting convenient.

APPLICATIONS The Polaroid High Speed Print Films are used in science for high speed event analysis and nondestructive test recording, and are employed in medical photography for diagnostic records. These films are used in photomicrography to record average to low contrast specimens, and whenever high speed film is needed. Polaroid High Speed Print Films are also widely used for CRT image recording, non-freeze-frame ultrasound devices, open-shutter nuclear medical equipment and CAT scanners, as well as are in commercial photography, especially where low light levels must be used. These films are useful in architectural photography where great depth of field is needed and indoors where low light levels are encountered. In short, wherever a very high speed black-and-white instant print film is needed, one of the Polaroid High Speed Print Films is commonly used.

DUPLICATING

Introduction to *DUPLICATING*

Duplicating—the art of making slides from slides, negatives from slides, instant prints from slides, slides from negatives, and negatives or slides from prints—used to be the province of professionals, but with the advent of new equipment can be done by almost anyone.

Using standard duplicating films requires a high degree of expertise because they require exacting color balance to make excellent duplicates. The problem with using standard films for duplicating is that they are of high contrast, which must be lowered by fogging the film with white light. Slide duplicating units, such as the Alpamaster, fog the film during the exposure via light drawn from the main flash through a fiber optic. Fogging can also be done with any duplicating setup if the camera used has provision for double exposure.

Duplicating serves many purposes. It is probably used most often to preserve the original transparency while the duplicates are passed around to clients and used in projectors. Duping is used to create new images through montage and special effects. Duping is also used a great deal to correct color balance and exposure mistakes. The duplicating of prints, often referred to as copying, serves many purposes. Prints are duplicated when the original negative is lost. Damaged prints are duplicated to restore them. Instant prints are duplicated in order to preserve the image and to make enlargements.

The main thing to remember is that modern equipment has taken all the mystery out of duplicating and makes it easy for any photographer to duplicate with excellent results.

Instant Print Films for Printing Transparencies

Instant print films have for many years been used only as in-camera films to produce original pictures. Years ago though, many began exploring the uses of instant print films as methods of making quick enlargements from color transparencies. The purpose was two-fold. One purpose was to produce quick prints from one to a few slides without having to set up a full color process, thus saving hours of work for a few color prints. The promise to send someone that you had photographed a picture became much easier by making an instant print copy.

The second purpose is more for professional and commercial applications than for personal reasons. Black-and-white conversions for printing purposes require a lot of time-consuming work making black-and-white internegatives and black-and-white prints from the internegatives. The instant black-and-white print materials provided the answer for producing quick black-and-white conversions from color transparencies. Not only can you make a quick print, but you can also produce a black-and-white negative to make enlargements from slides by using Polaroid's Positive/Negative films.

O + ER of Reston, Virginia has designed a series of enlarging easels for the various instant film holders, which has solved the mechanical problems of enlarging with instant print films, so that printing a transparency on instant print film is easy once you have made a few tests. Instant print films are a lot faster than standard enlarging films so you will have to add some neutral density filtration to your enlarger. Kodak PR 144, for ex-

ample, needs 30CC of cyan (C), magenta (M), and yellow (Y) for neutral density, plus CC40 cyan and CC15 yellow for a total filter pack of 70C, 30M, and 45Y, with an exposure time around 8 sec. using a Kodachrome or Ektachrome original slide. With Agfachrome slides, the filter pack is slightly different at 70C, 50M, and 40Y. Different film stocks will vary in the filtration needed and each enlarger will be different in color balance and light intensity, so testing is very important.

Polacolor ER and Polacolor 2 have an unusual feature: when they are exposed for times of 4 sec. or longer, their reciprocity characteristics are such that they become balanced for 3200K light. The Chromega C-700 enlarger uses a 3200K tungsten halogen lamp, which is perfect for printing these Polacolor films. Thus only neutral density filtration of 60C, 60M, and 60Y is needed to make Polaroid Instant Print copies. With Polaroid P/N films, use 90 units of each of cyan, magenta, and yellow.

Using a printing time of 8 sec. or more allows enough time to dodge shadow and dark areas to lighten them. However, because most of the instant print materials are very dark and low-light printing levels are used, it is hard to see the image. Turn the darkroom lights off and adjust to the darkness before you do any dodging.

The use of instant print films as enlarging materials gave rise to a new type of machine, the instant slide printer. Instant print films are balanced for exposures by daylight-type light. Thus all the instant slide printers use electronic flash to make their exposures. The

machine is loaded with instant print material, the 35mm slide is placed in a holder, the "expose" button is pressed, and the instant print is removed and develops according to the type you are using. These instant print machines are very easy to operate and in fact, are being used in many areas from making copies of personal photos to send to family and friends, to commercial and professional uses in color labs, photo stores, graphic arts, and publishing.

The most versatile instant print machine is the O + ER Proprinter II. It uses double UV filtration, strong light diffusion for lower contrast, and a flat field enlarging lens with apertures from $f/3.5$ to $f/16$. The Proprinter II has a Grafloc-type mount that takes any Grafloc-type back. It uses both $3\frac{1}{4} \times 4\frac{1}{4}$ or 4×5 Polaroid pack and sheet films and produces full frame or cropped images from 35mm transparencies. Because of its versatility, you can also make instant copies on Polaroid high-speed films and their high-contrast film. You can also use the Proprinter II to make color or black-and-white internegatives, and even enlarged color transparencies using sheet film in standard sheet film holders.

The only printer with contrast control is the Polaroid Polaprinter, which uses a variable lenticular screen. The Polaprinter produces only cropped images on $3\frac{1}{4} \times 4\frac{1}{4}$ pack film. Polaroid also makes the only large-format instant slide printer in their Polaprinter 8 × 10 slide printer. The Polaprinter 8 × 10 produces either full-frame or cropped prints or overhead transparencies on 8 × 10 Polaroid Polacolor ER, Polacolor 2, or Polagraph 891.

The Hanimex Diaprint is the only instant slide printer that can be used as an integral part of a slide projector as well as an independent unit. Used on any Hanimex La Ronde projector, you can press a lever to move the slide being viewed into the Diaprint. Press the exposure button and you can continue the slide show while the print develops.

The Durst Diacopy 810 is the only machine that uses Kodak instant print material. It has enough exposure latitude to use either PR 144 or HS 144. The Samigon Rapid Image 205 produces full-frame images on $3\frac{1}{4} \times 4\frac{1}{4}$ Polaroid pack film and the Vivitar Instant Slide printer produces cropped images on the same film. The Vivitar unit is the least expensive of the instant slide printers, but produces excellent quality images. It has become a favorite of color labs and camera dealers for producing instant prints from slides for customers.

While the highest quality prints for display and exhibition purposes are produced on conventional enlarging papers, there are many cases where instant prints from slides can be very useful for personal, professional, business, commercial, and industrial applications.

Using Standard Films As Duplicating Films

Any standard color reversal film can be used to make duplicate transparencies of original transparencies. Any color negative film can be used for making color internegatives and any black-and-white negative film can be used to make black-and-white internegatives. The best films to use are generally those with slow speed, because they have the finest grain and highest resolution. But, to turn a fine-grained original into a textured, grainy image, use high-speed grainy films and even push process them for increased effect.

There are many reasons for making duplicate slides and internegatives. Business and industry use duplicate slides to give to their salesmen for presentation work. Photo agencies use them to submit images to their clients. Photographers use them to make submissions to agencies and other clients. The duplicate prevents loss or damage of the original in the mails or in the client's hands. The duplicate is also used by many photographers for general handling and projection. Each time a slide is projected, the light causes a bit of fading to take place, project a slide enough times and it will be quite changed from its original coloration. Protection from damage and multiple use of an image are the most common uses of duplicating.

Another major use of duplicating is to correct an original slide. While extensive color corrections cannot be made to bring a transparency to perfection, a satisfactory substitute can be created. However minor color corrections, such as a slight warming or cooling of tone, are easy to do successfully. Cropping an image to improve its composition is also easy to do and can make a drab slide into an exciting one. Duping is also useful for creative purposes, from making montages of two or more images, to creative color or image enhancement through the use of special filters. You can also make false color images from correct color originals by using Ektachrome Infrared Film.

Internegatives are useful in areas where there are no labs able to make prints from slides. Internegatives are often used when very large prints are going to be made from small color reversal originals, for instance a 35mm slide will be intermediately enlarged onto 120mm or 70mm film or even 4 × 5 sheet film from which the final print is made. For black-and-white prints from color slides, the simplest method is to make a black-and-white internegative, which will produce excellent prints.

While either daylight or tungsten film can be used for making duplicates, it is important to match the film to the light source you will be using when duping. A color enlarger head such as the Omega C-700, which has built in dichroic color filtration, or a unit such as the Chromapro slide duplicator, to which you only need to attach your camera to make dupes, use 3200K tungsten halogen lamps. Therefore, it is best to use tungsten-balanced films with such units.

Other units, such as the Bowens Illumitran, Copytram, or Alpamaster, are set up with built-in electronic flashes for use with daylight films. Beseler makes a du-

plicator that uses both tungsten and flash illumination so that you can use both types of film. Spiratone (a mail order house in Flushing, New York) makes a number of different slide duplicators and duping accessories in the inexpensive to moderate price range, and most can be used with any light source from daylight, to electronic flash, to tungsten.

No matter what film you use to duplicate, always use an ultraviolet filter such as a Kodak Wratten 2B or Tiffen UV 17 because ultraviolet light will degrade the duplicate. When using tungsten light, always use a heat-absorbing filter between the light source and the originals to protect them from heat damage. Also use a small fan if you can, to draw heat away from your slides and camera. The Chromapro has a built-in fan exhaust system to insure coolness at the slide stage, even though there is a built-in heat absorbing filter.

The standard slide mount for all 35mm slides is slightly smaller than the image area of the film. To make a good 1:1 (lifesize) duplicate or internegative of the entire image area, remove the slide from its original mount and remount it in a full-frame slide mount, such as the ones made by Gepe or Spiratone. If you duplicate a slide in its original mount, you will only record 86 percent of the original picture area.

Standard films have higher contrast than duplicating films and the duplicating process itself builds contrast. Fogging is used to keep the contrast under control. The Bowens Illumitran has an accessory called a Contrast Control Unit as a fogging device. It is a second flash system that sends a burst of light into the image path via a piece of glass at a 45-degree angle. The Alpamaster uses a fibre optic to pass some of its flash directly to the film via a connection at the camera mount. The extra light is recorded in the lower tones of the image, which raises the brightness of these tones, thus effectively lowering the contrast.

Both the Illumitran and the Alpamaster have variable controls on their fogging units to adjust the amount of contrast control for individual images as well as individual films. For instance, Fujichrome 50 requires a fogging setting of 8 on the Alpamaster, while Kodachrome 25 needs a setting of 11 because it is a contrastier film.

For units such as the Bowens Copytran, the Chromapro, and the Spiratone units, fogging is done via double exposure. One exposure is made of the light source without the image in place at about ⅙ of the exposure used for recording the image. The light intensity is cut down by using neutral density (ND) filters between the light source and the camera. Start out with an ND 1.5 plus one, two, or three of the ND.3 filters will give you very good control of the contrast of the film you are using, plus control of various images. Make one exposure without the slide in place, but the ND filters in place. Use the double-exposure lever to cock the camera without advancing the film. Remove the ND filters, put the slide to be copied in place, and make a second exposure. You have now made a dupe with reasonable contrast.

Standard films will need no color-correction filtration for straight duplication unless critical color balance is needed. Testing and exact replication of your successful results will make duplicating easy and help you to preserve your precious original images.

Ektachrome Slide Duplicating Films
5071, 6121, and SO-366

MANUFACTURER: *Eastman Kodak*
TYPE: *very slow-speed, low-contrast color reversal film for duplicating original transparencies*
SIZES: *35mm cartridges, and sheets*
FILM SPEED: *see chart below*
COLOR BALANCE: *see chart below*
NOTES: *process in E-6 or equivalent; may be processed by the user*
APPLICATIONS: *slide duplication*

The Ektachrome Slide Duplicating Films are E-6 process films that are processed exactly as all other E-6 films unlike earlier duplicating films which required special processing times. Though results are the same with each of the three films, different exposure durations and light sources are used for each one.

The Ektachrome Slide Duplicating Films are geared to reproduce original transparencies, a procedure that by its nature increases contrast. Thus these Ektachromes have unusually low contrast in order to minimize contrast buildup. They are also *very* slow speed and have extremely fine grain so as not to add to the grain of the original, and very high resolving power to reproduce fine detail.

All Ektachrome Duplicating Films require the use of color compensation (CC) filtration, usually a combination of two of the three primary subtractive colors (yellow, magenta, and cyan) or three additive colors (red, green, and blue). The 6121 sheet films come with exact CC filtration information for that batch listed on the information sheet while 5071 and SO-366 have both CC and exposure correction information on their packages. Full details for applying correction information are given on each film data sheet. Kodak's recommendations may seem somewhat inaccurate in actual use, but this is because the emulsions were not tested on your equipment, whose color and exposure variations may be different from those of Kodak's test lab equipment. Therefore it is always wise to do a test roll before using any of these emulsions for the first time. Always use the same lab to develop duplicating films, too, as these films are much more susceptible to processing variations than standard emulsions.

Ektachrome Duplicating films are delicately balanced to reproduce original colors as accurately as possible. It is, therefore, important to use a UV blocking filter such as a Kodak Wratten 2 or 2E, or a Tiffen UV17, as ultraviolet light can greatly alter color balance from one original to the next. It is also important to use a heat absorbing filter between the light source and the original transparency when working with an enlarger or

other tungsten light source directly behind the original transparency, as excessive heat will cause a slide to warp. .

When using Ektachrome Duplicating Films, the UV filter, and heat filter when necessary, remain constant regardless of the original. However, the CC filtration may need to be adjusted for different film types and makes. Any film type or make of transparency can be successfully duplicated, but each type needs customized filtration, so be sure to set up a group of average test slides, one from each type of original transparency material you use, and test this group with each new batch of duplicating emulsion. Both the standard set of originals and the set of duplicates are useful when making comparisons to the results of new batches.

It is not possible to produce an *exact* duplicate of any original, no matter what film stock is used for duplication. So look at "dupes" as if they were other originals: if they look good and please you, then they are good. Only when there is something wrong, such as poor color balance, do you then go back and check the original to work out where the problem is.

The Ektachrome Duplicating Films are delicate emulsions and must be refrigerated. It is advisable to buy a batch of one emulsion number, make tests and freeze the remainder until use to limit emulsion changes as much as possible.

PROCESSING The Ektachrome Duplicating Films are sold without processing. They may be processed by the manufacturer via Kodak mailers or through any photo dealer, by any lab using E-6 chemicals, or by the user in such chemistries as Unicolor Rapid E-6. It is most important when processing Ektachrome Duplicating Films to standardize processing methods for consistent results.

APPLICATIONS Here is how each film is most commonly used.

Ektachrome Slide Duplicating Films—Recommended Setups

6121 sheet films balanced for tungsten exposure and contact printing or for use in an enlarger. Exposure time is set for ten sec. with latitude of five to 20 sec. Using a ten-second exposure time, the correct aperture will be at ½ footcandle or 5.38 LUX without filters in the light path.

5071 35mm and 46mm roll films balanced for tungsten light and used in-camera. This emulsion is set up for exposures at, or around one second with exposure indices from 2/5° to 16/13°.

SO-366 known also as Ektachrome SE Duplicating Film because it is designed for the short exposure duration of electronic flash set at ¹⁄₁₀₀₀ sec. Exposure indices of 2/5° to 16/13° are used with a constant light source to compose and focus the slide to be copied, and when daylight is used to expose SO-366 with an exposure time of ¹⁄₁₀ sec. (SO stands for special order which means that most dealers do not keep this emulsion in, but can order it for you from Kodak: Catalog No. 159 0223 for a 36-exposure roll or Catalog No. 159 0236 for a 100-foot roll of 35mm.

Kodak Vericolor Slide Film

MANUFACTURER: *Eastman Kodak*
TYPE: *color film for making transparencies from color negatives or reverse text slides*
SIZES: *#5072: 35mm × 100 feet; #50–279: 35mm × 36 exposures*
FILM SPEED: *EI 3/6°–12/12°*
COLOR BALANCE: *tungsten 3200K*
NOTES: *process in C-41, Unicolor K-2 or similar process*
APPLICATIONS: *used to make 35mm slides for projection (or printing) from 35mm color negatives; for reverse-text and reverse-image slides; audiovisual use*

Kodak Vericolor Slide Film is actually a color negative film specially balanced to produce color transparencies directly from color negative films. Instead of using the colored coupler, color negatives normally used for color prints, Vericolor Slide Film uses colorless couplers to produce slides for projection. Vericolor Slide Film is a negative film stock and does not need reversal processing because it is used to duplicate from a negative image.

PROCESSING Vericolor Slide Film is processed in standard color negative processes such as Kodak C-41, Unicolor K-2 or similar chemistries with standard negative processing times because it produces a negative *from* a negative. Some care should be taken to standardize processing procedures so as not to alter color balance, as the Vericolor slide is the final (positive) product, and no further corrections may be made in exposure or color balance.

APPLICATIONS Vericolor Slide Film is used for making positive transparencies from color negatives, and designed for exposure times of ¼ to eight seconds with ideal exposures from one to four seconds. When using a standard duplicating setup with tungsten illumination, set the exposure meter to ISO 6/9° and bracket exposures two stops in half-stop increments. Start with a filter pack of CC50 Magenta and CC50 Yellow for exposure tests. Then vary the filter pack ± CC20 of both Magenta and Yellow in CC5 increments. This should correctly establish both exposure and filtration for any original color negative film stock. Make color tests for each color negative film stock used.

Vericolor Slide Film may also be used to produce reverse-image and reverse-text slides. Any black-on-white print, line drawing, or text from books or papers can be used to produce white images on a colored background. Kodak publication S–26, "Reverse-Text Slides," discusses six different methods for making reverse text/image slides. This publication is available from Eastman Kodak Company, Department 412-L, Rochester, New York 14650.

Using Color Negative Films for Copying Transparencies and Prints

Many people feel that a major drawback to using instant print materials is that they are final prints and cannot be reproduced as negatives or transparencies can. This is not true, for they can be easily copied on color negative stock. The methods are different, but the result is the same as if you made a color negative from a transparency. A color negative is made from a transparency using light passing through the transparency image. An instant print, an Agfachrome Speed in-camera print, or any color print where the negative or transparency has been lost, is copied on color negative film by reflected light.

The easiest method is to use a copy stand with a pair of lights positioned at 45-degree angles to the exposing plane. Most copy stands have light bulb sockets for using 3200K tungsten bulbs, but you will want to use electronic flash, because all standard color negative films are balanced for daylight. Spiratone Inc. and Morris-Toshiba both make electronic flash units that fit into ordinary light bulb sockets, and they are reasonably priced. But you can use any pair of electronic flashes; your local photo dealer can help you in getting mounts to attach them to the light arms of your copy stand.

Meter the flash output at the image-taking surface with a flash meter, such as the Minolta or Sekonic flash meters, using a flat diffuser. Some standard hand-held light meters, such as the Gossen Luna Pro sbc and the Sekonic DX-1, can also meter flash illumination. If you do not have a meter that can measure electronic flash, make a series of tests on a roll of your favorite fine-grained

color negative film from your largest to your smallest aperture. The only filtration you need is a UV filter to block the excessive ultraviolet inherent in electronic flashes. Since the color negative film is balanced for daylight-type light, you will get a negative that will reproduce the colors of the original print pretty much as you see them. Minor color adjustments can be made in the printing process.

Copy work like this is surprisingly easy to do. For some reason it has been made to seem a difficult and mysterious process, but one or two rolls of test film should make you a copy pro. Remember to keep your copy lights at 45-degree angles from the copy surface. Also make sure your copy is flat. Some photographers use a piece of glass to keep their copy flat, but the glass must be thoroughly cleaned with glass cleaner and polished before use. I prefer to use double-sided tape and lightly press the print to it if it does not lay flat; I find this a lot easier than cleaning and polishing a piece of glass.

Of course, if you do not want to do the copy work yourself, you can always have Polaroid make copies of your Polaroid instant prints. Some labs also offer copy services and will make a negative from any print that you bring to them. Many labs also will make internegatives from slides or larger size transparencies for you, but you can also do this yourself with a minimum of trouble.

Internegatives can be made from slides with inexpensive slide duplicators, a white board to reflect sunlight into the back of the duplicator, and a roll of your favorite fine-grained negative film in your camera. Inex-

pensive slide duplicators, which contain their own flat-field lenses are available from Kalt, Spiratone, and many other suppliers. The only other thing you will need is a UV filter to absorb ultraviolet radiation, which would alter the colors of the transparency being copied. Use the meter in your camera and bracket your first exposures plus or minus one stop on your first roll. After seeing your results, you will know how to expose future rolls.

These duplicators can also be used with an electronic flash unit. The flash unit can be faced directly at the diffusion glass at the back of the duplicator. Measure the distance carefully from the glass to the front of the flash and make a series of test exposures at 3, 4½, 6, 8½, 9, and 12 inches. Unless your flash is very powerful, one of these distances should be correct. Make sure that you use your flash unit on manual to produce consistent exposures.

There are also more sophisticated slide duplicators such as the Bowens Illumitran and Copytran, and the Alpamaster. As with the other duplicators, the only extra thing you need is a UV filter for correct color balance. The instructions provided with each unit give you the relationship between their focusing lights and the output of their flash tubes so that you can meter each slide with your built-in camera meter and get a perfect exposure every time. For example, with the Alpamaster and an ISO 100/21° color negative film you would set your meter at an EI of 1600/33°. The camera shutter speed is set to ¹⁄₆₀ sec. and you adjust your aperture until you get a correct indication and make your exposure.

Making color internegatives using standard color negative films is an easier process than making internegatives with internegative film, or making slide duplicates with duplicating films, both of which need color balance adjustments for various emulsions. You need use no color correction filtration when using standard color films and daylight quality light.

The only problem you may run across is a building in contrast, which is inherent in any type of copy or duplicating process. The Alpamaster has a contrast control unit built in, which adds a controllable amount of white light to the copy film during exposure thereby lowering the contrast of the image being copied. The Bowens Illumitran has a contrast control unit available as an accessory.

If you do not have a contrast control unit and you are getting results that are consistantly too contrasty, you can lower the contrast via the following double-exposure method. First determine the exposure for the slide copied and make an exposure. Then, using the double exposure method for your camera, cock the shutter. Remove the slide from the duplicator and replace it with a neutral density filter (ND) 2.0. Change nothing else and make a second exposure through the ND 2.0, which should add enough fogging to lower the contrast of the image. If the fogging is too much, add more neutral density, and if it is not enough, subtract neutral density. This method for lowering contrast can be used with any type of duplicating setup, as long as your camera has method to make double exposures.

The reason for making copies of instant print film images and other prints where the negative is lost or unavailable are obvious: the negative allows you to make duplicate prints.

Kodak Vericolor Internegative Film

MANUFACTURER: *Eastman Kodak*
TYPE: *low-contrast color negative film for making negatives from transparencies*
SIZES: *35mm cartridges, 46mm and 70mm long rolls, and sheets*
FILM SPEED: *rolls: EI 3/6°–18/14°; sheets: see below*
COLOR BALANCE: *tungsten 3200K*
NOTES: *processing is standard C-41, Unicolor K-2 or equivalent process*
APPLICATIONS: *used to produce internegatives from slides for printing, and when transparencies are to be enlarged in whole or part to great size*

Kodak Vericolor Internegative films are specially designed with very low contrast to produce color internegatives from color transparencies. Vericolor Internegative films serve many purposes. They are often used in areas where no labs are available that print directly from slides on color reversal papers. Many labs that offer "C" prints (prints from negatives) also provide internegative services using Vericolor Internegative film. Kodak Vericolor Internegative films are also used when very large prints are going to be made from small transparencies. For example, a 35mm transparency is intermediately enlarged onto a 4 × 5 sheet of Vericolor Internegative film, which in turn is used for the final enlargement. The intermediate enlargement stage helps control grain and image sharpness in the final print. Sections of a transparency can be selectively enlarged using this procedure to exclude unwanted detail so the final print can be of the best possible quality without incurring special printing charges.

Some photographers use both duplicating films and Vericolor Internegative film to keep track of their image files, and to keep originals in hand while still submitting pictures to clients. It is quite simple to use either the 35mm or 70mm size to make both negatives from color slides and color contact sheets to use as a record of filed slides and/or to show clients or friends. In this way, original transparencies receive as little handling as possible.

Vericolor Internegative roll films are usually used in-camera in some type of duplicating setup. Vericolor Internegative roll films are balanced for tungsten illumination and have an exposure index (EI) varying from 3/6° to 18/14° for cameras using through the lens meters. When using meterless cameras or high intensity printers, illumination at the exposing plane should be about 7½ foot candles. The ideal exposure duration for the roll films is between ½ and two seconds with an overall range of $\frac{1}{15}$ second to 30 seconds. When using a duplicating setup, start with a filter pack of CC30 Magenta and CC30 Yellow or try the filter pack recommended

on the accompanying information sheet. Make a series of test exposures, first varying the aperture, then varying filtration to determine correct exposure value and color balance for the combination of the emulsion being used and the one being reproduced. Once these values are established, it is quick and easy to make large numbers of internegatives from similar transparencies.

The sheet films are balanced for tungsten illumination and are used in enlargers or special duplicating setups with a light intensity at the exposing plane of 0.75 footcandles. Ideal exposures for the Vericolor Internegative sheet films are between seven and 15 seconds with an overall range of ½ to 30 seconds. Exact exposure time can be determined by test stripping a sheet of film and studying these negatives in the same manner as done with printing test strips. A second sheet may then be used to test for correct color balance.

Transparencies are the best color format when shooting for publication, and for permanence of color images. Vericolor Internegative can help keep track of transparency files and prevents precious images from being handled too much. Internegatives are surprisingly easy to make because they do not require the exacting exposure and color balance required for slide duplication, and only one test roll is necessary to determine exposure and color balance. Once correct color balance has been determined, it will rarely change, even when producing internegatives from different film brands, which is often critical when using Slide Duplicating film.

PROCESSING Kodak Vericolor Internegative films are developed in standard C-41 chemistry. Unicolor K-2 or any equivalent process may be used. It is wise to establish consistent processing habits if consistent results are desired. Some photographers feel that precise processing procedures are not necessary with color negative films because corrections may be made during the printing process. Sloppy processing often produces increased grain and sometimes uncorrectable color balance. Remember that the best prints always come from the best possible negatives.

APPLICATIONS Kodak Vericolor Internegative films are primarily used by color labs and professional photographers to produce internegatives from slides, but they can also help amateur photographers control and preserve their slide collections.

APPENDIX

Protecting and Preserving Photographic Film

Photographic film is perishable both before and after exposure and before and after processing. The most permanent films are black-and-white, silver-image films because the silver stands up well to heat, humidity, pollutants, light, and time. Color transparencies are next in order of permanence, as they use colorless couplers, which have good stability. Kodak Kodachromes use couplers in the developer and have the greatest stability of all the color transparency films. However, advances in color dye technology have greatly improved the permanence of the E-6 type films. Lowest on the permanence list are the color negative films, which have colored couplers that do not have the permanence of colorless couplers. But there have also been advances here so that the modern color negative films should last twice as long as earlier ones.

Professional films should be stored at 55°F or cooler until you are ready to use them. The lower the temperature, the longer a film's characteristics will be preserved. Films can be frozen for many years with little change in their exposure characteristics or color balance. While professional films need cool storage because they are manufactured at peak proficiency, amateur films can also be refrigerated or frozen if being kept for a long time before use. When using cool storage, films should be left in their original sealed containers. Instant print films and sheet films should first be wrapped in airtight plastic bags and sealed before refrigeration.

Exposed and unexposed films must be protected from heat, humidity, strong light, x-rays, and harmful fumes such as auto ex-hausts and gases created by chemical preservatives used in making new furniture. Unexposed film in its original sealed container will be protected from gases, but not from heat or x-rays. An hour or two in the trunk of a car or the back of a truck with the sun beating down can destroy a film. The only way to protect unexposed film from heat and humidity is cool storage. When travelling for any length of time, film can be kept cool with ice in a cooler.

Unexposed films are particularly susceptable to x-rays, which expose the silver halide crystals in the emulsions. One pass through a modern x-ray machine properly set will not produce any noticeable change in the slower speed films up to ISO 400/27°. There will, however, be some change. Since exposure of light sensitive emulsions is cumulative, a few passes through even safe x-ray machines will build up enough exposure to ruin your pictures. High-speed films cannot take even one pass through a safe x-ray machine. By the way, checked luggage is often x-rayed at most airports, so you cannot bypass x-ray equipment by putting film in your luggage.

At airports in the United States, Canada, and Great Britain, you can request hand inspection of items sensitive to x-rays, such as film, tape, vitamins, medicines, etc. But France, Italy, Belgium, Denmark, and Switzerland, and most Eastern Bloc countries refuse to give hand inspections. There have also been some recent reports from West Germany of hand inspection refusals.

The only protection for travellers carrying film that will be x-rayed is to enclose them in

specially designed lead protectors. Sima has two grades of lead foil protectors: Film Shield, which comes in two bag sizes and sheets for wrapping large film sizes, and Super Film Shield, designed with a double thickness of lead to protect high-speed films from x-rays. Filmgard by Security is a soft Cordura bag with heavy duty lead protection for all films. Coast has two sizes of camera bags called Protect-A-Bag, which are lead-lined to protect films up to ISO 400/27°.

One note of caution. Some airlines use high dose x-ray units in some locations: British Airways in Great Britain; Cathay Pacific in Hong Kong and Bangkok; Phillipine Airways in Phillipines; Singapore Airlines in Singapore; and all Concorde departure points. At these locations you should request hand inspection even if you have lead protection. Irwin Diamond, President of Sima, reports that authorities are very cooperative at these points.

Storing negatives and transparencies once they have been exposed and processed presents a different set of problems. The big enemies of processed films are heat, humidity, harmful gases, and the UV radiation that accompanies most light. The sad fact is that the most widely used method of storage is in poly-vinyl-chloride (PVC) pages. PVC emits vinyl chloride gas, which attacks the emulsion and destroys it. Black-and-white films start by losing their lighter tones. Color emulsions begin to lose their dyes, producing color shifts and then serious fading.

Polypropylene, acetate, glassene, and mylar are archivally safe for storing films. Pages and sleeves in these materials are made by Nega File, Print File, Leedal, Kimac, and Kleer Vu Industries (Pro-Line). Franklin Distributors make Saf-T-Stor and Leedal has The Journal, both of which are made of moulded polypropylene, allowing air to circulate around the slides. Nega File makes a series of wooden storage cabinets, which have the added advantage of protecting films from humidity. Large filing systems for slides are made by Leedal and Multiplex.

Processed films should be stored at 70°F or lower with a relative humidity of 40–50-percent. Kodak makes special cold storage envelopes for storing color films up to 8 × 10-inches. Cold storage is the ideal method for storing important films. Some photographers make duplicates of important originals, use the duplicates for everyday use, and use the Kodak cold storage envelopes to protect the originals from heat, humidity, gases, UV radiation, and the ravages of time.

List of Manufacturers

Agfa-Gavaert, Inc.
275 North Street
Teterboro, New Jersey 07608
(201) 288-4100

Durst North America, Inc.
641 South Rockford Drive
Tempe, Arizona 85281
(602) 968-7225

Eastman Kodak Company
343 State Street
Rochester, New York 14650
(716) 325-2000

Falcon Safety Products, Inc.
1065 Bristol Road
Mountainside, New Jersey 07092
(201) 233-5000

Fuji Photo Film USA, Inc.
350 Fifth Avenue
New York, New York 10118
(212) 736-3335

Gossen Division
Berkey Marketing Co., Inc.
25-20 Bklyn-Queens Expressway West
Woodside, New York 11377
(212) 932-4040

Ilford, Inc.
West 70 Century Road
Paramus, New Jersey 07652
(201) 265-2000

Konishiroku Photo Industry U.S.A., Inc.
560 Sylvan Avenue
Englewood Cliffs, New Jersey 07362
(201) 568-3100

Negafile Systems, Inc.
3069 Edison-Furlong Road
P.O. Box 78
Furlong, Pennsylvania 18925
(215) 348-2356

Omega Division
Berkey Marketing Co., Inc.
25-20 Bklyn-Queens Expressway West
Woodside, New York 11377
(212) 932-4040

Perutz Company
Munich, West Germany

Polaroid Corporation
549 Technology Square
Cambridge, Massachusetts 02139
(617) 577-2000
(800) 225-1384

Sekonic Exposure Meters
Copal (USA) Inc.
16-00 Route 208
Fairlawn, New Jersey 07410
(201) 794-8004

Sima Products Corp.
4001 West Devon Avenue
Chicago, Illinois 60646
(312) 286-2333

Spiratone, Inc.
130 East 31st Street
New York, New York 10001
(212) 886-2000

3M Company
3M Center Building
St. Paul, Minnesota 55144
(612) 733-1110

Tiffen Manufacturing Corporation
90 Oser Avenue
Hauppauge, New York 11788
(516) 273-2500

Unicolor Division
Photo Systems, Inc.
7200 Huron River Drive
Dexter, Michigan 48130
(313) 426-4646

List of Films by Manufacturer

AGFA-GEVAERT

Agfachrome 50S Professional
Agfachrome 50T Professional
Agfachrome CT 18
Agfachrome CT 50
Agfachrome RS 50
Agfachrome 64
Agfachrome 64 Professional
Agfachrome CT 64
Agfachrome RS 64
Agfachrome 100
Agfachrome 100 Professional
Agfachrome CT 21
Agfachrome CT 100
Agfachrome RS 100
Agfachrome 200
Agfachrome 200 Professional
Agfachrome CT 200
Agfachrome RS 200
Agfachrome Speed
Agfacolor XR 100
Agfacolor XR 200
Agfacolor XR 400
Agfa Dia/Direct
Agfapan 25 Professional
Agfapan 100 Professional
Agfapan 400 Professional
Agfapan Vario-XL Professional

EASTMAN KODAK COMPANY

Ektachrome 50 Professional
Tungsten Film (EPY)
Ektachrome 64 ER
Ektachrome 64 Professional EPR
Ektachrome 100 EN
Ektachrome 100 Professional EPN
Ektachrome 160 ET
Ektachrome 160 Professional EPT
Ektachrome 200 ED
Ektachrome 400 EL
Ektachrome P 800/1600 EES
Ektachrome Slide Duplicating Film 5071
Ektachrome Slide Duplicating Film 6121
Ektachrome Slide Duplicating Film SO-366
Kodachrome 25 KM
Kodachrome 25 Professional PKM
Kodachrome 40 Type A
Kodachrome 64 KR
Kodachrome 64 Professional PKR
Kodacolor VR 100
Kodacolor VR 200
Kodacolor VR 400
Kodacolor VR 1000
Kodak Direct Positive Pan Film
Kodak Ektachrome Infrared
Kodak High Speed Infrared Film
Kodak Panatomic-X
Kodak Panatomic-X Professional
Kodak Photomicrography Color Film 2483 (PCF)
Kodak Plus-X Pan
Kodak Plus-X Pan Professional
Kodak Plus-X Portrait

Kodak PR 144
Kodak Recording Film 2475
Kodak Technical Pan 2415
Kodak Tri-X Pan
Kodak Tri-X Pan Professional
Kodak Verichrome Pan
Kodak Vericolor III
Kodak Vericolor Internegative Film
Kodak Vericolor Slide Film
Kodamatic HS 144 Trimprint

FUJI PHOTO FILM COMPANY

Fujichrome 50 RF
Fujichrome 50 RFP Professional D
Fujichrome 100 RD
Fujichrome 100 RPD Professional D
Fujichrome 400 RH
Fujicolor HR 100
Fujicolor HR 200
Fujicolor HR 400
Fujicolor HR 1600

ILFORD LTD.

Ilfochrome 100
Ilfocolor HR 100
Ilfocolor HR 200
Ilfocolor HR 400
Ilford Pan F
Ilford FP4
Ilford FP4 Professional Sheet Film
Ilford HP5 Professional Sheet Film
Ilford HP5
Ilford XP1 400

KONISHIROKU PHOTO COMPANY

Konica Chrome 100/
Sakurachrome 100
Konica/Sakura SR 100
Konica/Sakura HR 200
Konica/Sakura SR 200
Konica/Sakura HR 400

PERUTZ

Peruchrome C19

POLAROID CORPORATION

Polachrome CS Autoprocess Film
Polacolor ER Type 59
Polacolor ER Type 559
Polacolor ER Type 669
Polacolor ER Type 809
Polacolor 2 Type 58
Polacolor 2 Type 88
Polacolor 2 Type 108
Polacolor 2 Type 668
Polacolor 2 Type 808
Polagraph HC Autoprocess Film
Polapan CT Autoprocess Film
Polapan Type 52
Polapan Type 552
Polaroid Type 55 P/N Film
Polaroid Type 665 P/N Film
Polaroid Type 51 High Contrast
Print Film
Polaroid Time Zero
Polaroid Type 778
Polaroid 600
Polaroid Type 779
Polaroid Type 47
Polaroid Type 57
Polaroid Type 87
Polaroid Type 107
Polaroid Type 107C
Polaroid Type 667

3M

3M Color Print HR 100
3M Color Print HR 200
3M Color Print HR 400
3M Color Slide 100
3M Color Slide 400
3M Color Slide 640T
3M Color Slide 1000—Daylight

List of Films by Application

GENERAL PURPOSE

Agfapan 25 Professional (black-and-white negative)
Kodachrome 25 KM (color transparency)
Kodachrome 25 Professional PKM (color transparency)
Kodak Panatomic-X (black-and-white negative)
Kodak Panatomic-X Professional (Black-and-white negative)
Polachrome CS Autoprocess (instant color transparency)
Agfachrome 50S Professional (color transparency)
Agfachrome CT 18 (color transparency)
Agfachrome CT 50 (color transparency)
Agfachrome RS 50 (color transparency)
Fujichrome 50 RF (color transparency)
Fujichrome 50 RFP Professional D (color transparency)
Ilford Pan F (black-and-white negative)
Agfachrome 64 (color transparency)
Agfachrome 64 Professional (color transparency)
Agfachrome CT 64 (color transparency)
Agfachrome RS 64 (color transparency)
Ektachrome 64 ER (color transparency)
Ektachrome 64 Professional EPR (color transparency)
Kodachrome 64 KR (color transparency)
Kodachrome 64 Professional PKR (color transparency)
Peruchrome C19 (color transparency)
Polacolor ER Type 59 (instant color print)
Polacolor ER Type 559 (instant color print)
Polacolor ER Type 669 (instant color print)
Polacolor ER Type 808 (instant color print)
Polacolor ER Type 809 (instant color print)
Polacolor 2 Type 58 (instant color print)
Polacolor 2 Type 88 (instant color print)
Polacolor 2 Type 108 (instant color print)
Polacolor 2 Type 668 (instant color print)
Agfachrome 100 (color transparency)

Agfachrome 100 Professional (color transparency)
Agfachrome CT 21 (color transparency)
Agfachrome CT 100 (color transparency)
Agfachrome RS 100 (color transparency)
Agfacolor XR 100 (color transparency)
Agfapan 100 Professional (black-and-white negative)
Ektachrome 100 EN (color transparency)
Ektachrome 100 Professional EPN (color transparency)
Fujichrome 100 RD (color transparency)
Fujichrome 100 RDP Professional (color transparency)
Fujicolor HR 100 (color negative)
Ilfochrome 100 (color transparency)
Ilfocolor HR 100 (color negative)
Kodacolor VR 100 (color negative)
Konica Chrome/Sakurachrome 100 (color transparency)
Konica/Sakura SR 100 (color negative)
3M Color Print HR 100 (color negative)
Ilford FP4 (black-and-white negative)
Ilford FP4 Professional Sheet Film (black-and-white negative)
Kodak Plus-X Pan (black-and-white negative)
Kodak Plus-X Professional (black-and-white negative)
Kodak Plus-X Portrait (black-and-white negative)
Kodak Verichrome Pan (black-and-white negative)
Polapan CT Autoprocess (instant black-and-white transparency)
Polaroid Time Zero (instant color print)
Polaroid Type 778 (instant color print)
Kodak PR 144 (instant color print)
Kodak Vericolor III (color negative)
Agfachrome 200 (color transparency)
Agfachrome 200 Professional (color transparency)
Agfachrome CT 200 (color transparency)
Agfachrome RS 200 (color transparency)
Agfacolor XR 200 (color negative)
Ektachrome 200 ED (color transparency)
Ektachrome 200 Professional LPD (color transparency)
Fujicolor HR 200 (color negative)
Ilfocolor HR 200 (color negative)
Kodacolor VR 200 (color negative)

Konica/Sakura HR 200 (color negative)
Konica/Sakura SR 200 (color negative)
3M Color Print HR 200 (color negative)
Kodamatic HS 144 Trimprint (instant color print)
Agfa Color XR 400 (color negative)
Agfapan 400 Professional (black-and-white negative)
Fujichrome 400 RH (color transparency)
Fujicolor HR 400 (color negative)
Ilfocolor HR 400 (color negative)
Ilford HP5 (black-and-white negative)
Ilford HP5 Professional Sheet Film (black-and-white negative)
Kodacolor VR 400 (color negative)
Kodak Tri-X Pan (black-and-white negative)
Kodak Tri-X Pan Professional (black-and-white negative)
Konica/Sakura SR 400 (color negative)
Polapan Type 52 (instant black-and-white print)
3M Color Print HR 400 (color negative)
3M Color Slide 400 (color transparency)
Polaroid 600 (instant color print)
Polaroid Type 779 (instant color print)

INDOOR
Polaroid Type 55 P/N (instant black-and-white negative and print)
Kodachrome 40 Type A (color transparency)
Agfachrome 50T Professional (color transparency)
Ektachrome 50 Professional Tungsten (color transparency)
Polaroid Type 665 P/N (instant black-and-white negative and print)
Ektachrome 160 ET (color transparency)
Ektachrome 160 Professional EPT (color transparency)
Polapan Type 52 (instant black-and-white print)
Polapan Type 552 (instant black-and-white print)
3M Color Slide 640T (color transparency)
Polaroid Type 47 (instant black-and-white print)
Polaroid Type 57 (instant black-and-white print)
Polaroid Type 87 (instant black-and-white print)
Polaroid Type 107 (instant black-and-white print)
Polaroid Type 107C (instant black-and-white print)
Polaroid Type 667 (instant black-and-white print)

HIGH SPEED

3M Color Slide 640T (color transparency)
Kodacolor VR 1000 (color negative)
3M Color Slide 1000—Daylight (color transparency)
Ektachrome P 800/1600 ES (color transparency)
Fujicolor HR 1600 (color negative)
Polaroid Type 47 (instant black-and-white print)
Polaroid Type 57 (instant black-and-white print)
Polaroid Type 87 (instant black-and-white print)
Polaroid Type 107 (instant black-and-white print)
Polaroid Type 107C (instant black-and-white print)
Polaroid Type 667 (instant black-and-white print)

VARIABLE SPEED

Agfachrome Speed (instant color print)
Agfapan Vario-XL Professional (black-and-white negative)
Ilford XP1 400 (black-and-white negative)
Ektachrome P 800/1600 (color transparency)

SPECIAL PURPOSE

Agfa Dia/Direct (black-and-white transparency)
Ektachrome Slide Duplicating Film 5071 (color duplicate transparency)
Ektachrome Slide Duplicating Film 6121 (color duplicate transparency)
Ektachrome Slide Duplicating Film SO-366 (color duplicate transparency)
Kodak Ektachrome Infrared (color transparency)
Kodak High Speed Infrared Film (black-and-white negative)
Kodak Photomicrography Color Film 2483 (color transparency)
Kodak Recording Film 2475 (black-and-white negative)
Kodak Technical Pan 2415 (black-and-white negative)
Kodak Vericolor Internegative Film (color duplicate negative)
Kodak Vericolor Slide Film (color duplicate transparency)
Polaroid Type 51 High Contrast Print Film (instant black-and-white print)
Polaroid Type 55 P/N (instant black-and-white negative and print)
Polaroid Type 665 P/N (instant black-and-white negative and print)

Designed by Areta Buk
Production Manager: Hector Campbell